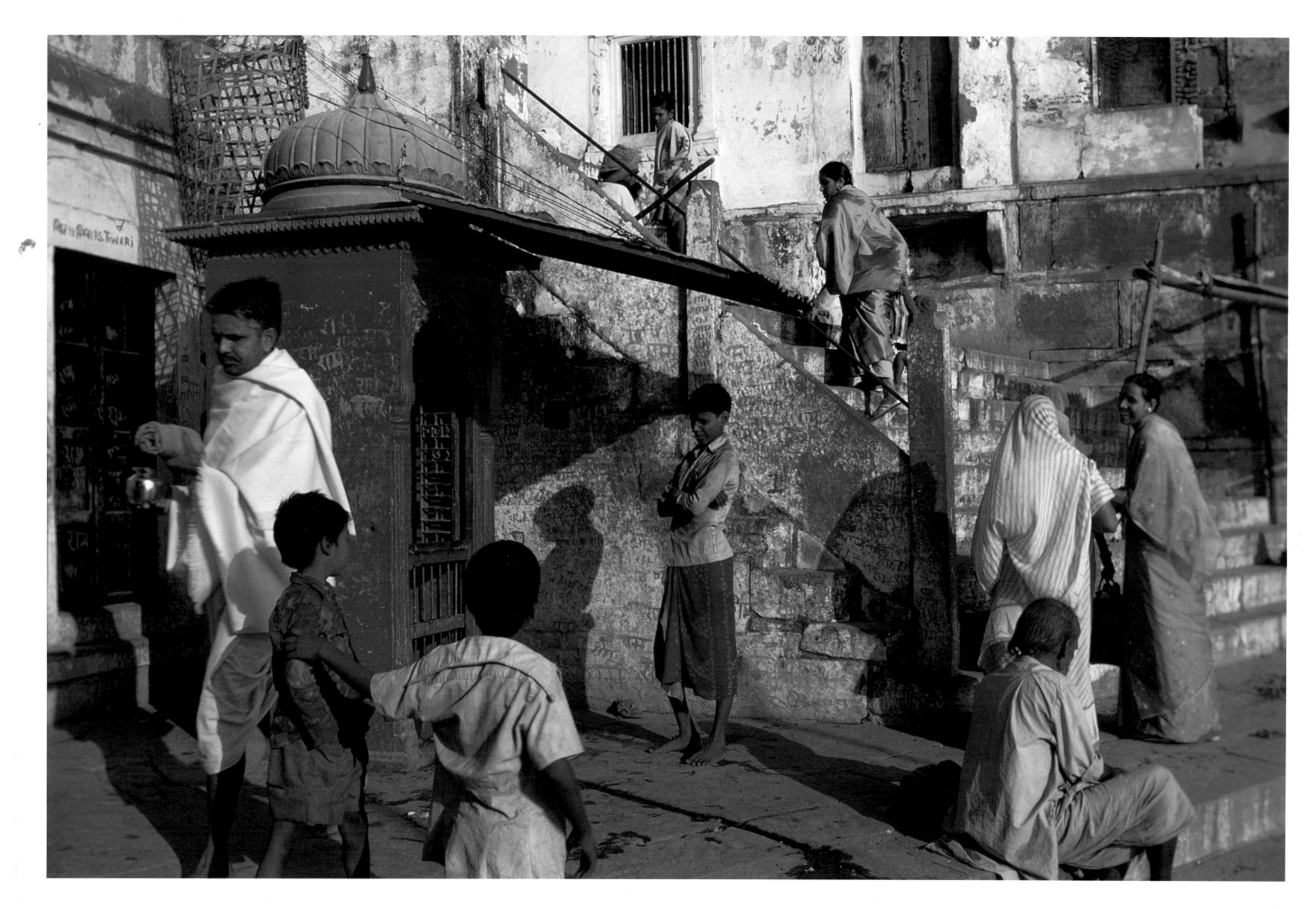

RIVER OF COLOUR THE INDIA OF RAGHUBIR SINGH

For Devika, a teenager of two worlds, and for Satyajit Ray, who showed
us how to bridge them, without the loss of one's identity.

Phaidon Press Limited
Regent's Wharf
All Saints Street
London N1 9PA

First published 1998
River of Colour The India of Raghubir Singh
© 1998 Phaidon Press Limited
Photographs and Singh essay © 1998 Raghubir Singh

ISBN 0 7148 3806 3

A CIP catalogue record for this book is available from
the British Library.

Library of Congress Cataloging in Publication Data
available.

Printed in Hong Kong

1 Morning on Panchganga Ghat, Benares, Uttar
Pradesh, 1985

PREFACE

In the world of photography, the name of Raghubir Singh is synonymous with India. His many books on the subject also identify him as one of the foremost photographers working exclusively in colour. The high level of development to which he has brought his art through his rich and seductive subject is apparent in this volume, which has been edited with an eye to his best photographs. In this book India is of course present in every image, but so, for the first time, is Singh's marvellous career.

As an artist in his mid-fifties, Raghubir Singh faces a period in which many artists admit more about the world and themselves than they discover. For many, the end of mid-career is a time that permits past experience to be substituted for spontaneous invention, as inner reflections create new meanings about that which is already known. As promising as such a period might seem for humanists and intellectuals, it is a period that is usually met with resistance on the part of those who have spent their active careers creating photographs.

Raghubir Singh has had and continues to have such a career. His first book was published in 1974. Since then he has produced 11 others, all concerned with India. His first books were an exploration of the country region by region; he photographed the Ganges, Calcutta and his native Rajasthan. Singh's books have taken readers from Kashmir in the north to Kerala on the west coast, and to the great cities of Benares and Bombay. In addition to photographing its geography, Singh has also found subjects in those aspects of India that constitute its great spirit and identity, including the Grand Trunk Road. In this book, Singh rediscovers India not through specific regions but through the way life was conducted around him.

River of Colour is an excellent title for this retrospective view of his career. In his long career, Singh not only refined his understanding of an immense subject, but also discovered ways to accommodate the fact that his subject, and his perception of it, are in constant flux. For more than a quarter of a century, Singh's exploration of India has been like a steadily flowing current. As his river coursed on, it reached a place where he began interacting visually with outer realities; it was as though he and they were both part of his inner emotional and intuitive swirling stream. Increasingly, his photographs began to point out active, rather than passive, aspects of India. When photographers begin to work in this manner they no longer use their medium to create an inventory of objects or sites, but instead begin to 'capture life in the act of living', as Singh's hero Henri Cartier-Bresson once put it. This intuitive approach to photography is perfectly suited to what Singh cherishes about the Indian way of observing and shaping the world.

Becoming a photographer who is part of the artistic flow of an ephemeral and eternal India, at the same time as being in constant observation of the culture, demands something of a balancing act. This might be instigated by curiosity and luck, but is mastered only by evaluation and experience. Although Singh continues with youthful determination to discover new ways to observe India, he is now at a stage in his career where he no longer dismisses his past work as he goes on to his next project. In selecting and arranging this book, he offers the viewer new themes and ideas. As Singh pondered the precise sequencing of the photographs in this book, he was forced to think about his feeling for his subjects and for his art. This led him to consider not only the place he occupies within his subject matter, but also his personal philosophy about the larger world of art and ideas.

When one considers Singh's development as an artist, another India becomes subtly visible in this book. This other India is not just a homeland willing to be observed in its wild diversity. It is an India that offers coexisting realities, at the same time as a self-contained history which suggests a magical cosmos; it is an India that offers details of common ways of life alongside metaphors of the fantastic. In *The Discovery of India*, Jawaharlal Nehru, then an imprisoned leader, prophetically quotes Nietzsche as a way of touching on the universal aspect of what all active, ancient cultures contain: 'Not only the wisdom of centuries – also their madness breaketh out in us. Dangerous is it to be an heir.' The wise and mad cultural heritage of India is out in the streets for everyone to see, but it is only a photographer of Singh's talent and perception who can truly reflect Nietzsche's words through a sympathetic composition of colour. Singh achieves his own level of wisdom and madness – not by careful analytic depiction but rather in the Indian way, through the cultural tradition of a total immersion in the rush of experience.

It would be wrong to think that this book signals an introspective phase of Singh's career. His appetite for the inexhaustible magnitude of India has not been dulled; neither does he believe his successes have tamed his subject-matter. Singh could return (and has) to any region or theme of India and discover that his inner eye is still inventing new ways of seeing it. Because this book looks back on a career rather than on a single project, we might assume, as has been the case with other photographers, that something is being brought to an end. This is not the case. If Singh's career seems comfortably settled, it is only because he has so deftly suspended it for our musing, whilst at the same time finding a way to tell his own story. Self-satisfying as this may be, Singh is not likely to spend too long dwelling on this retrospective now that it is done. As ever, he is restless with a spate of new projects. His future is with the India of the present. If it seems to us that he is discovering another India, it is because he has gained another perspective along the course of his career. His view of India has become more profound and his river coloured with new reflections. Happily, he is not so old or self-indulgent that he will sacrifice what enchants him for what is easy to explain to himself or others. Perhaps that is what keeps him youthful and perpetuates his stature as a great photographer.

David Travis, March 1998
Curator of Photography, The Art Institute of Chicago

RIVER OF COLOUR: AN INDIAN VIEW

There is that universal beauty which is seen by the inner eye, heard by the inner ear...but different race or individual consciousnesses form different standards of aesthetic harmony.

The Foundations of Indian Culture by Sri Aurobindo

In the Rajput courts of my native Rajasthan, neither art nor life could be imagined without the brilliant plumage of a bird in flight. Colour has never been an unknown force in India. It is the fountain not of new styles and ideas, but of the continuum of life itself. In India, no one uses the commonplace and self-conscious Western term 'colourist' – the word does not even exist in our artistic vocabulary. Indians know colour through intuition, while the West tries to know it through the mind. Indeed, India is a river of colour.

If photography had been an Indian invention, I believe that seeing in colour would never have posed the theoretical or artistic problems perceived by Western photographers. In condemning colour photography, Henri Cartier-Bresson has privately used unprintable French-army language and publicly called it the province of painting. Walker Evans declared it vulgar and André Kertész, in his books and exhibitions, never showed his colour photographs. While a whole new generation of photographers have embraced colour, these seminal figures preferred the distancing quality inherent in black and white images to the emotional plunge resident in colour pictures.

Before colonialism and before photography, Indian artists did not see in black and white, though they made delicate drawings filled in with colour. The medium of drawing, as it is known in the West, has never existed in India – neither aesthetically nor technically: India has never had a Leonardo, Rembrandt or Goya. Even the exquisite drawings of the Moghul court are far different from the drawings of the West in that they are usually heightened with colour, or with tan washes known as *nil kalam*. In the sixteenth-century court of Akbar, it was an enormous surprise when Jesuits from Goa presented the Moghul emperor with the Royal Polyglot Bible, packed with engravings. After recovering from their surprise, the emperor and his courtiers and artists must have mentally filled in the stark and dense engravings with colour. The great seventeenth-century drawing, *Inayat Khan Dying*, created for Emperor Jehangir, does not have the dark mood or the light and shade of European masterpieces. The drawing was a preparation for a painting. Such drawings were found in the ateliers of artists rather than in the princely collections. Today these drawings are scarce, suggesting the secondary role they played to the vibrantly coloured Moghul and Rajput paintings.

From antiquity, the Judeo-Christian world has seen colour through a succession of theories. Judaism had no sense of colour and representation until as late as Chagall; while Christianity displayed an adversity towards colour. In his book *Civilisation,* Kenneth Clark talks of Turner and the transference of nature into art. He concludes: 'Colour was considered immoral – perhaps rightly, because it is an immediate sensation and makes its effect independently of those ordered memories which are the basis of morality.' John Gage, in *Colour and Culture*, devotes a whole section to the moral theory of colour from Aristotle to Kandinsky. And Charles A. Riley II, in *Color Codes,* states: 'Color is a source of great anxiety ... many of our most acclaimed artists, such as Brice Marden, Frank Stella and Jasper Johns, feel a profound uneasiness about its use. Precisely because it is largely an unknown force, colour remains one of the most vital sources of new styles and ideas.'

Unlike those in the West, Indians have always intuitively seen and controlled colour. Our theories, from early in antiquity, became a flowing and rhythmic entity of India's river of life – its river of colour.

According to the nine *Rasas* which guide India's classic aesthetics, the human imagination is detached from earthly bondage and attached to a flight of fantasy, interlocking the magical, the marvellous and the mystical. These conditions, of which colour is an intrinsic part, have forever fired the mind of India. The truly Indian colour photographer, therefore, cannot escape this enchantment of sight and sense. This aesthetic is as apparent in Rajput painting, in Indian classical music, in the Bharat Natyam dance and in Indian sculpture as it is in India's daily life. It is also highlighted in a painting from the *Padshahnama*, the seventeenth-century album from the time of Shah Jehan. It shows the murder of Khan Jahan Lodi against a setting of flowers and of a paradise-like green. Contrast this Moghul painting to *The Death of Marat* (1793) by David and the psychological-cum-pictorial differences are clear. In the Moghul work the Indian artist had the power to see simultaneously a most gruesome murder as well as a kingfisher catching fire.

Much of Western vision in this century has been a depiction of angst, alienation and guilt. Man and woman are alone in the universe; with the death of God there is nothing to redeem them from their loneliness. The vision of loneliness and hell can be best conveyed in monochromatic or muted tones – tones that are alien to India and its buoyant life and philosophy. The fundamental condition of the West is one of guilt, linked to death – from which black is inseparable. The fundamental condition of India, however, is the cycle of rebirth, in which colour is not just an essential element but also a deep inner source, reaching into the subcontinent's long and rich past. In India's epic literature there is just one brief, but vivid, vision of hell: the river of blood of the *Mahabharata*. Apart from this exception, the Indian view of life resonates with optimism, with sparkle, with illusion, with lively pictorialism and with the bonding spirit of community. This is the essence, the *Rasa*, of India's pictorial spirit – an essence which the artist cannot ignore.

The true Indian artist can also not ignore the blessing of colour

that is written into the Indian idea of *darshan* – sacred sight – which we know from childhood. This idea is a way of seeing that encompasses the sensuality of touch and feel, human contact and intimacy. Black does not fit into the idea of *darshan*. Indeed, the eyes of India see only in colour. Today, of a population of a billion people, at least 850 million– with the exception of India's Islamic and tribal world – consider black to be taboo.

For these reasons, I believe that however much we Indians genuinely admire the black and white arts of the West, the Indian photographer cannot produce the angst and alienation rooted in the works of Western photographers such as Brassaï, Bill Brandt, Robert Frank and Diane Arbus. Psychological empathy with black is alien to India. Can any Indian seek inspiration in those low-life characters of Stendhal and, particularly, Dostoevsky that inspired Brassaï to do *Paris de Nuit* and *The Secret Paris*?

When black and white is used in India it is most successful when extreme contrasts are avoided and the complete grey scale becomes a living transposition of all colours, as in the films of Satyajit Ray and photography of Henri Cartier-Bresson. Satyajit Ray was very conscious of the differences between India and the West. In his films he used black and white as a psychological metaphor for the colours of India, thus giving his cinema a sense of sunlight. Even in Ray's saddest films, there is, almost always, an optimistic quality: death is depicted again and again but it is handled very differently than in the works of Western directors. The dark vision related to the abjections of life is absent from his works. As the director himself once explained: 'Violence in our country somehow gathers a debasing quality … In the West, experience of violence can have a transmuting or ennobling quality. Think of the dimension in which they had it for such a long time. There is also the overburdening Christian sense of guilt. They can even have a mystique of violence… I can't imagine any Indian raising evil to the level of a work of art, as say, Buñuel does'.

My voice is essentially that of someone who spent his formative

years in Rajasthan. My artistic sense was shaped early on by the ideas of the culture of the Rajputs of Rajasthan. In my home in Jaipur, black was a colour we shunned, in spite of the dinner jackets that the British brought in. We associated it with evil. My mother would wear dark and dense colours on only one night, the darkest night of the year, the night of the Diwali festival. Yet the dense blue she wore sparkled with tiny tinsels, as though her sari were the darkness of night and the tinsels the stars that gave life to the blackness. In Rajasthan, the colours of food and clothing are closely tied to the seasons. Songs are also sung about colour. A favourite is 'Kesariya Balam', about a young woman pining for her lover. She sings of the desert land and its three jewels: her lover, herself and the colour *kasumal*, a kind of saffron-yellow. The sensuality of love is equally attached to the monsoon and its colours. When the monsoon breaks and the dusty-brown of the desert becomes a wet-brown dappled by lush greens, the *lariya* colour also leaps to life through clothing, its greens and yellows assuming a consonance with nature. When winter gives way to spring, shades of rose and yellow are worn. In the summer, pale colours dispel the heat. At death, the monochrome sheen of white is the colour of mourning; but it is also a colour of life – it is the colour that bonds life and death because unlike black it is receptive to the whole chromatic scale of colour. In keeping with this story, almost all Indian painting, before the blight of the British academic style set in, resonates in the use of white, a use that can be traced as far back as the eighth-century AD to the Kailas temples at Ellora and Kanchipuram, whose exterior surfaces evoked the very snows of the sacred mountain of the Hindus and the Buddhists.

The Portuguese, the Dutch, the Danish, the French and finally the British sailed to India's shores, over the dreaded black waters. They brought with them the fruits of industrial Europe and alongside the steamship, the telegraph and the train, the camera became an instrument of colonialism. Through its illusion of documentary realism and through its widespread use, early colonial photography demolished miniature painting. It was as if the foreign demon – dangerously

black – had destroyed the colourful goddess of the Indian arts. My favourite school of painting, the Kotah style, whose high emotional charge stands at odds with the documentary aesthetic of the Moghul school, was among the last to die. At the very end of the nineteenth century it was the swansong of a vibrant art. Thereafter, Rajasthan's visual arts outside of the folk tradition were dead.

In Bengal, however, a process of stamping Western art with an Indian aesthetic had begun. It was as if Indian colours had to be filled into a Western mould. It was as if the camera, the Western mould, made a drawing into which the colours of India had to catch fire. In the artistic continuum of 'filling in' colours, some nineteenth-century Indian photographers hand-coloured their photographs. Using a rich palette, they made the colouring very different from that done in other cultures. These Indian photographers, some of them the descendants of painters, were re-doing miniature painting all over again. In a sense, they foreshadowed the Indian colour photographer of today.

About the time of the introduction of photography into India, the British began creating a class of people who would help them govern the land. Along with a new class of English-speaking Indians, the seeds of a new imported visual language – the art-school style of London's South Kensington – were sown in India. Under these new conditions the Indian photographer became a craftsman-artist who looked at life through an imported instrument, with a new kind of sight, but did not have the confidence to create his own kind of language. His own tradition was unlike that of Japan, where art included reportage through woodcuts and modernist inventions in perspective and fragmentation, that related to the minimalism of Zen and haiku. He could intuitively borrow something from the tradition of Indian miniature painting, such as hand-colouring or flat perspective. But this was a brief fling, a brief flirtation with the past, and one that had no future, because the domination of colonialism swept aside the concept of a personal language.

The British photographer, however, came to India conscious of the

pictorial tradition that had led to photography. He worked in the lineage of the picturesque school of Poussin, Lorraine and Ruisdael – widely emulated first by colonial painters and then by photographers such as Samuel Bourne. British architectural photographers such as John Murray and Linnaeus Tripe had inherited knowledge and therefore the power to use India's strong sunlight for their art, in the tradition of light and shade in Western drawing and engraving.

By 1910, however, with the arrival of the hand-held camera, the grand period of British photography in India was over. Just as the French Impressionist painters had taken the new invention of paint in tubes out of the studio to capture new visions, the photographer moved away from the solidity of the camera-on-tripod, to surrender himself to the quick take or the rapidity of sight attached to drawing. Again, the Indian photographer, faced with a medium without a cultural tradition, had to reinvent the wheel. Additionally, he had to acquire a sense of individuality for which there was also little precedent. As Ananda Coomaraswamy explains in *The Dance of Siva*: 'Hinduism justifies no cult of ego-expression ... [That] is the proudest distinction of the Hindu culture. The name of the authors of the epics are but shadows.' By the time of the introduction of photography in India, the role of the author as a shadow was over.

Although British colonialism brought an end to many artistic traditions, it also ushered in new concepts. Colonial artists, many of whom travelled with the camera obscura, brought with them a tradition of depicting landscape, light and shade, chiaroscuro, and the street as subject. Colonialism introduced the concept of the individual – the assertiveness of the *I* replacing the passivity of the *we* – as well as the traditional anonymity of the Indian artist. Bold frontal portraits replaced elliptical ones and the first democratic assemblage of artistic-minded audiences through galleries and museums was established.

With India's independence, however, patronage moved from one kind of power to another – to the mandarin, the politician and other Indian nationalists. Occasionally, these figures could be challenged in

their empire-building. For instance, during Indira Gandhi's dictatorship, her mandarins were uniquely distanced by Satyajit Ray, who in 1975 summoned the anger of Mantegna against the Pope, in refusing to make a documentary film on the prime minister. At that time, he had declined a seat in the Indian parliament. 'I am an artist!' – he shouted in anger, when the offer was made to him by a Bengali politician with sycophantic ties to Indira Gandhi.

Grand Indians, like Satyajit Ray, were not afraid of borrowing from the West, a condition which was opposed by a variety of Indian nationalists. Some nationalists still condemn such borrowing, as if the camera and the history of photography are uniquely Indian items, as pristine as the sacred source of the Ganges. They do not understand that India, like the Ganges meeting the sea and therefore another world, has a thousand mouths. In his seminal essay, *The Meaning of Art*, Rabindranath Tagore declares: 'The sign of greatness in great geniuses is their enormous capacity for borrowing ... only mediocrities are ashamed and afraid of borrowing for they do not know how to pay back the debt in their own coin ... our artists were never tiresomely reminded of the obvious fact that they were Indians ... they had the freedom to be naturally Indian in spite of all the borrowings that they indulged in.'

I have borrowed a lot from the West, as well as from independent-minded Bengal, the same Bengal which was the first place in the subcontinent to attempt a fusion of the modern arts with the centrifugal force of India that has forever sustained the land. Pointing to this subterranean source, Tagore wrote in the teenage Satyajit Ray's diary: 'I have spent a fortune travelling to distant shores and looked at lofty mountains and boundless oceans, and yet, I haven't found time to take a few steps from my home, to look at a single dew drop, on a single blade of grass.' The India that I set out to photograph, however, was not the India reflected in the lenses of the British colonial photographers but the India in the dew drop that Tagore talked of, the dew drop which mirrors India's geography: the mountain, the monsoon, the plain, the plateau and the wide web of rivers. To be a photographer I had to

dive into the depth of the dew drop in order to know not only the ecological and moral foundations of India, but also that other important aspect of the inner source: the art and culture of the country. Simultaneously, I had to dive into the history of photography – which is wholly Western – as well as the arts of many faraway places. But wherever I have dived and come up for air, the breath I take is deeply Indian because all my working life I have photographed my country. In doing so, I have been carried by the flow of the inner river of India's life and culture.

To build my chromatic eye, I have borrowed little from the nineteenth-century British photographer and a good deal from Cartier-Bresson and other masters of the miniature camera. And yet, by intuition, I distanced myself from the angst, the alienation and the guilt of recent nihilistic photography in the West. Cartier-Bresson's photographs of India on the occasion of its Independence offer the Indian photographer a variety of visual connections to the Western world. Cartier-Bresson's photography was dramatically different to the photography done in India in the 1940s and 1950s. He was the first artist-photographer to look at Indians as individuals, investing his photographs with what Satyajit Ray called a 'palpable humanism'.

Cartier-Bresson's first of four journeys to India was the most spirited and successful. It was done in the tradition of Delacroix's journey to Morocco, both artists escaping from the bourgeois society of Paris. In Morocco, Delacroix found a life full of what he called 'readymade pictures' – a phrase that evokes the pictorialism of India. Some of the photographs that Cartier-Bresson took in India can be directly compared to the paintings of Delacroix in Morocco and some drawings from the school of Michelangelo. Take for example, Cartier-Bresson's photograph of men exercising at Kurukshetra; in its sense of movement it is a visual parallel to the Delacroix painting, *The Aissaouas*. In his post-1930s photography Cartier-Bresson also worked with a deep knowledge of Masaccio and other masters. His photograph of devotees praying at Tiruvannamalai parallels Masaccio's murals in

the Brancacci Chapel in the Santa Maria del Carmine in Florence. Just as Matisse, Frank Stella, Francesco Clemente and others owe a debt to Delacroix for laying the first visual bridge between East and West, contemporary Asian photographers owe a debt to Cartier-Bresson for laying a photographic bridge between the pictorialism of Europe and the pictorial life of Asia.

Cartier-Bresson blazed a modernist-pictorial route through the Indian subcontinent, which the Indian photographer was free to restructure according to his own needs. Like the ancient pathfinders, the Indian photographer had to cut his own route, using a Western instrument and adapting the Western tradition to India's aesthetics. In this pathfinding, could the Indian photographer ignore India's anti-modernist tradition of beauty and nature that the West deems dead? And could he ignore the ideas of spirituality and of humanism, that the West calls old-fashioned? Cartier-Bresson sought the tranquil and the sublime that is necessary to fine art through the great European tradition. The Indian photographer must do the same through his or her own grand heritage: the psychology of India.

I met Cartier-Bresson in 1966, in Jaipur, my home town, when I was invited for dinner by Marilyn Silverstone, a Magnum photojournalist, who then lived in India. Cartier-Bresson was on a self-assigned mission to photograph a country in the process of slow but steady change. A remark he made that evening stuck in my mind. 'It is boring to be successful,' he said in reference to a major-magazine photojournalist who had told the French master of the money he hoped to make through photography. With Cartier-Bresson's liberating remark in mind I watched him work for a few days in Jaipur. I could see that he was far from being a photojournalist. He was an original! I saw first-hand his quickfire intuition attached to a clarity of eye and a surety of stance. I have never forgotten the champagne headiness of those days. I still possess *Beautiful Jaipur*, a little-known book that Cartier-Bresson published in 1949. In my high school years, I had found it at home on a bookshelf. It was poorly printed and bound in Bombay yet it stoked

the youthful fire in me. A decade later, when I went to live in Paris, I visited Cartier-Bresson in his apartment near the Louvre. I gave him copies of my own first two books. He barely opened them, glancing at them suspiciously, flipping a few pages and pushing them towards Martine Franck, his second wife. I knew he had no love for colour photography. But this attitude, and my own fear of failure, made me redo the two works.

When one takes a creation of the West, such as the camera, and is influenced by the concepts of the West, from Marxism to neo-realism to magic realism; or if one takes the concept of street photography, from Kertész to Gary Winogrand, and transforms it through one's own voice, the standard of excellence always remains vision and vision alone. Vision is rooted in one's own culture and upbringing, however much it might have borrowed from other cultures. Therefore, however gifted the Indian photographer might be, however personal and intimate his or her photographs, he or she will find it a quixotic quest to bond oneself to the Eurocentric Western canon of photography, in which the contemporary concepts of morality and guilt push aside the idea of beauty. Beauty, nature, humanism and spirituality are the four cornerstones of the continuous culture of India. To touch these values when photographing Asia, Cartier-Bresson intuitively distanced himself from the core of the Western canon in which his early work was squarely planted. The Indian photographer, who is culturally distant from the Eurocentric tradition, works in a country which is immersed in the four cornerstones of Indian art and life. Therefore, he stands remarkably alone.

The Indian photographer stands on the Ganges side of modernism, rather than the Seine or the East River side of it. This leads me to believe that Indian photography needs to develop its own kind of adaptations to the modernist canon. Beauty, nature, humanism and spirituality should remain working wellsprings in the Indian photographer's armoury, in spite of the great danger of sentimentality that modernism attaches to these values. We have the same instinctive

response to these values as we have to colour. In India, these concepts play an important part in the fervent role of the epics – the *Ramayana* and the *Mahabharata* – across the length and breadth of India. No equivalent exists in the contemporary Western world. Therefore, what makes India different is its great and ancient bond with religion. Religion in India rises to the cultural values that Abindranath Tagore talked of: 'the real India is larger than Hindu-India, its real art greater than Hindu art'. The failure of modernism in India has been that it has tried to absorb the philosophical foundations of Western modernism rather than edit out those psychological elements that do not fit into Indian culture. The difficulty, of course, is that in true art the entities of language, life and philosophy are inseparable. Therefore, it is not easy to extract one's own artistic needs from the mysterious totality of a true work of art, forcing those who create to go back to the master works, again and again, to elicit those elusive truths. That is why only geniuses like Satyajit Ray could successfully plunge in and take what they wanted of the modern, yet at the same time 'Indianize' their own prodigious output.

'Make It New!' is how Ezra Pound advocated modernism, while T.S. Eliot, the high priest of the movement, anticipated images that would appear in modernist photography in his poem *The Love Song of J. Alfred Prufrock*; Prufrock compares the evening sky to a patient upon a surgery table. Then the Polonius-like Prufrock goes on to sing of half-deserted streets, one-night cheap hotels, sawdust restaurants and the butt-ends of his days. It is as if Eliot had mapped out the territory of alienation for Robert Frank and other important American and European street photographers. Modernism did not become a photographic force until the emergence of Stieglitz, Strand and Weston and until the Surrealists began to consider the intuitive modernism of Atget as a work falling within their own manifesto. After Atget, the tenets of modernist photography spread in various directions; one of them led to Walker Evans, Bill Brandt and Robert Frank.

In the wake of Robert Frank, another photographer who stepped

right out of Eliot's poem is Lee Friedlander, the master modernist of our time. Twice he travelled with me in India. Observing him photograph, I realized that the beauty of my homeland meant little to him. He could be disdainful of it. When a dust storm hit Jaisalmer, in Rajasthan, Lee and his wife Maria, and my wife Anne and I, watched its mesmerizing movement towards us from our hotel. Then Lee startled me when he said half to me and half to himself: 'What would Atget have done here?' As the rest of us were relaxed and soaking up the sight, Lee Friedlander remained the self-conscious modernist evoking the muse of Atget. In India, Lee was often looking for the abject as subject. For that reason, it is not romantic Rajasthan, but crowded Calcutta, with its intense and sometimes wounded life, that is Lee's favourite place in India. In Calcutta, Lee told me in the tradition of Baudelaire's ragpicker and Breton's secondhand stores: 'I like to collect junk, through my photographs.' I have had a different outlook when photographing Calcutta. My subject is never beauty as seen in abjection, but the lyric poetry inherent in the life of India: the high range of the colouratura of everyday India. Those delicious notes, those high and low notes, they do not exist in the Western world.

In discussing modernism, I must say something about post-modernism. This off-shoot of modernism stands at odds to the very values of India. Above all, post-modernism, through its anti-religious stance, cocks a snook at the spiritual foundations of India's culture. The new kind of Indian artist – the wordly-wise artist and photographer – will very selectively borrow more aspects of the modern and less of the post-modern, particularly adapting the idea of the low to democracy and the colouratura of the human setting. And yet, it will be a long time before a museum or gallery in India will show Duchamp's sardonically signed urinal – *The Fountain* – as a work worthy of aesthetic meditation. R. Mutt will not have an Indian reincarnation as R. Dutt until India is completely Westernized. Until Indian artists, horror of horrors – in the tradition of George Bataille, Gilbert and George, Ingmar Bergman, Don DeLillo and so many others

– begin meditating on excreta, on bodily functions, on dirt, on garbage and junk. Let these abjections lie along the railway tracks and the slummy roads of India. Let the Indian mind continue taking its cue from the Hindu and Jain mandalas of man, that look inward while the Western mind, continues taking its inspiration from Leonardo da Vinci's *Study of Human Proportion in the Manner of Vitruvius* and other drawings and meditations on the workings of the body.

Though we understand the Western canon and the depths of its philosophic roots we must distance ourselves from it because the pulse of India's richly textured and vibrantly coloured life beats to the rhythm of a dynamically different drum. India dances to the drum of Siva who rises over religion and becomes a universal entity through high art. To stand before a Nataraja – the bronze sculptures showing the cosmic Dance of Siva – is to be in another time, in another place, in another dimension, as Rodin was when he was transfixed by its timelessness. The timeless emerges out of time. It shapes and sculpts craft, that sense of craft that is alive and well in Asia with its loitering sense of life, but is a bad word in the fast-forward world of the West. We should follow the Rodin maxim, 'what you do with time, time respects'.

To enrich photographic modernism to give it another dimension, to add other dimensions to its Eurocentricity, is not an impossibility. After all, in international cinema Ray and Ghatak, Mizoguchi and Ozu, never aimed to enter the heart of Hollywood but they nevertheless, achieved mesmerizing positions in the medium, giving it a new soul. Similarly, in literature R.K. Narayan never entered the thicket of Western writing and remained steeped in the comic elements of southern India's small town life. It is V.S. Naipaul, the Outsider, who through his cathartic sense brings us close to the West. He told me: 'In India, there is a lot to write about. When that is exhausted, Indian writers will turn to the art of writing.' We photographers have much to learn from Naipaul's words. In the Proustian sense he has spent a lifetime contemplating life and the form of the novel.

In many cultures all over the world, there are awakenings whereby

language and life are one entity to be examined from within. The new players are the likes of Abbas Kiarostami, the filmmaker from Iran, now shaping the language of humanist cinema; Alfredo Jarr, the installation artist from Chile looking at the world with a political eye; Gu Wenda, the painter from China raising calligraphy to a new kind of art; Shazia Sikander from Pakistan reinventing Indian miniature painting; Ravindra Reddy, the sculptor from India taking a leap from pop-art to folk tradition and two players whose work is done: Seydou Keita, the veteran portrait photographer from Mali, who has depicted the human spirit of his people; and Nhem Ein who has uniquely photographed the brutal spirit of our time, in his native Cambodia.

Western modernism in photography will in time be broadened, by non-Western artists through a fine disregard of the philosophical stance of the West and of the related rules of the game. If the world must move on through modernism and post-modernism, it must also move on through multiculturalism and globalization. Independent India's own pluralistic journey has been in that dynamic direction.

My own life was worlds away from the internationalism that I have described. In Rajasthan with the collapse of colonial rule the feudal society of my people, the Rajputs, had come to the very end of its possibilities: the scribes sitting at our gateway maintaining records and accounts disappeared; the servants who were bonded to our family were fashioning new lives; my father's Arab stallions were sold off; the horse carriages began to rot. Our joint-family broke up, our large *haveli*-house became fragmented. I saw no future in staying on. I had to find a way in the world. After finishing high school in Jaipur, I made a journey to Calcutta. I wanted to follow my elder brother's footsteps as a tea planter. That journey sealed my fate because I was rejected by every tea company – still largely British-run in 1961 – where I appeared for an interview. I had a fall-back position. In high school I had developed a passion for photography, so much so that my heartbeat ran an umbilical cord to my camera. In Calcutta for a month I went about taking pictures. I even managed to show my photographs to Satyajit Ray, who,

after patiently looking through them, declared to another visitor as I was leaving the film-maker's home: 'No guts!' Nevertheless, Calcutta became a regular destination of mine because there the Bengalis had created a cosmopolitan world. I became a regular visitor to the Ray home. Years later, I reminded him of his remark, which he had forgotten. He laughed and wished that remark away. In Calcutta, through my contact with Satyajit Ray and his work – deeply rooted in the pictorial, rising out of the communal spirit of India and evoking the complex shades of the *Mahabharata* characters – I received an uplifting education. Additionally, through the deep literary interests of R.P. Gupta, a writer and a worldly encyclopedist in conversation, I began to make a journey of the mind. The Bengali film-maker, writer and artist, made me understand that the modern arts are all linked to the human condition. All modern Indian artists owe a debt to Bengal, where the novel took root and led to the humanism of our cinema and our photography.

I also owe a debt to that spirit of my native Rajasthan, that has given me a 30-year-long tenacity to pursue a demanding and difficult art in which the rewards are artistic rather than monetary. What is it about Rajasthan that calls me back again and again? Victor H. Mair states in his book *Painting and Performance* that well before Alexander's invasion, the painted story-telling scrolls of India reached as far as Europe and Japan and other places, providing a unique inspiration to the narrative visual arts of the West and the Far East. In my native Rajasthan I can still hear the bard sing before his scroll, like that depicting the story of Pabuji. Performing before the colourful scroll, the bard and his wife sing their sad songs without the hint of a dark vision. What these storytellers suggest to me is that sadness does not have to be portrayed through a dark vision, but is equally eloquent through vibrant colour.

The pulse of my being beats to the music of India, in spite of moving my base to Hong Kong, to Paris, to London and to New York. Shuttling between India and the West, I too have become something of a semi-

nomad. As a result, there are now very few parts of India that I have not visited. To photograph in India, to breathe the air of the little-known corners of the country, is my greatest joy. A noted American photographer, who travelled with me twice in India, observed: 'Raghubir, something happens to you in India!'

In India, I am on court, the tennis player's court, where the ball has to be hit to the edge of the camera frame, so that it raises dust, but yet, it is inside. Within the tension of those frame lines, there is the buoyant spirit of Kotah painting; and there is the Zen of sight and sense, the archer's oneness with the subject, to which Ananda Coomaraswamy has suggested an Indian outlook, in quoting these lines from the *Bhagvata Purana*: 'I have learned concentration from the maker of arrows.' And within those frame lines, I have looked at the densely Indian characters of R.K. Narayan, I have looked at the acute analyses of today's India in the prose of V.S. Naipaul, and of yesterday's India in the prose of Nirad C. Chaudhuri. I have looked at the pictorialism and bazaar energy of Salman Rushdie's fiction. I have looked at the Thames-side pictorialism pitched by Anish Kapoor, the Indian-born sculptor, and the sky and sunsplashed pictorialism raised by Charles Correa, the Indian architect. And early on, I put within my frame lines a sense of Jawaharlal Nehru's *The Discovery of India*: the ancient sites, the crossings, the confluences of rivers, their sources and mouths, the big and small roads, the big and small cities – as well as the peacock picking up a grain of millet in an Indian village. Simultaneously, I had begun to chase a variety of balls in art history – from the idea of detail, metaphor and colour from Indian art to an understanding of the human condition from Western art.

My earliest artistic memory, that is a long swim in my mind, is a folk singer's mastery over his uneven voice. In those mysterious moments between dusk and darkness on a small and deserted Rajasthan railway platform, a tall and turbaned man, his vocal chords straining to bursting point, belted out a song, as he accompanied himself with the dense but sparkling tones of the 28-string-folk-sarengi. The pain in his deep voice suggesting a hard life, he sang for about half-

an-hour, then he vigorously brought his song to an end as the hooting of the approaching train cut into his complete but imperfect art. This sense of India's imperfection is now imprinted in my subconscious.

Imprinted in my memory is another picture of pain: a tunnel-like corridor in my Jaipur home, connecting two courtyards of our *haveli*-house. A veiled sweeper-woman flattens herself against the wall, along with her broom and the metal pan in which she collects garbage, to let me and other family members pass untouched by her polluted self. In spite of her poverty, she wears faded but colourful clothing. The yellow and red sari she wears is lightly spotted with silvery tinsel, whose sheen is dulled by use. This is a memory from childhood. The woman has disappeared from our lives – as if she was ever part of it. Through what V.S. Naipaul has analysed in *India: A Million Mutinies Now*, we have changed more in this century, than perhaps in three thousand years. Against this backdrop, I sometimes think of that woman. The thought gives me a pang.

Raghubir Singh, May 1998

The people and religion, the mountains and the plain not only constitute the major features of the physical and moral entity called India, they are also related to one another very intimately. The geography of India exhibits a curious paradox...there is no intermingling of hill and plain, and in passing from the one to the other a man passes FROM ONE WORLD TO ANOTHER.

The Finest Story about India – In English by Nirad C. Chaudhuri

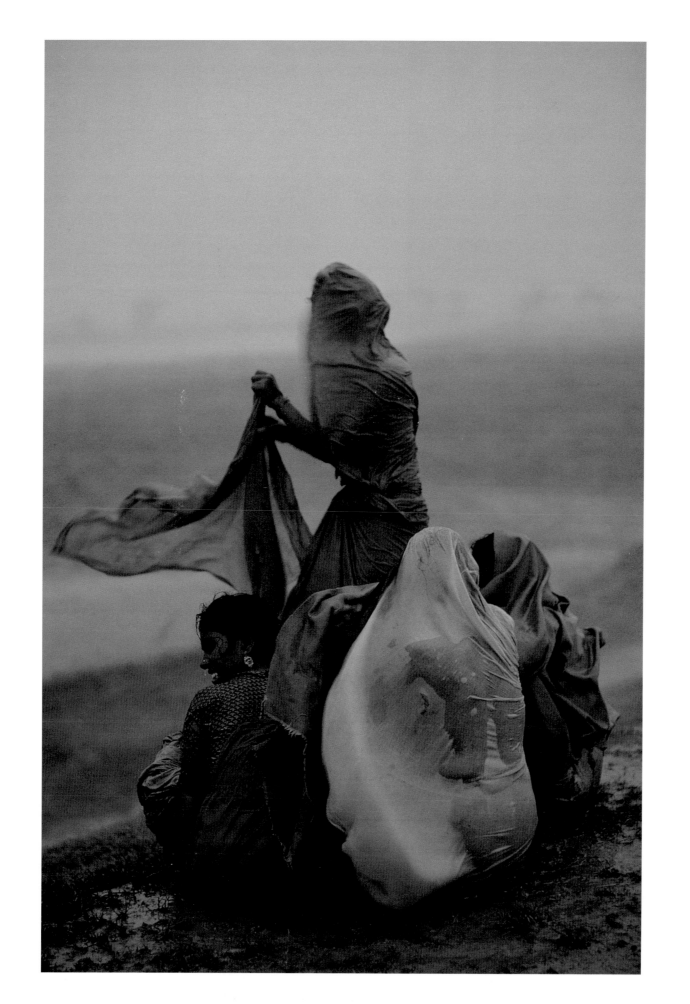

Monsoon rains, Monghyr, Bihar, 1967

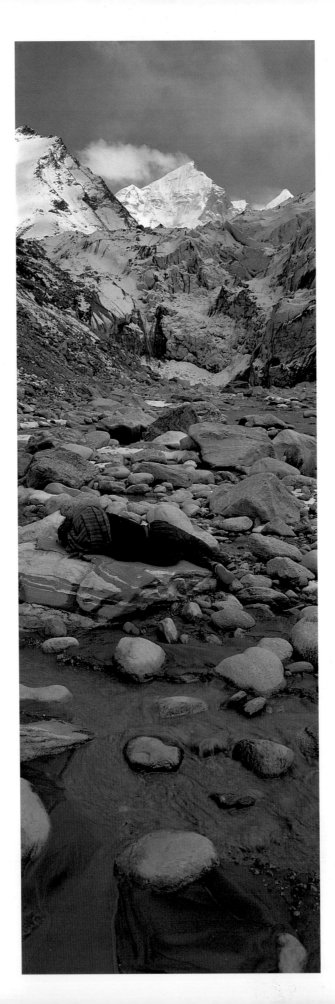

Porter, Bhagirathi peaks and Gaumukh – source of the Ganges, 1989

Pilgrim at Gaumukh, 1967

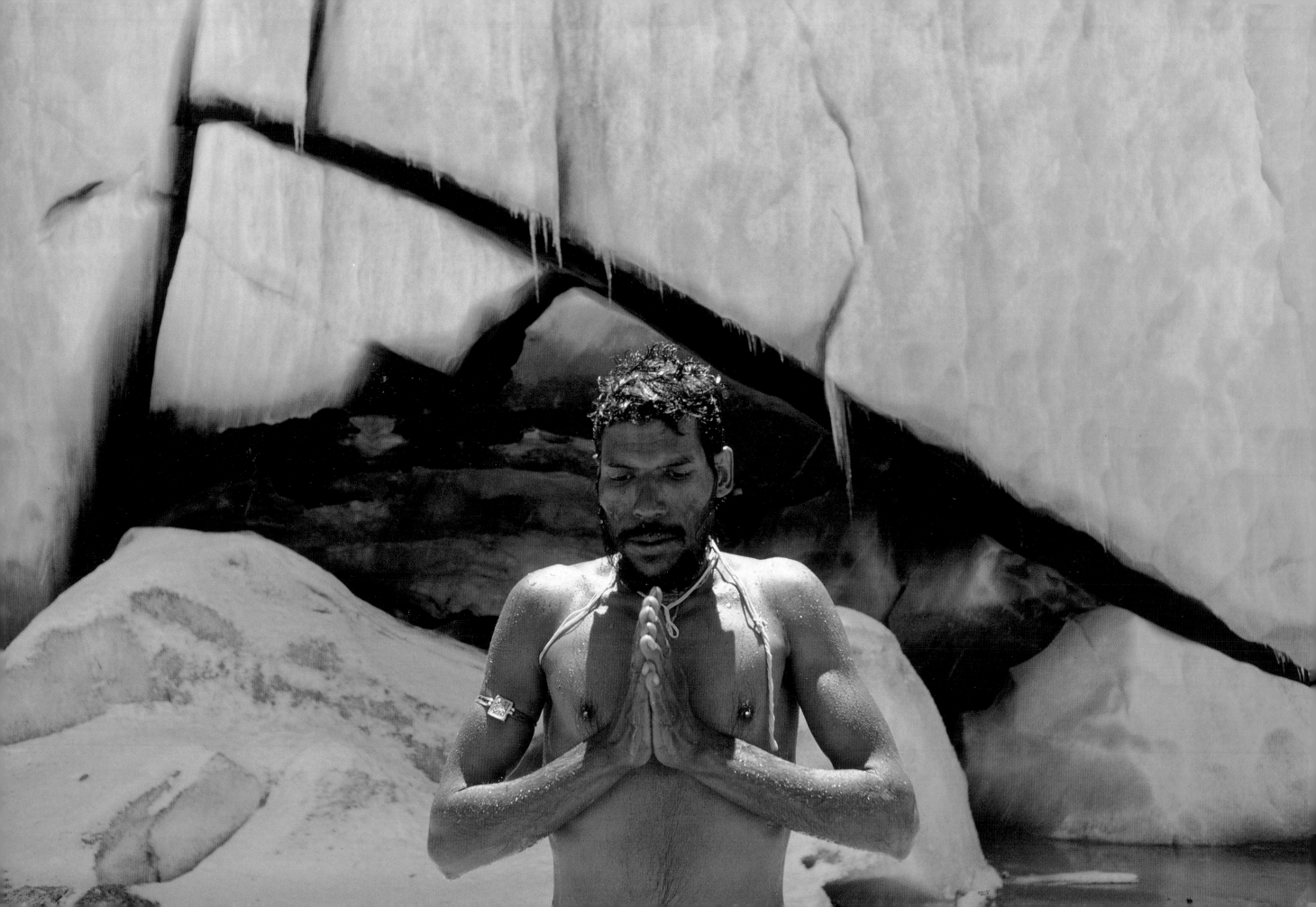

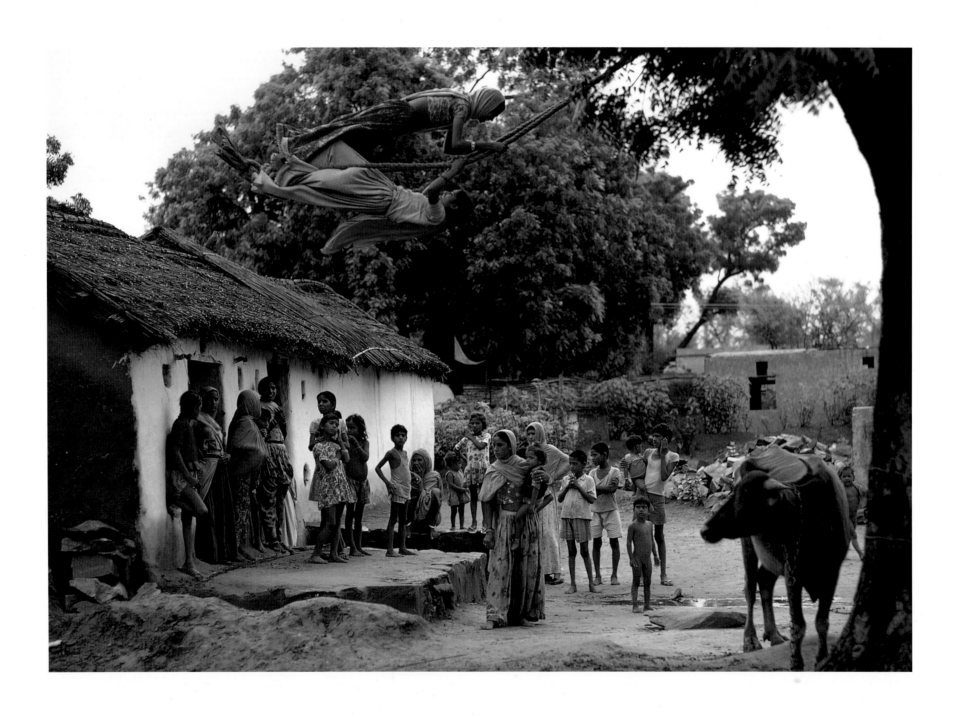

Catching the breeze, Hathod village, Jaipur, Rajasthan, 1975

Man diving, Ganges floods, Benares, Uttar Pradesh, 1985

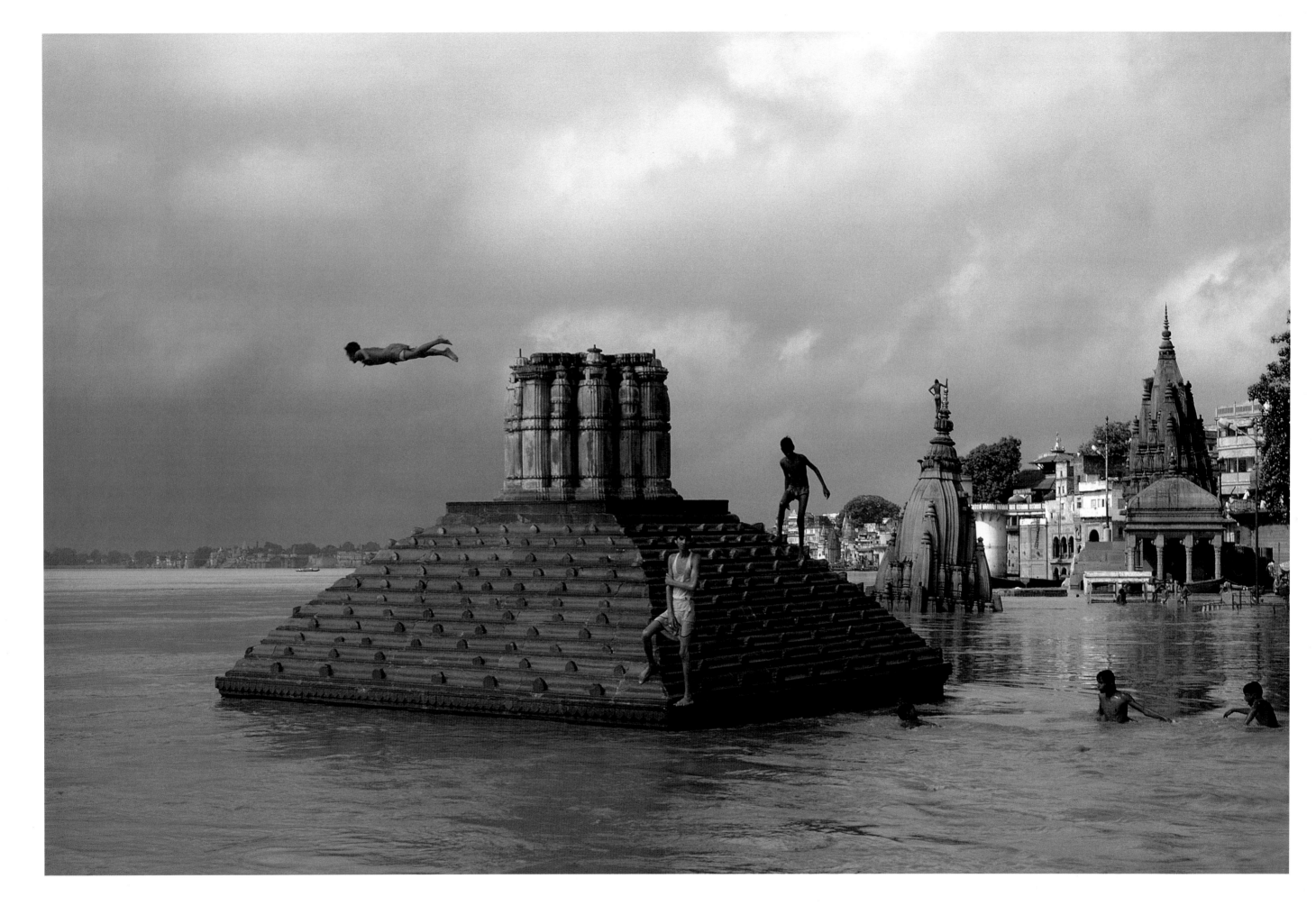

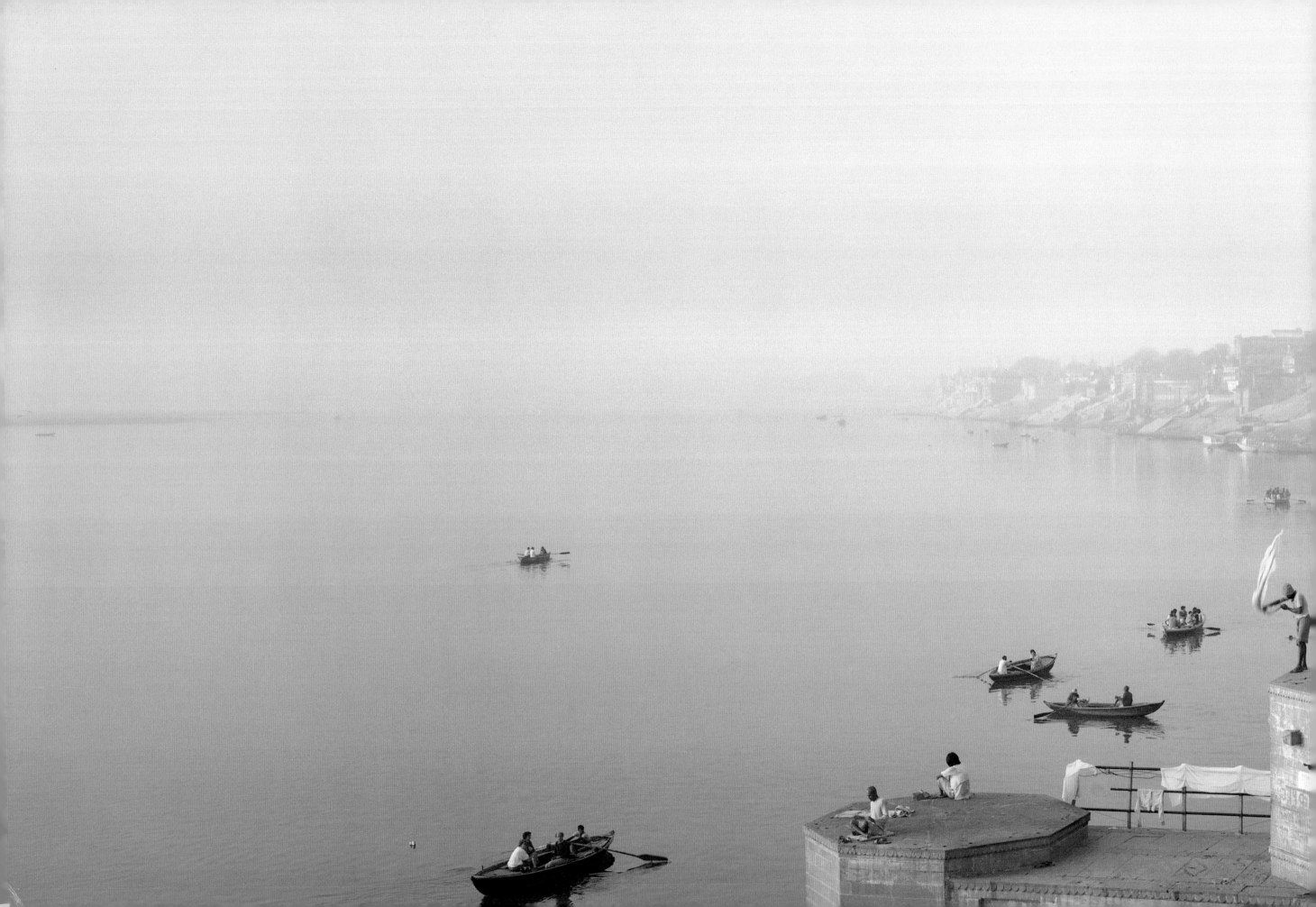

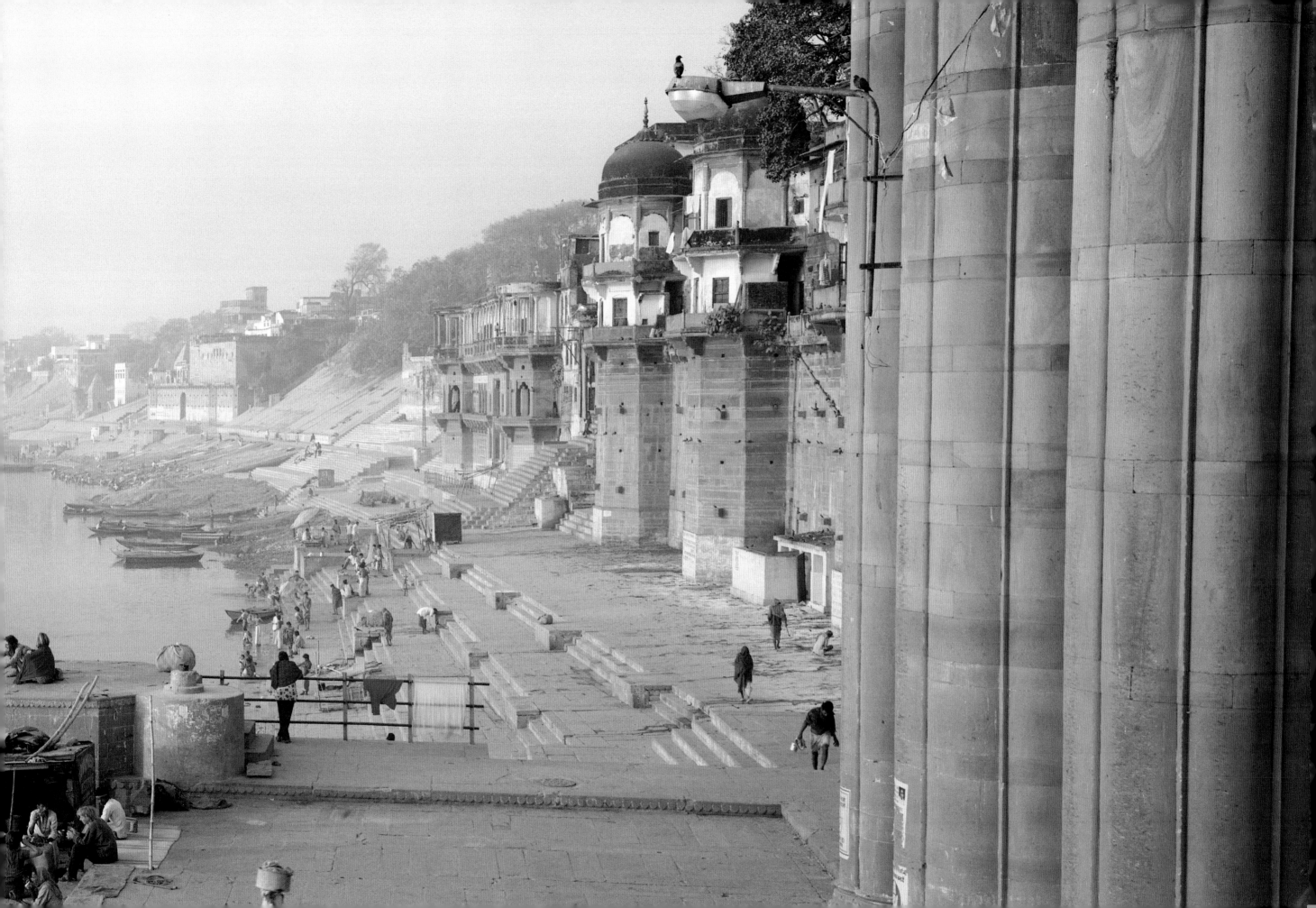

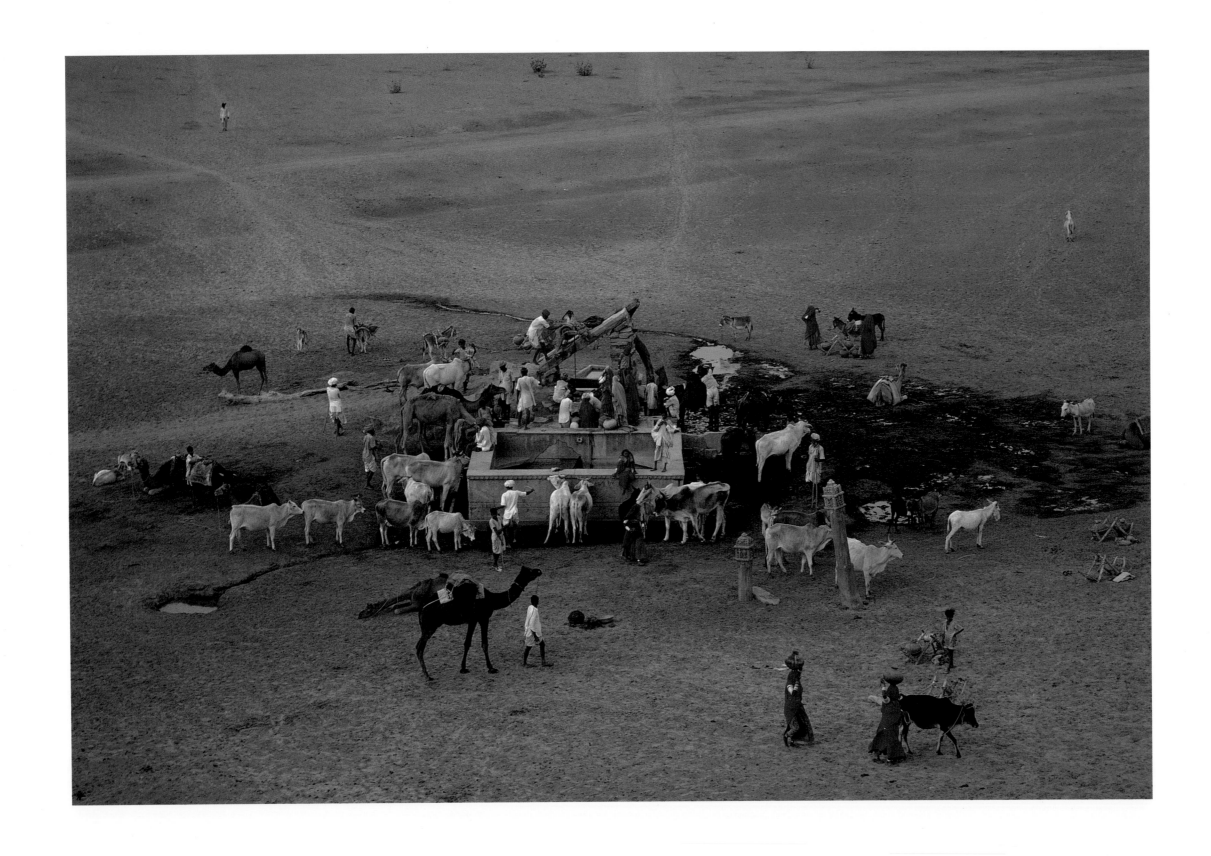

Morning on Dharbhanga Ghat, Benares, Uttar Pradesh, 1987
Village well, Barnawa, Rajasthan, 1977

Ganges from Malaviya bridge, Benares, Uttar Pradesh, 1987

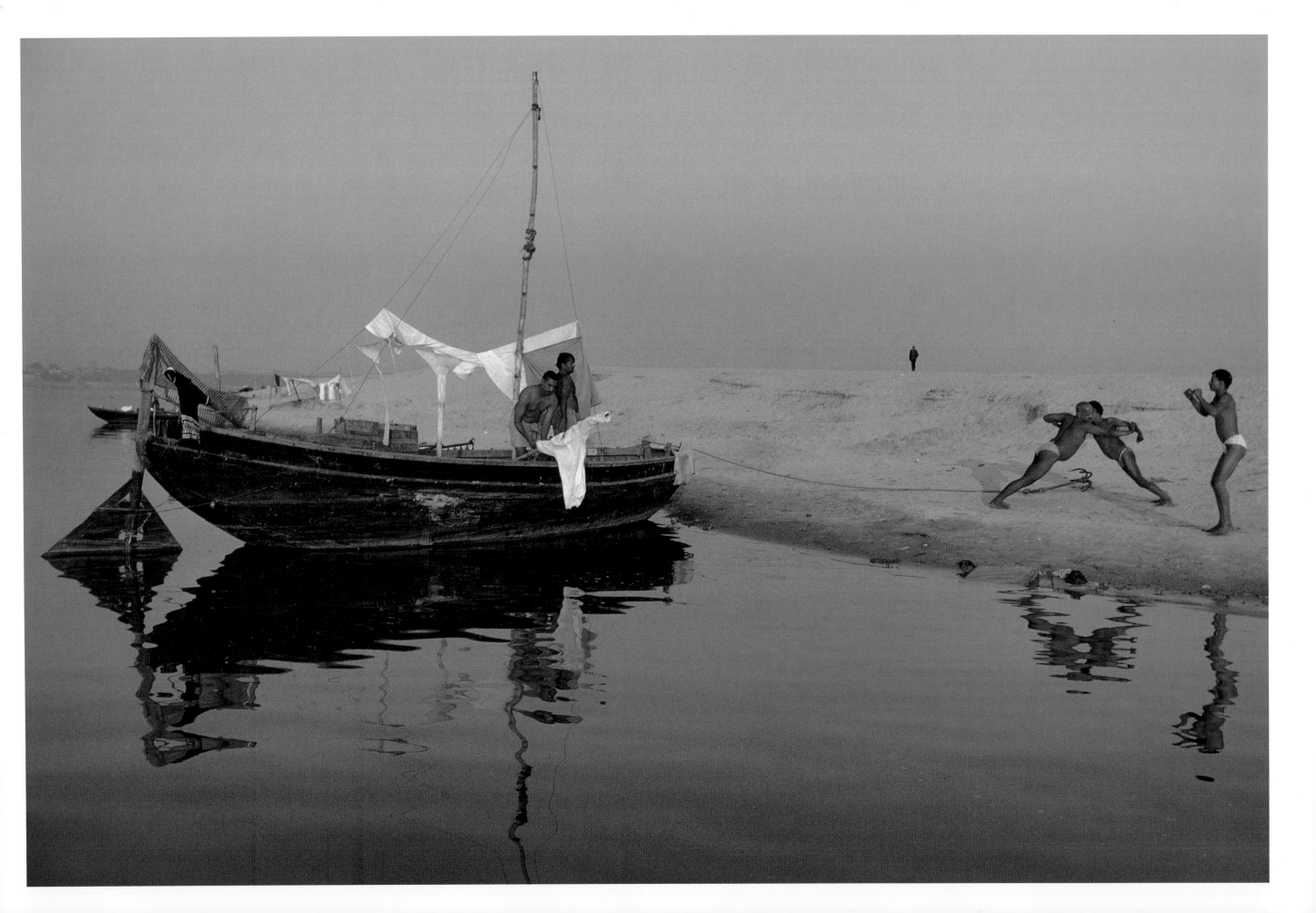

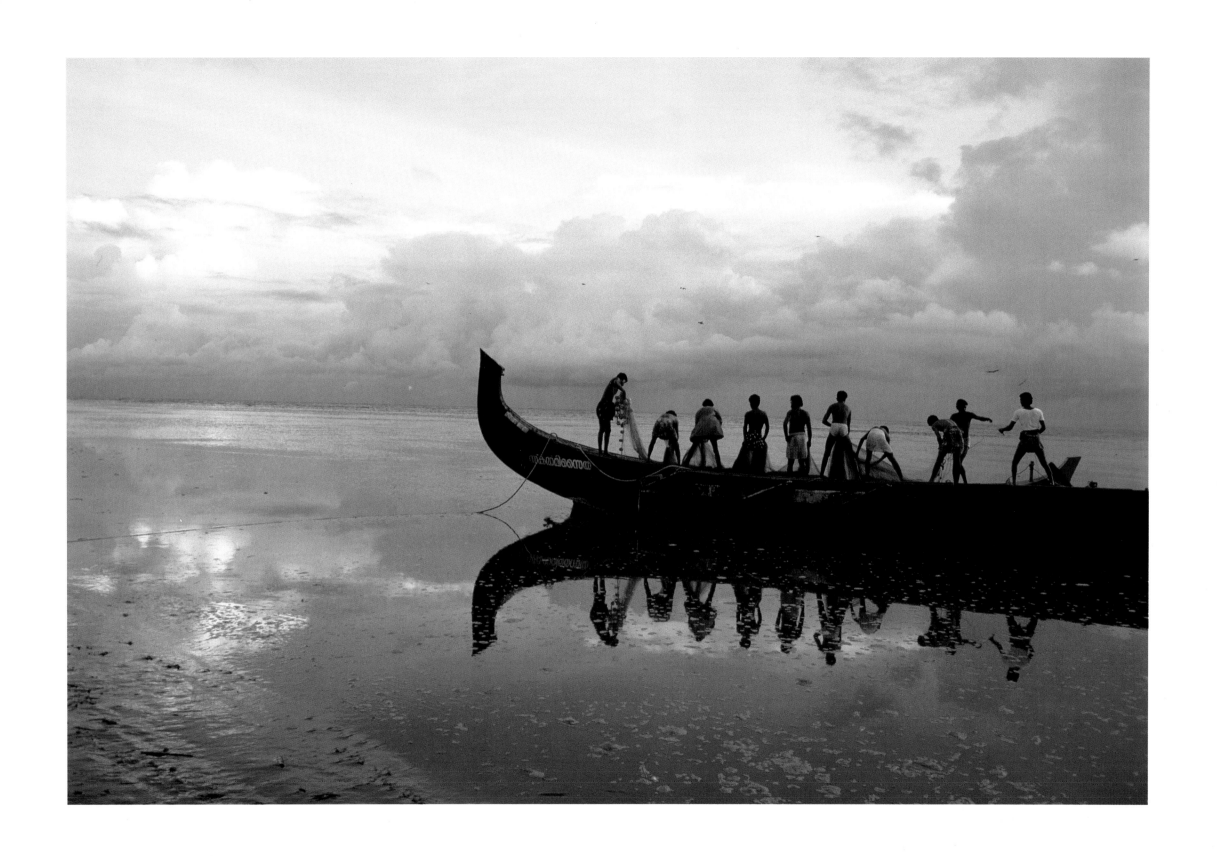

Exercises, Benares, Uttar Pradesh, 1985
Fishermen, Calicut, Kerala, 1996

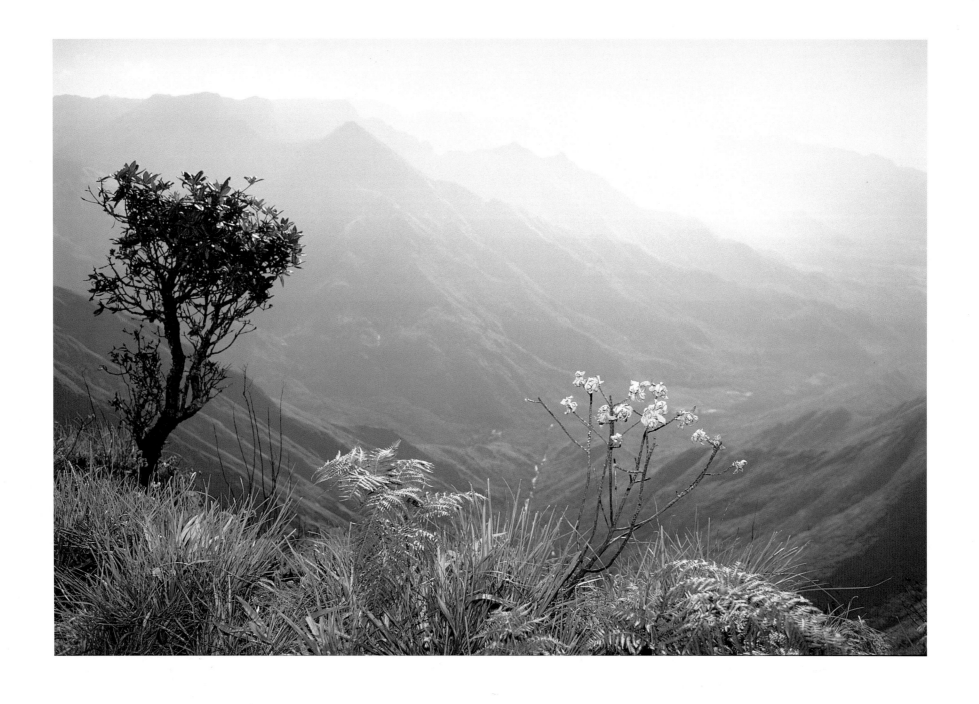

Western ghats, Tamil Nadu-Kerala state borders, 1995

On Vivekananda rock, Kanya Kumari, Tamil Nadu, 1994

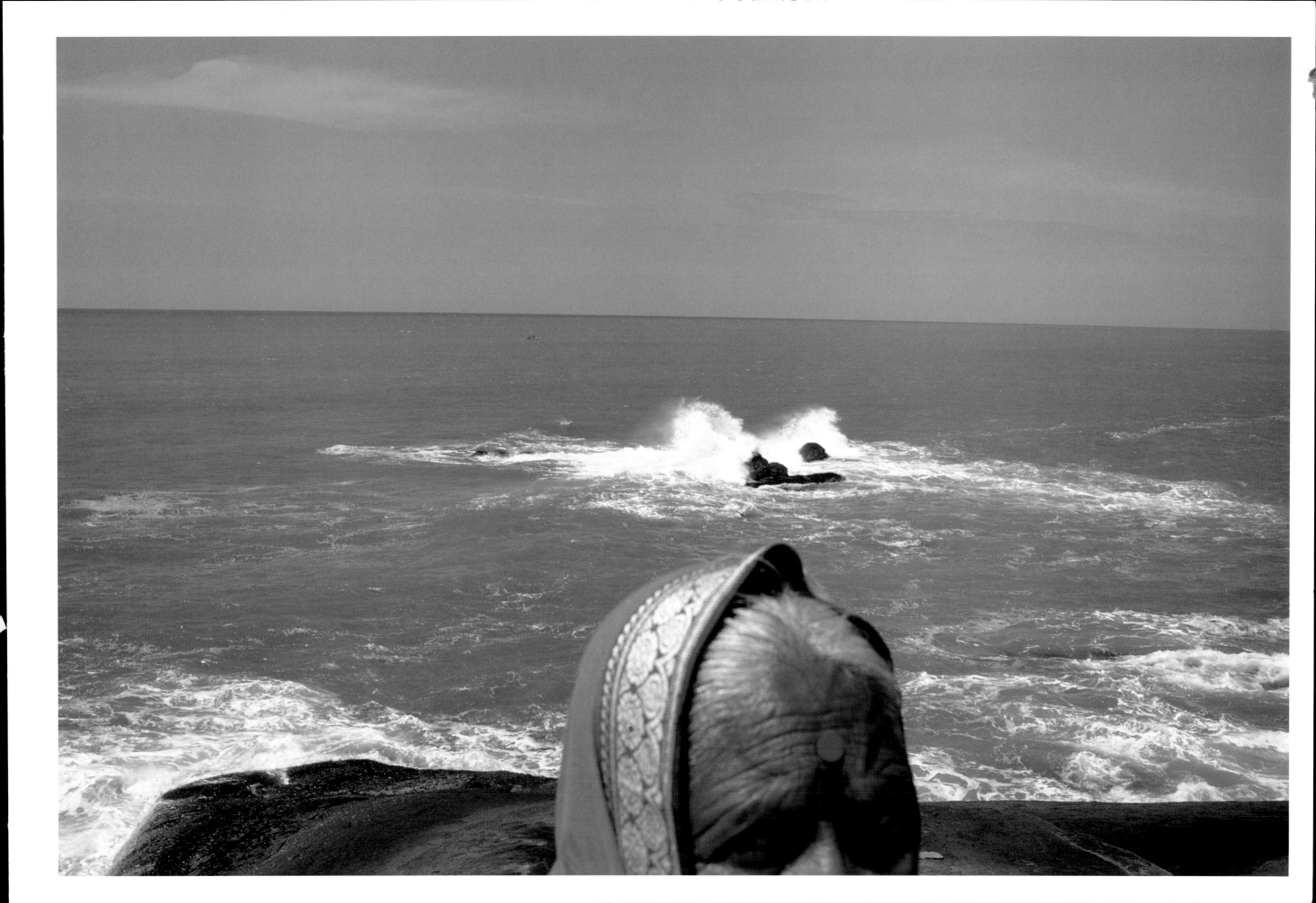

HUNDREDS OF THOUSANDS OF PILGRIMS, from all over the country and from all walks of life, had come by all sorts of ways: in aeroplanes, in trains, in cars, omnibuses and bullock-carts. From remote villages, thousands had walked, half-clad and half-fed, in this bitter January cold. They had all come just to bathe at this one particular spot at a particular hour. As we drew near we could see nothing but a sea of heads popping up and down!

Kumbha Mela by Dilip Kumar Roy and Indira Devi

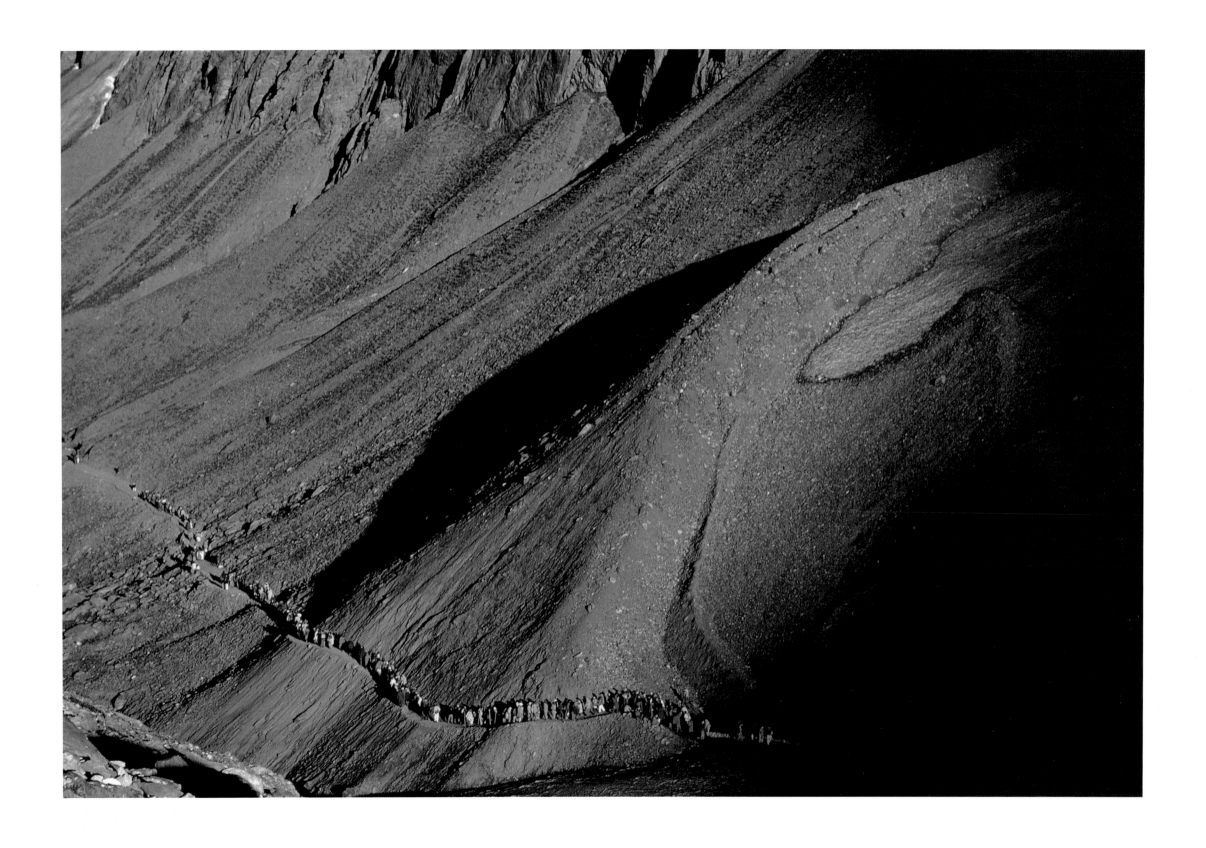

Himalayan pilgrimage, Amarnath, Kashmir, 1981

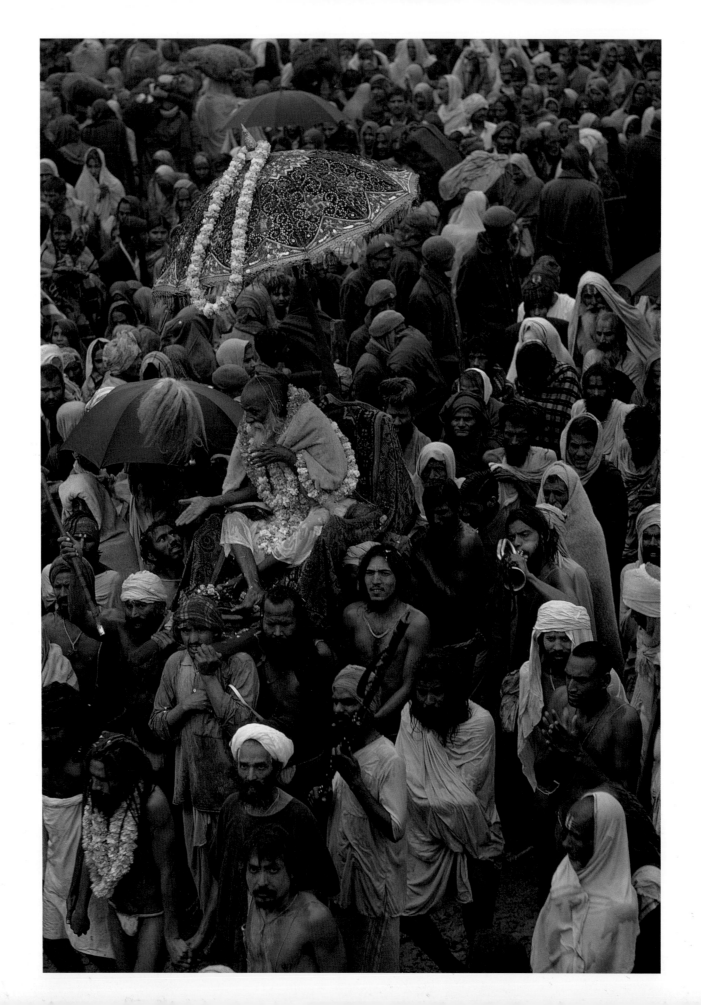

A holy man and devotees, Kumbh Mela, Prayag, Uttar Pradesh, 1977

Sadhus, Kumbh Mela, Prayag, Uttar Pradesh, 1989

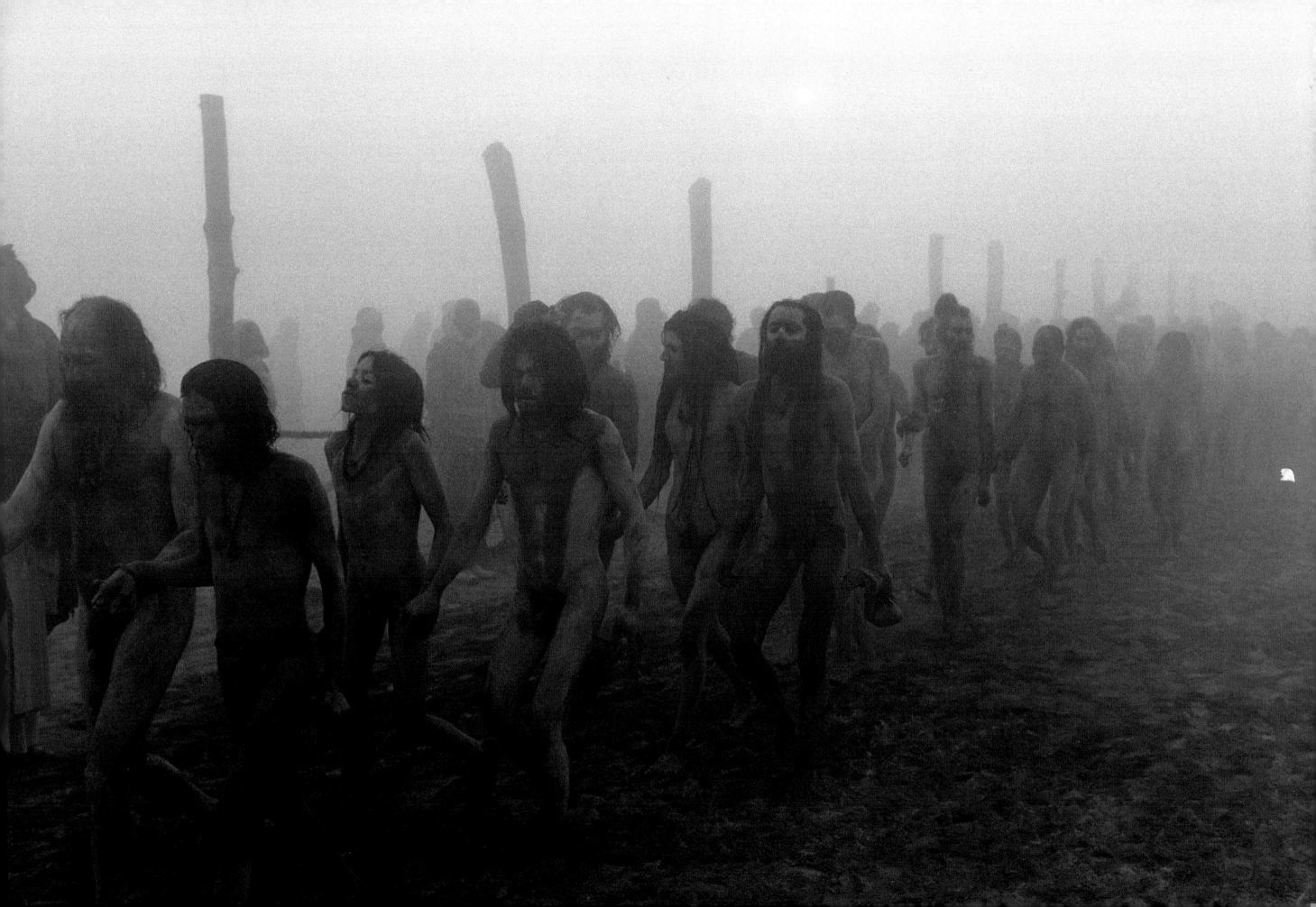

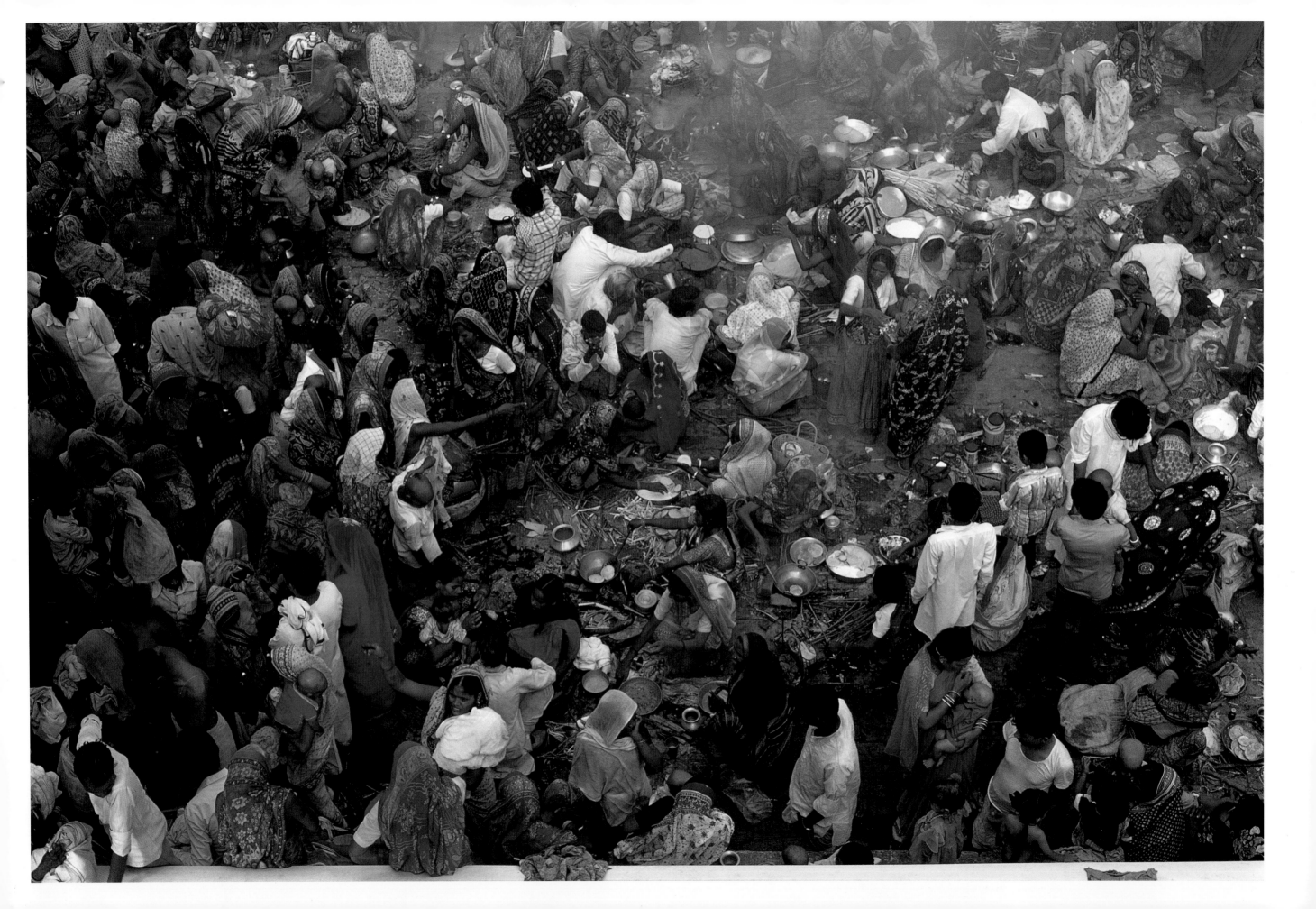

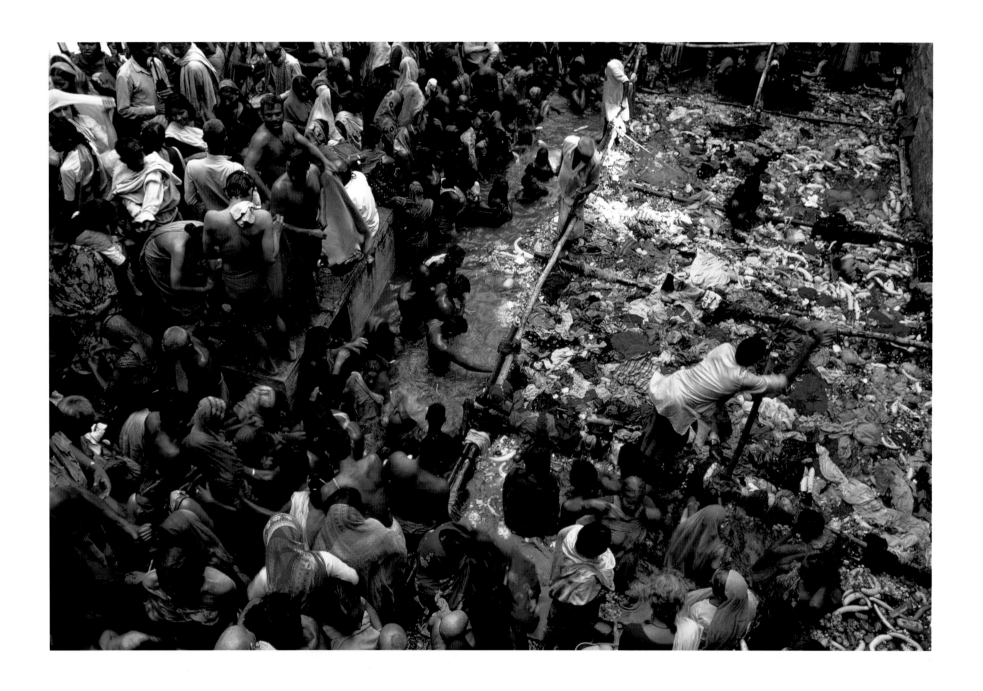

Pilgrim camp, Lolarka Shashti Festival, Benares, Uttar Pradesh, 1985

Bathing, Lolarka Shashti Festival, Benares, Uttar Pradesh, 1985

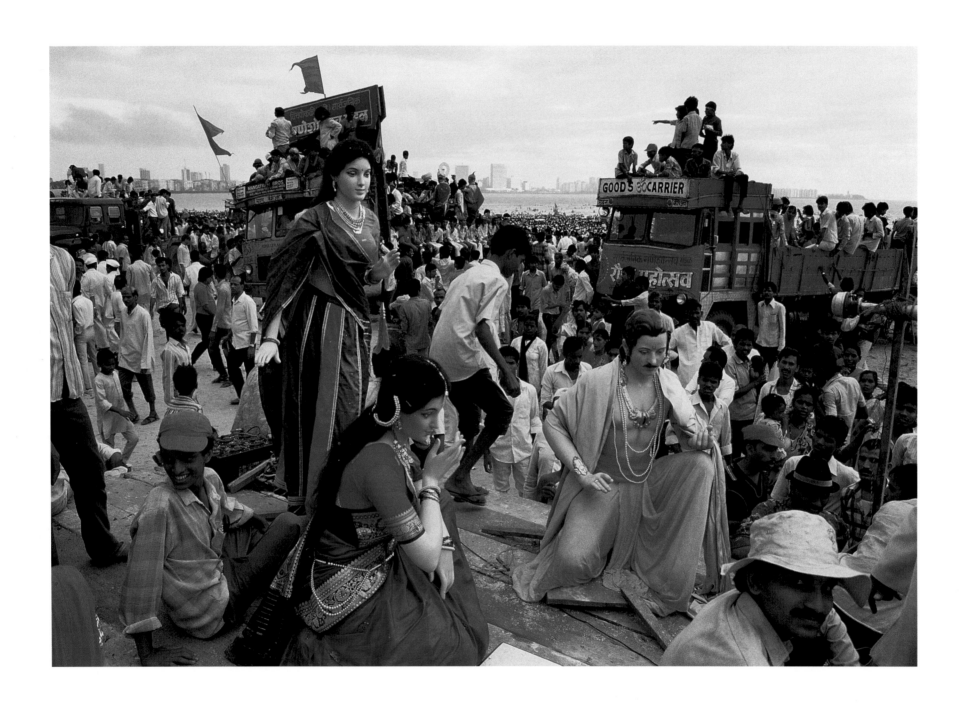

Ganesh Puga, effigies for immersion, Mumbai, Maharashtra, 1991

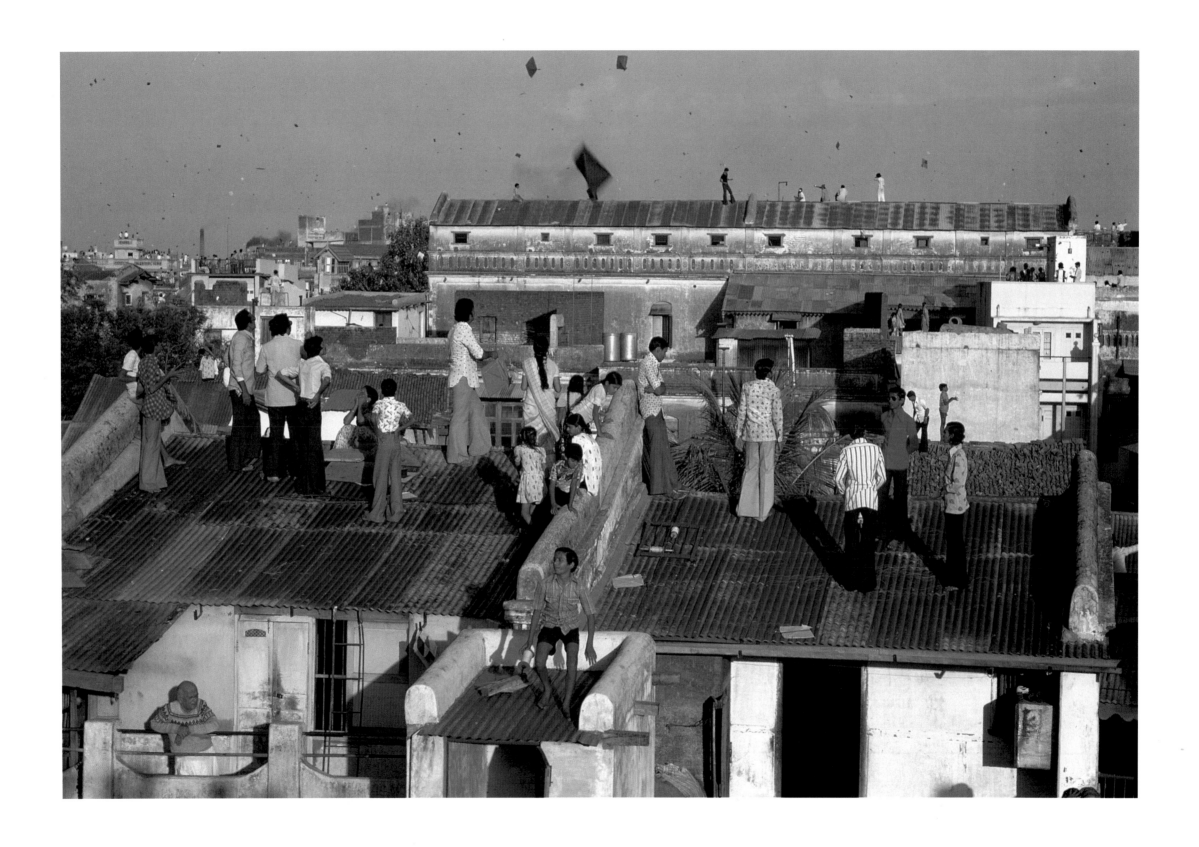

Kite-flying festival, Ahmedabad, Gujarat, 1981

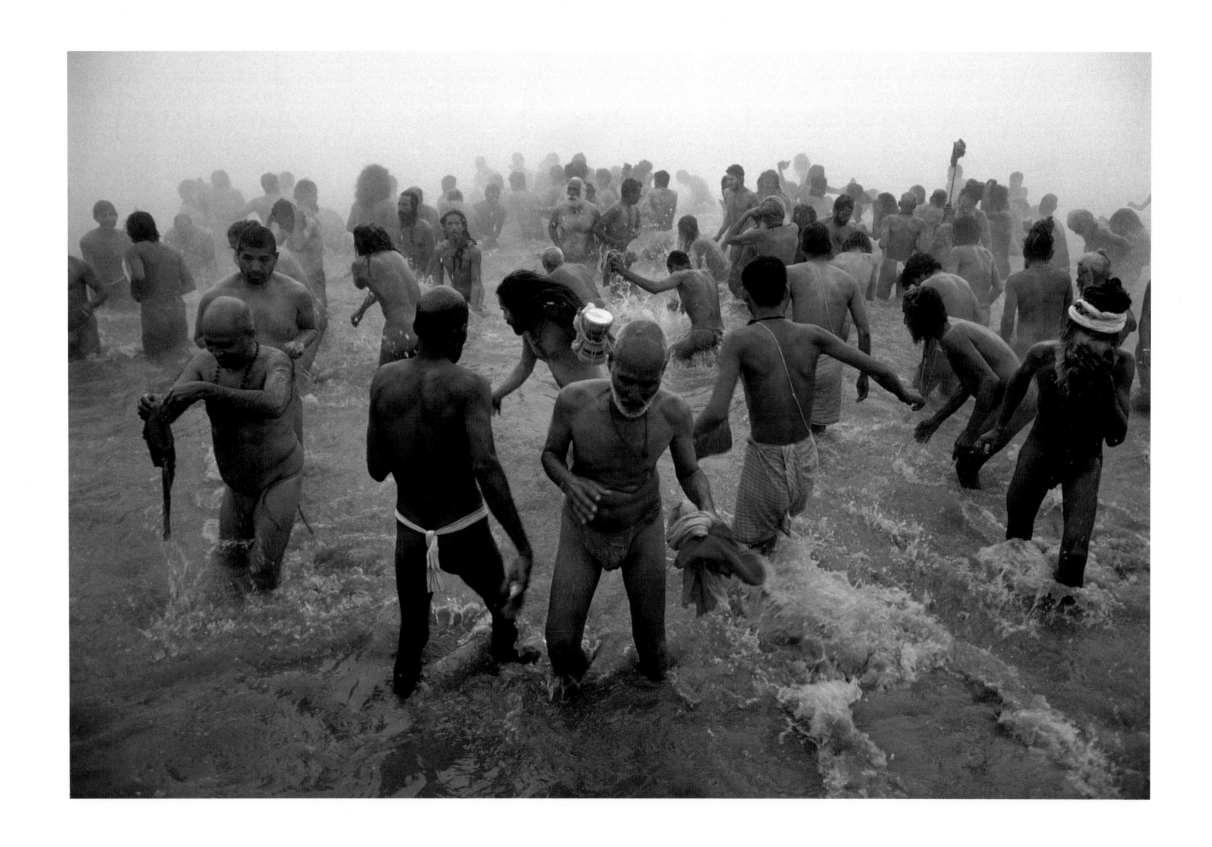

Sadhus bathe at Sangam, Kumbh Mela, Prayag, Uttar Pradesh, 1989

Teyyam performer, Badagara area, Kerala, 1984

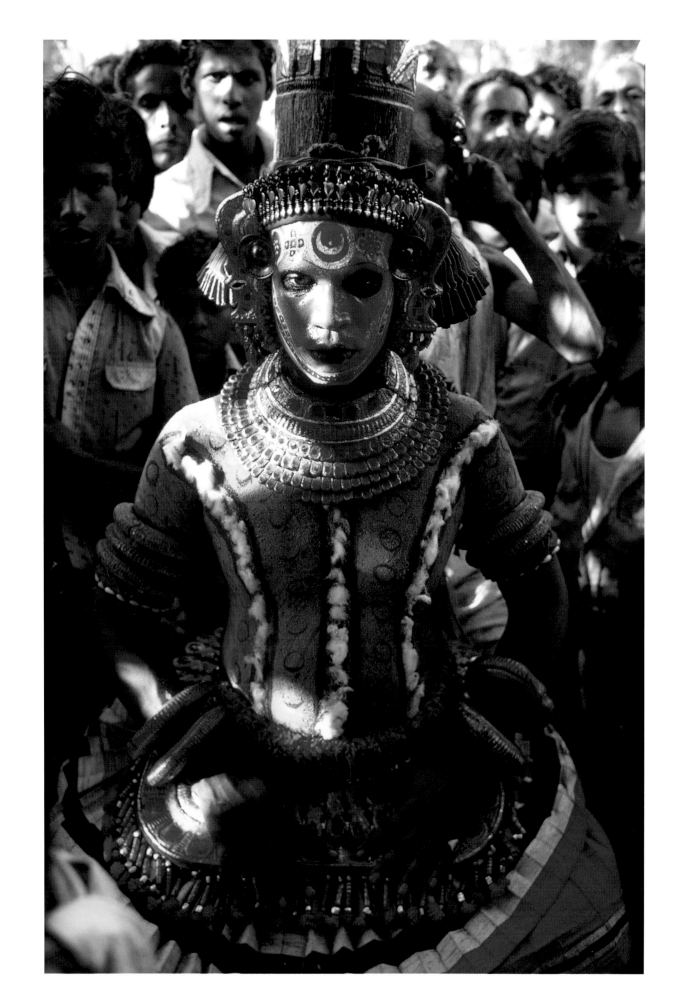

And everyday, IN THE CITY , their numbers grew. Every day they came from the villages, this unknown, unacknowledged India.

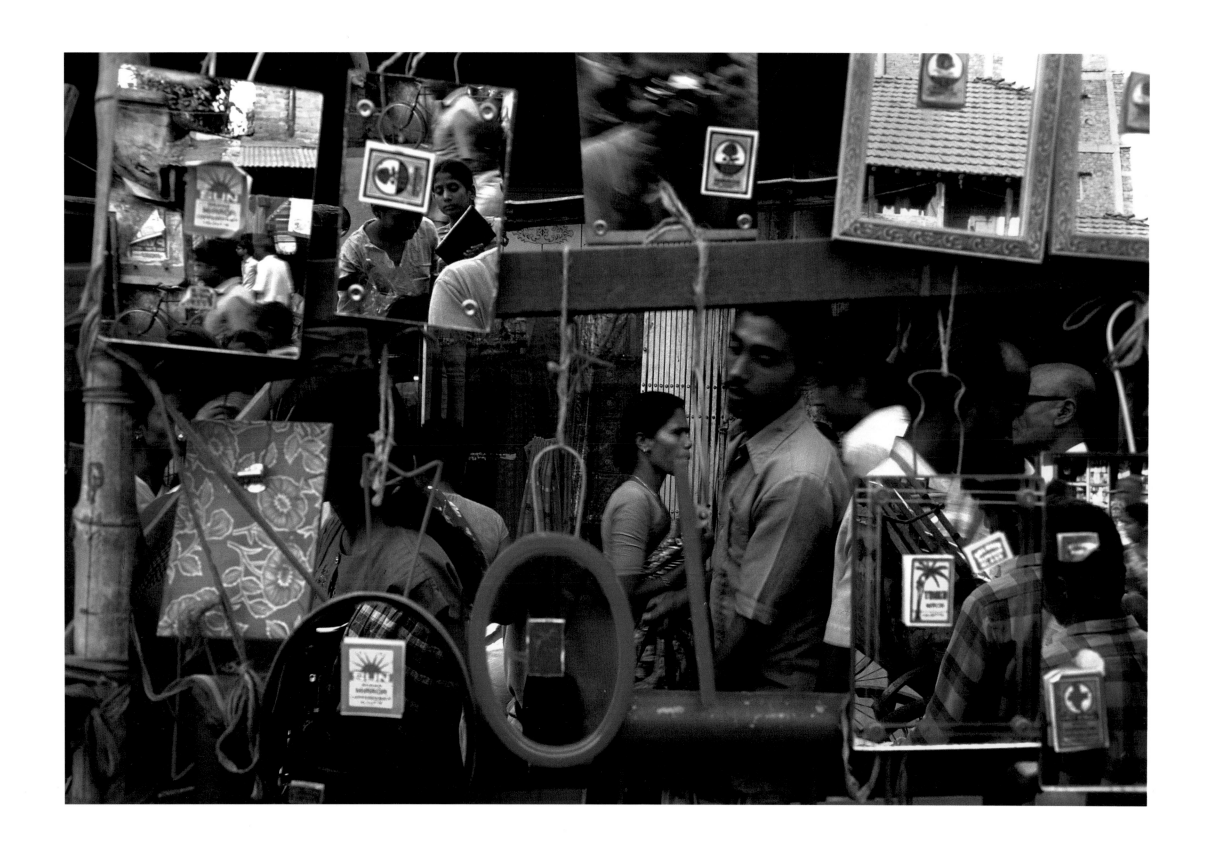

Pavement mirror shop, Howrah, West Bengal, 1991

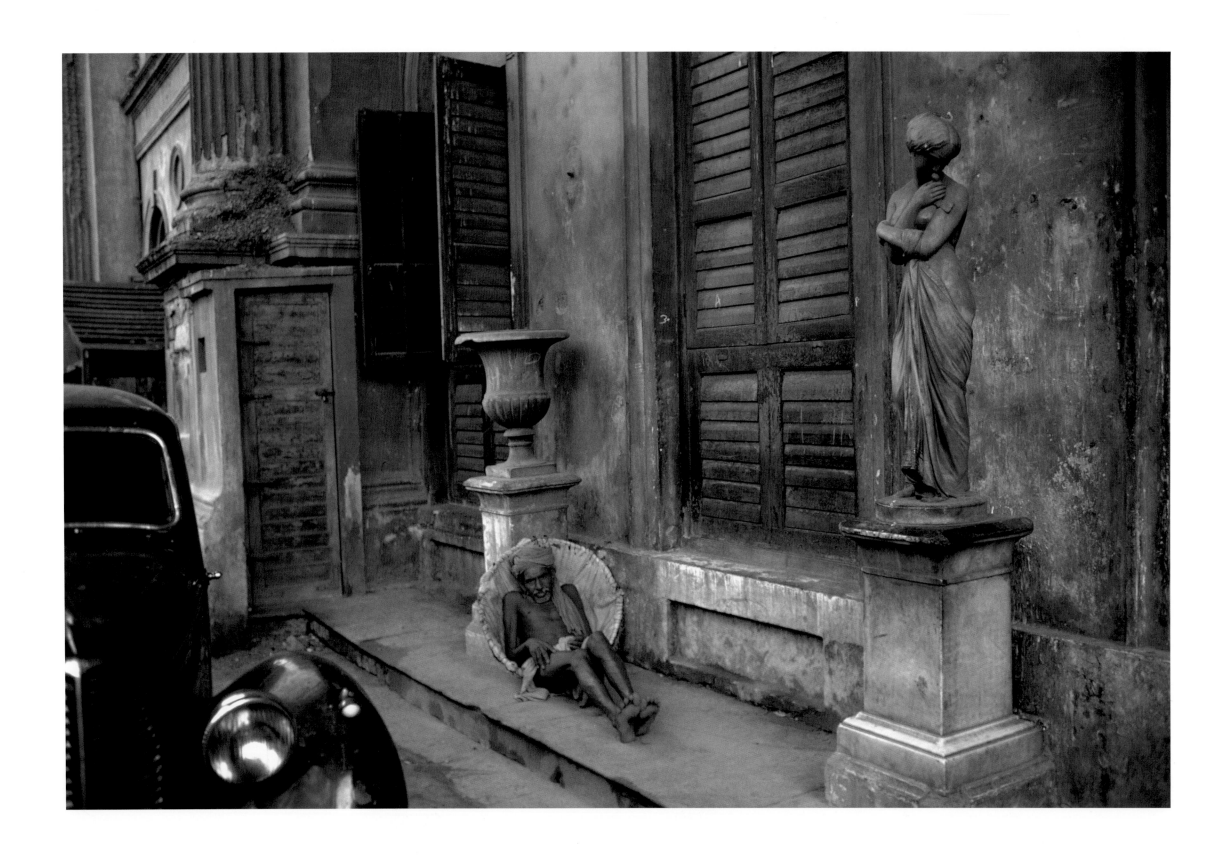

A porter in a *zamindar* mansion, Calcutta, West Bengal, 1971
A family, Kamathipura, Mumbai, Maharashtra, 1977

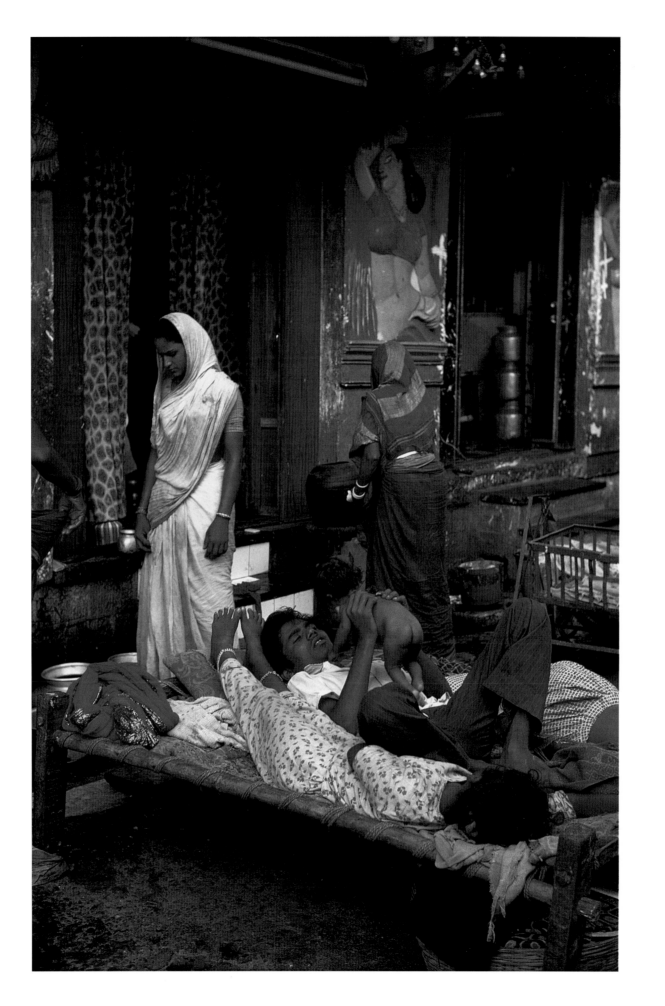

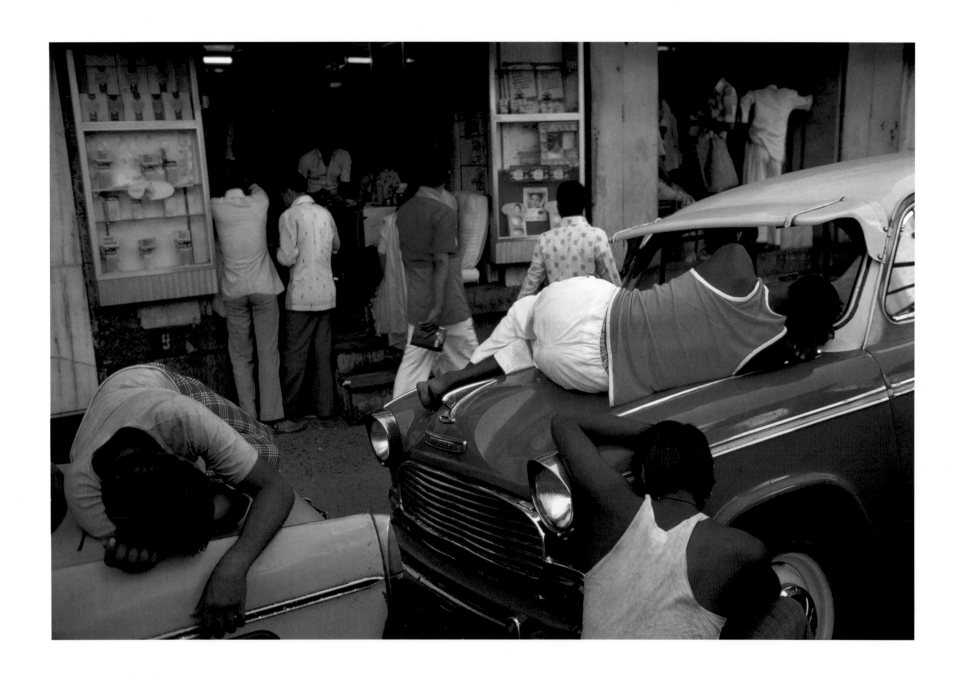

Exhausted workmen, Mumbai, Maharashtra, 1977

Slum dweller, Dharavi, Mumbai, Maharashtra, 1990

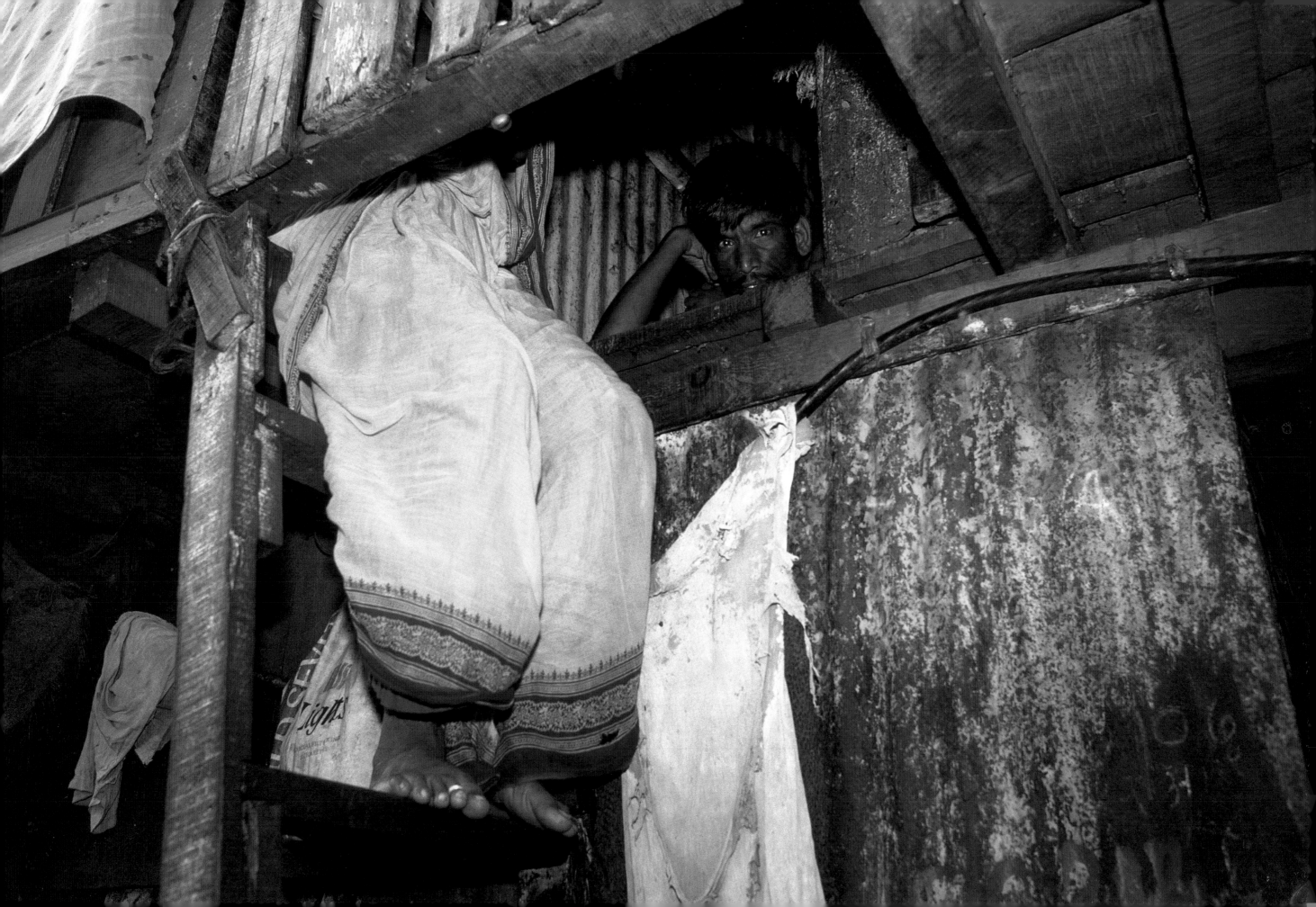

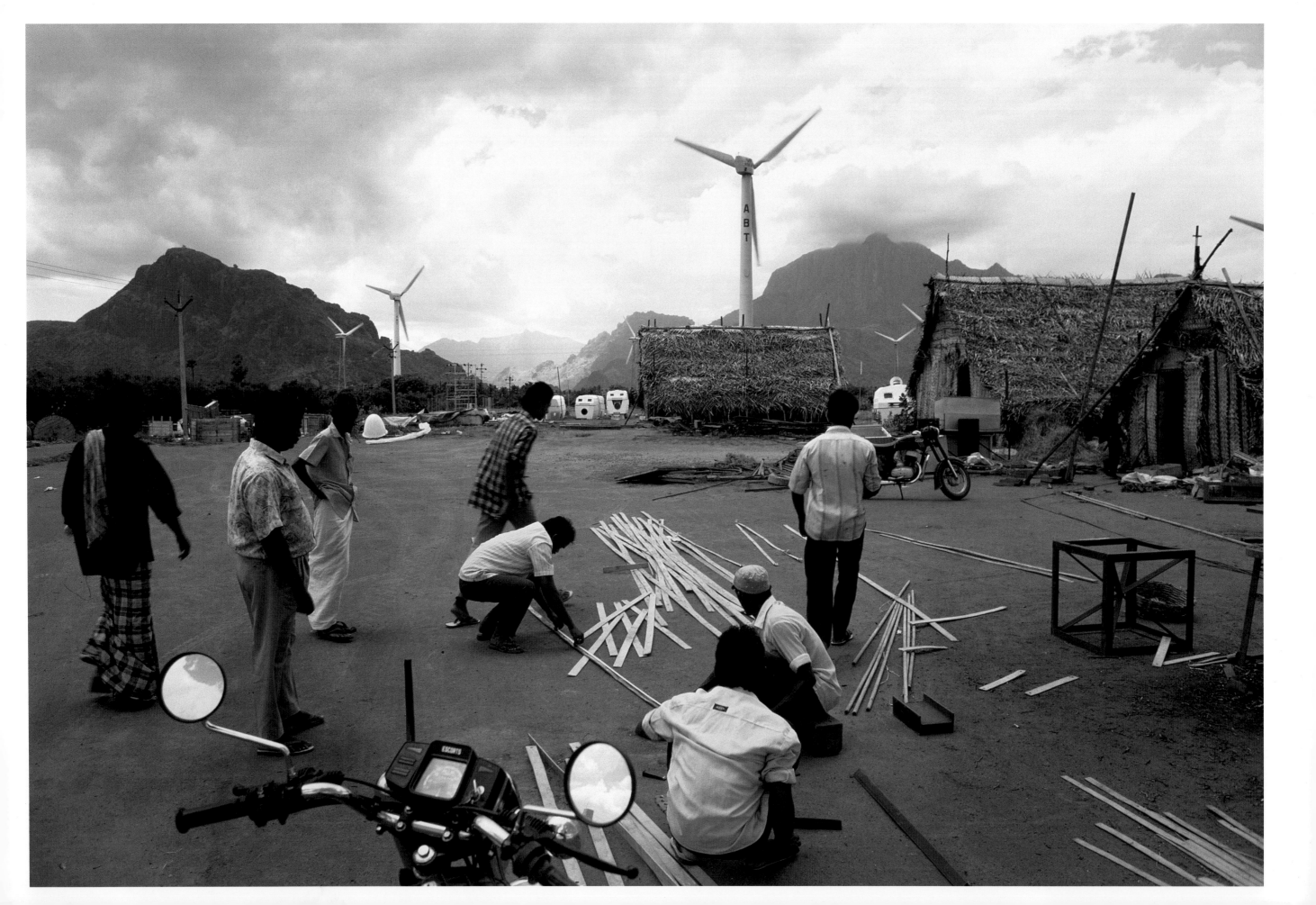

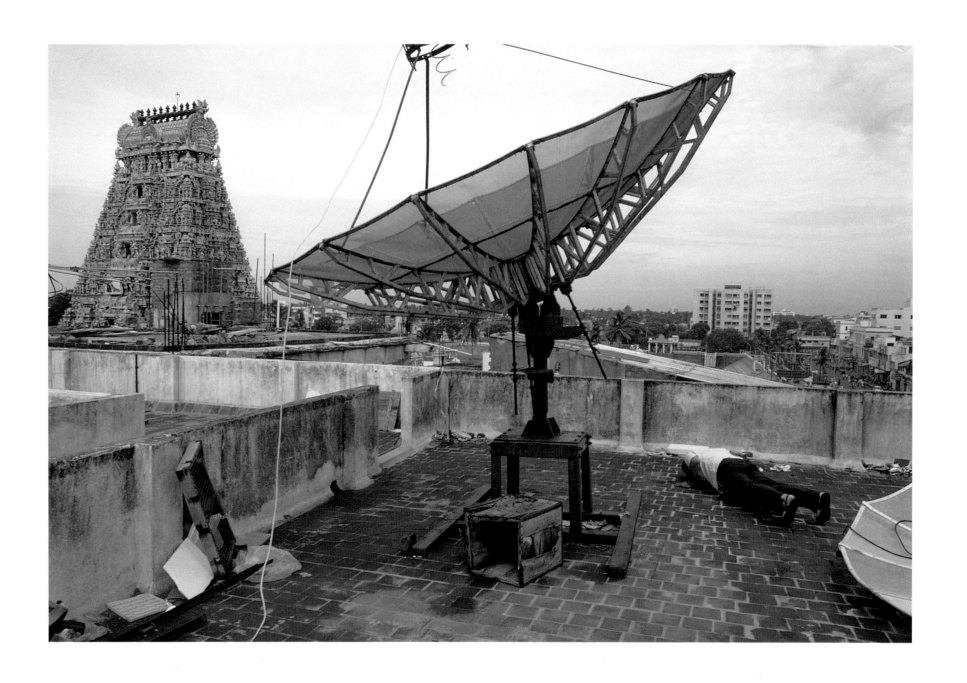

Windmill farm, Tirunelveli, Tamil Nadu, 1995
Worshipper, Kapalisvara Temple, Chennai, Tamil Nadu, 1994

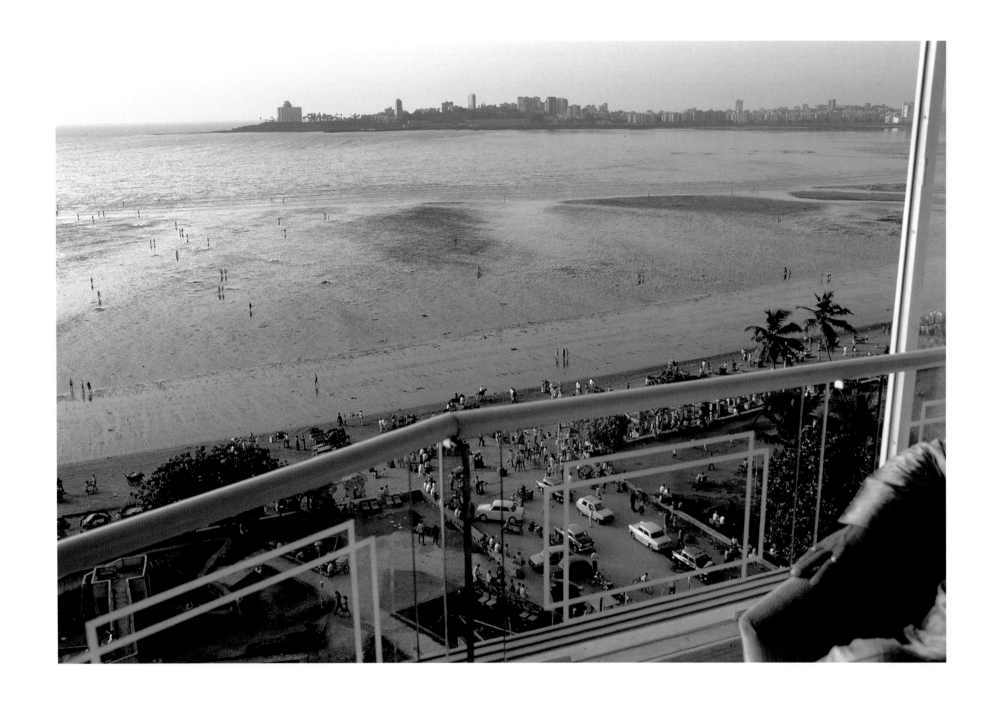

From a high-rise, Sivaji Park, Mumbai, Maharashtra, 1991

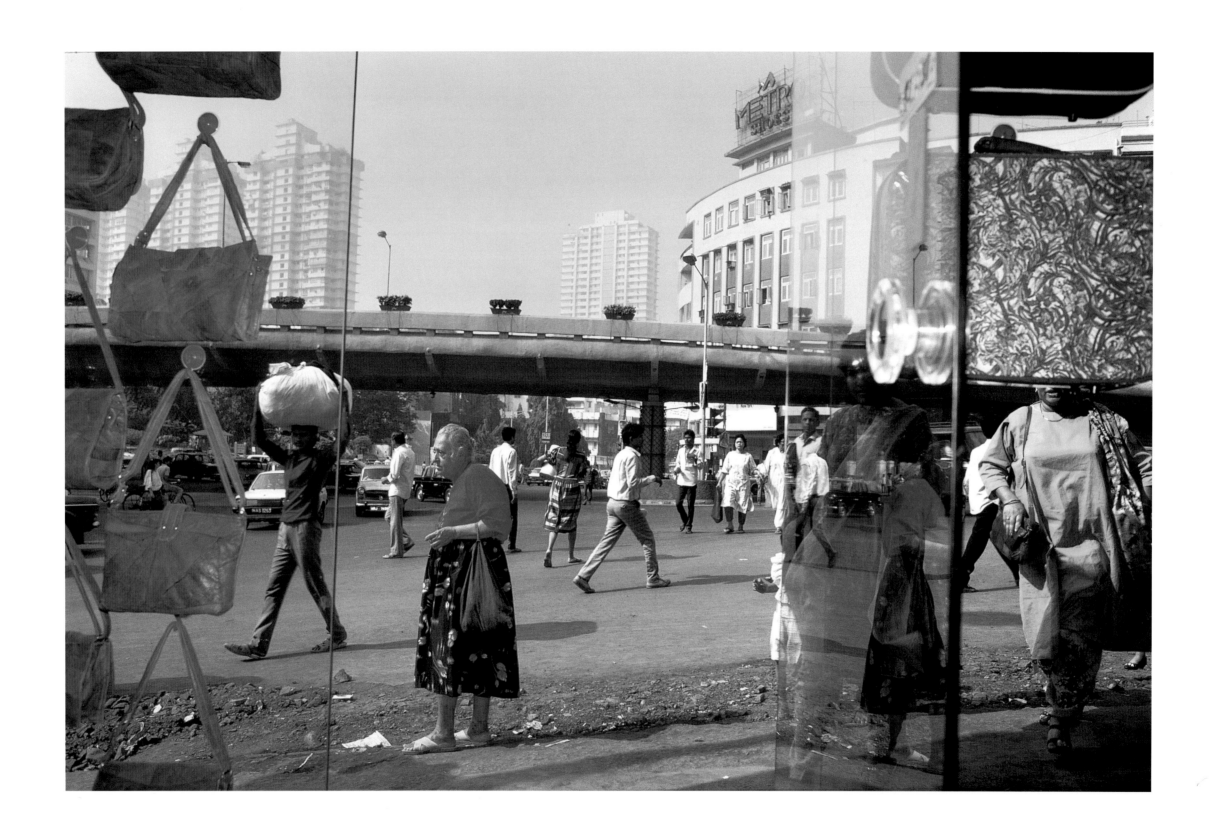

Pedestrians, Kemp's Corner, Mumbai, Maharashtra, 1989

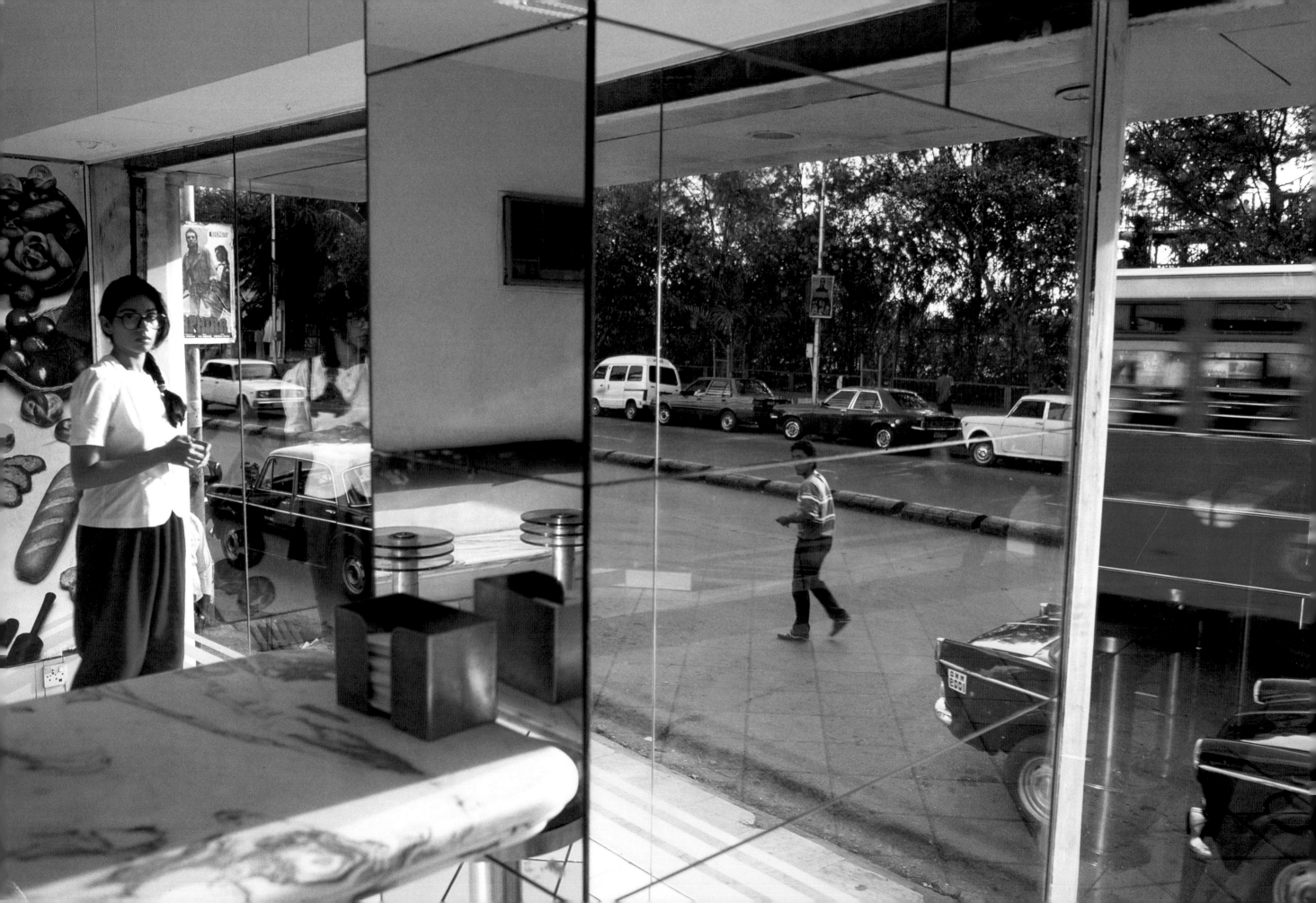

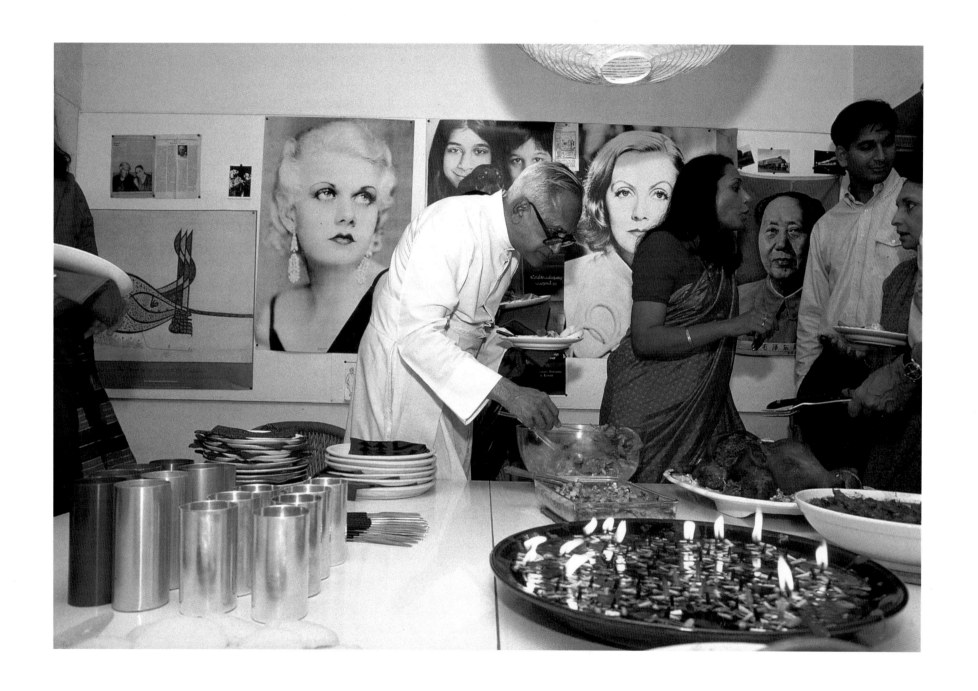

In a bakery, Warden Road, Mumbai, Maharashtra, 1990
Birthday party, Malabar Hill, Mumbai, Maharashtra, 1990

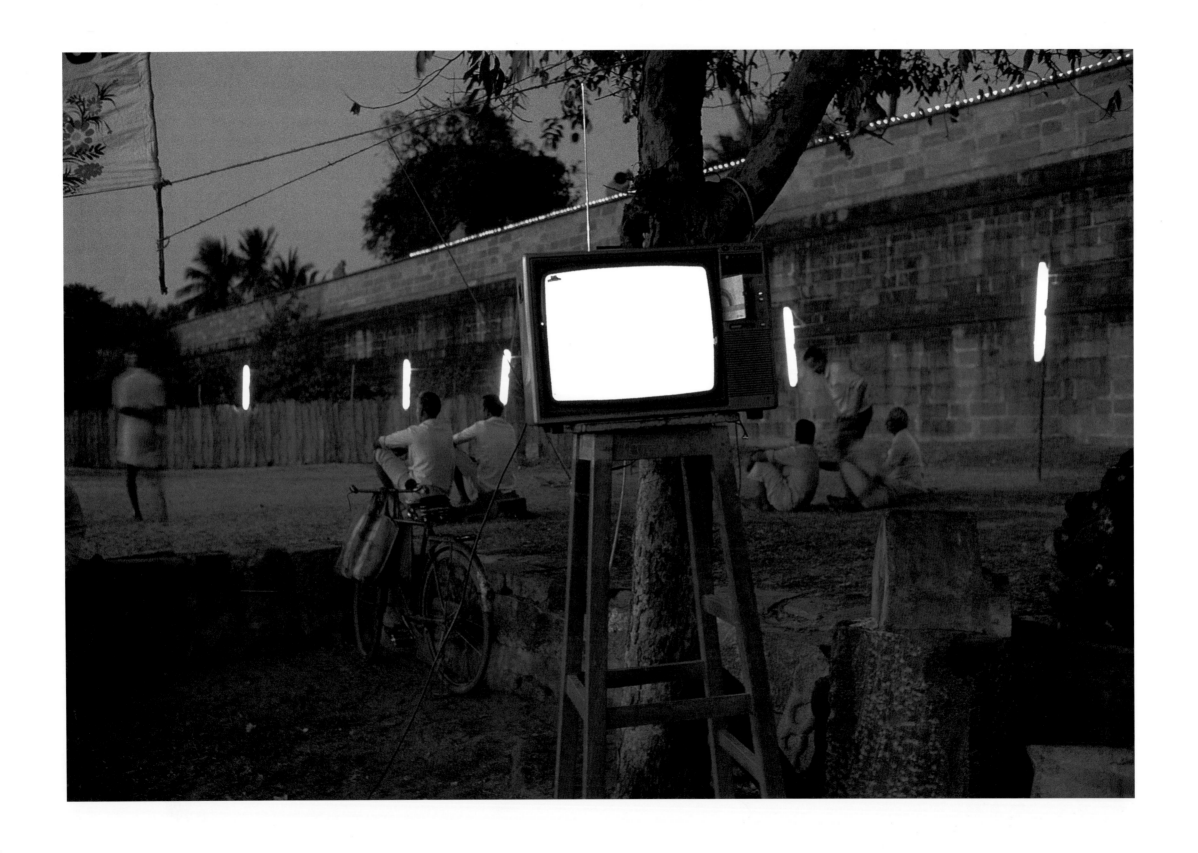

Television set, Chidambaram festival, Tamil Nadu, 1993

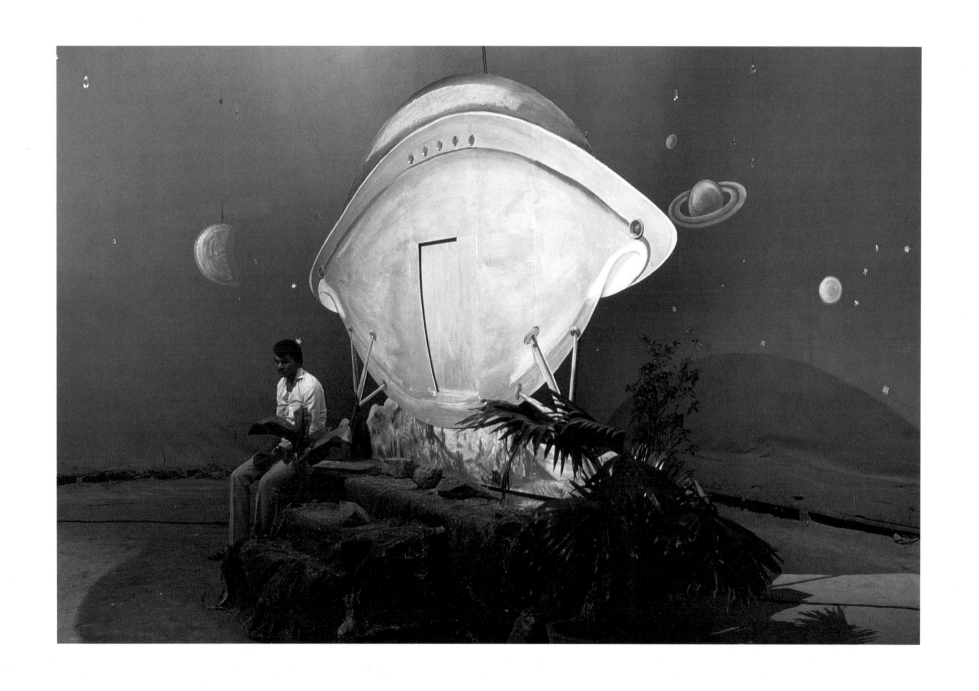

A film studio, Mumbai, Maharashtra, 1989

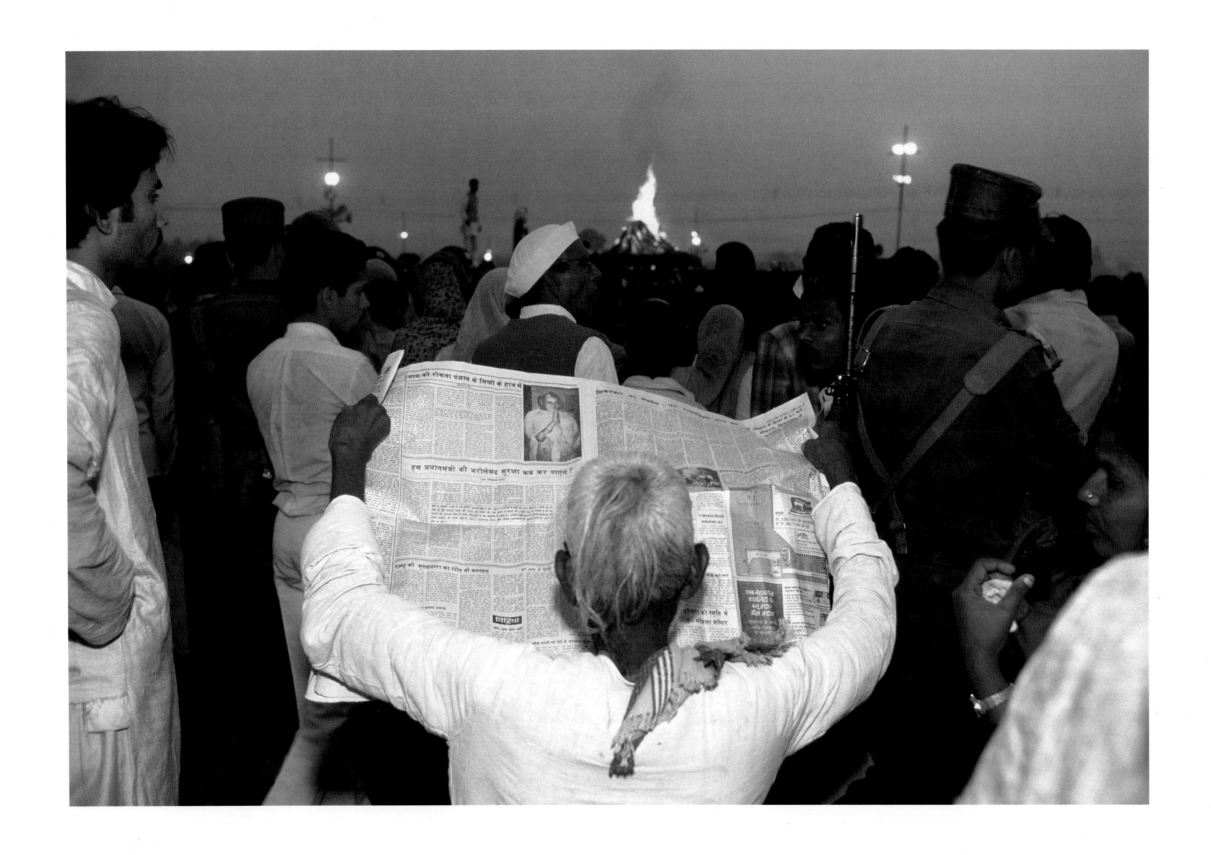

Prime Minister Indira Gandhi's funeral, New Delhi, 1984

A body for burning, Holika burns, Rajiv Gandhi poster, Benares, Uttar Pradesh, 1985

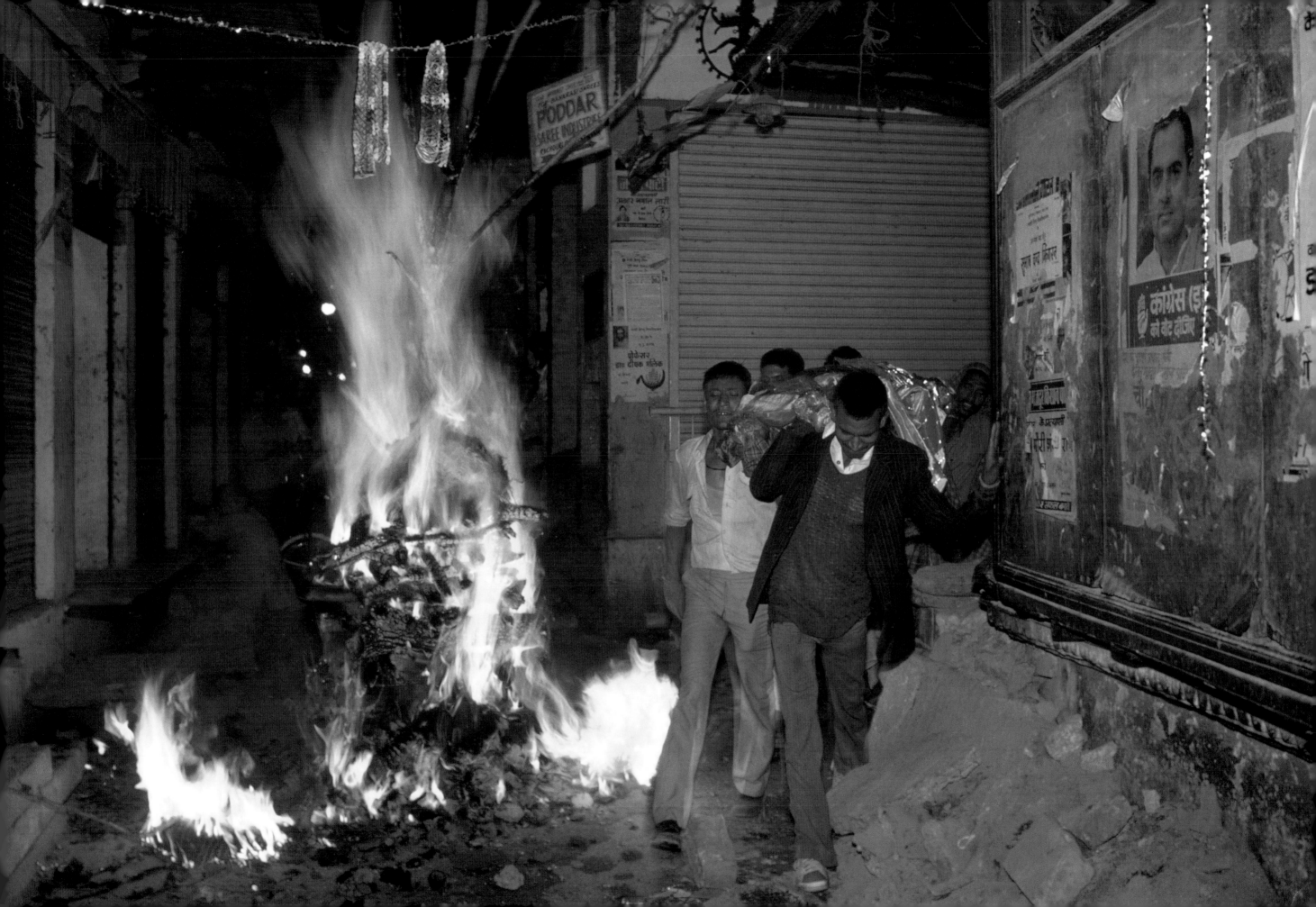

When we look at the architectural heritage of India, we find an incredibly rich RESERVOIR OF MYTHIC IMAGES and beliefs – all co-existing in an easy and natural pluralism. Each is like a transparent overlay – starting with models of the cosmos, right down to this century. And it is their continuing presence in our lives that creates the pluralistic society of India.

Introduction to *Vistara: The Architecture of India* by Charles Correa

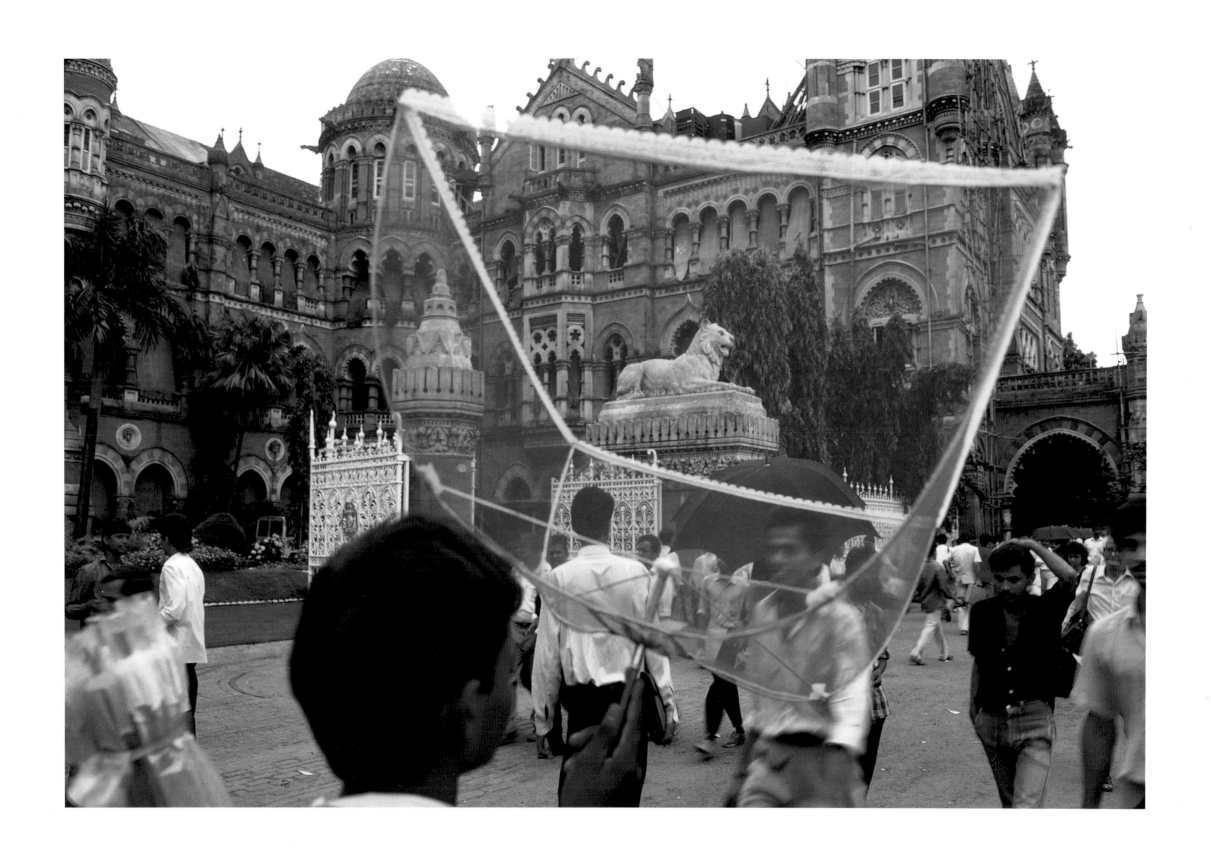

Victoria Terminus, Mumbai, Maharashtra, 1991

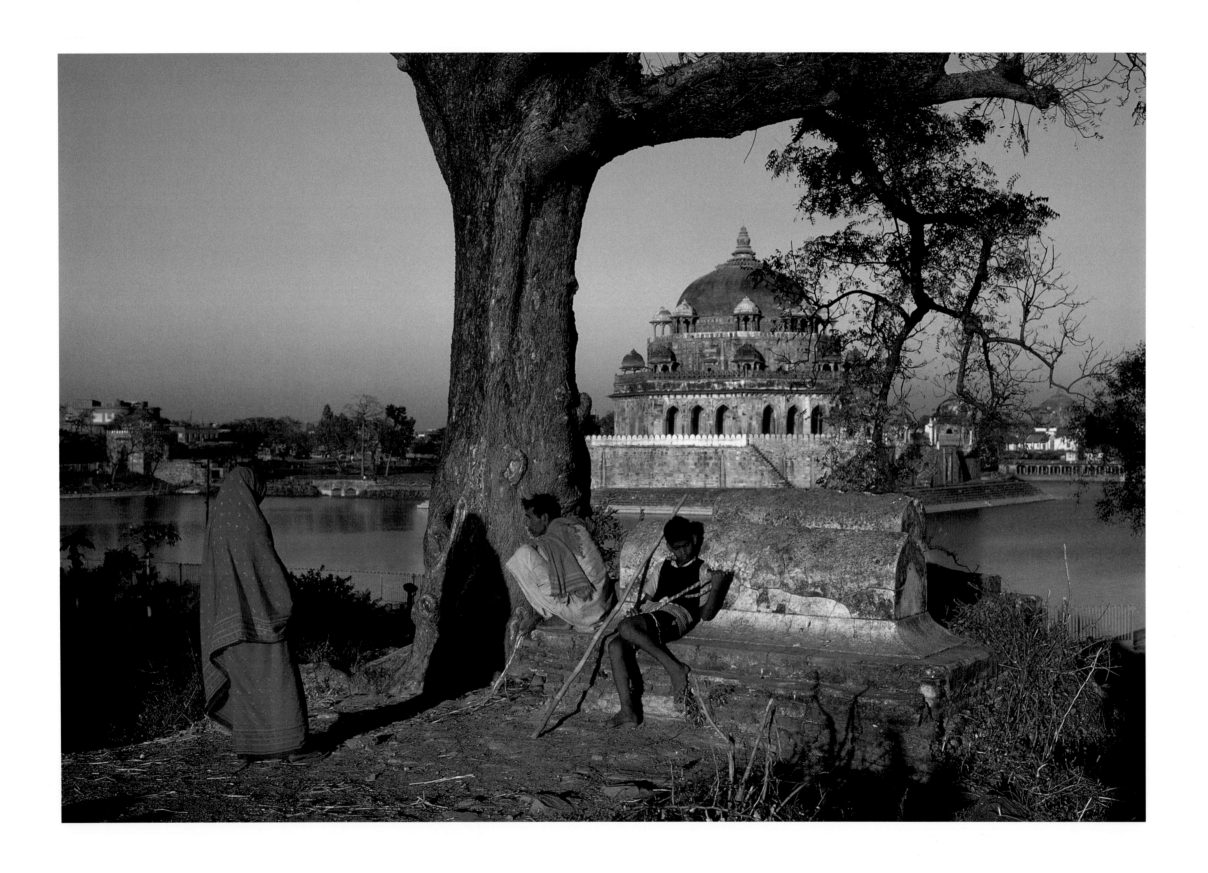

Sher Shah's Tomb, Sasaram, Bihar, 1987

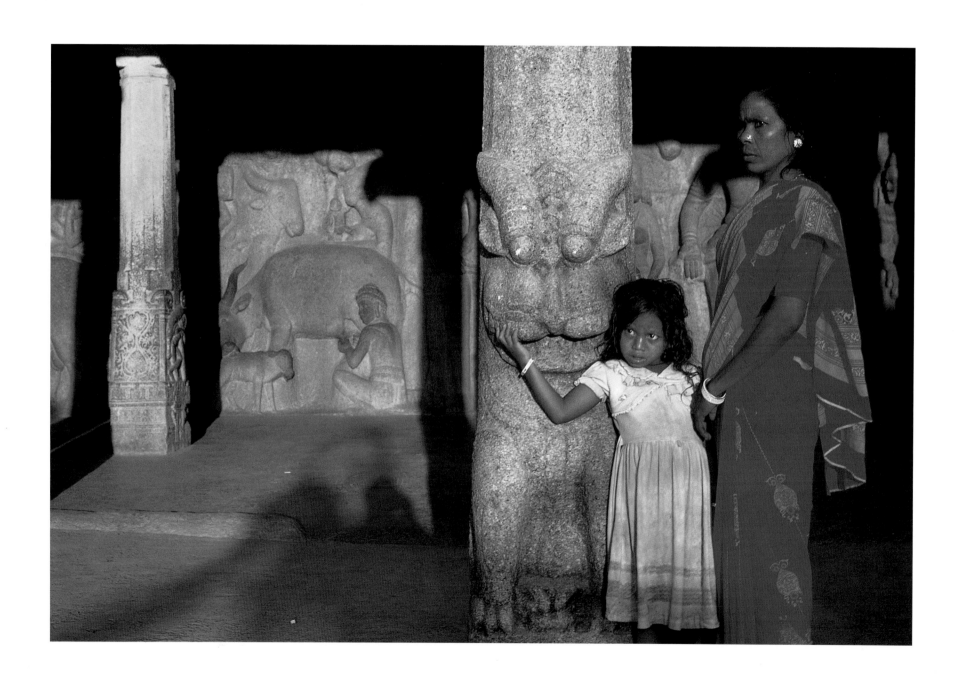

Visitors and the Krishna and cow frieze, Mamallapuram, Tamil Nadu, 1987

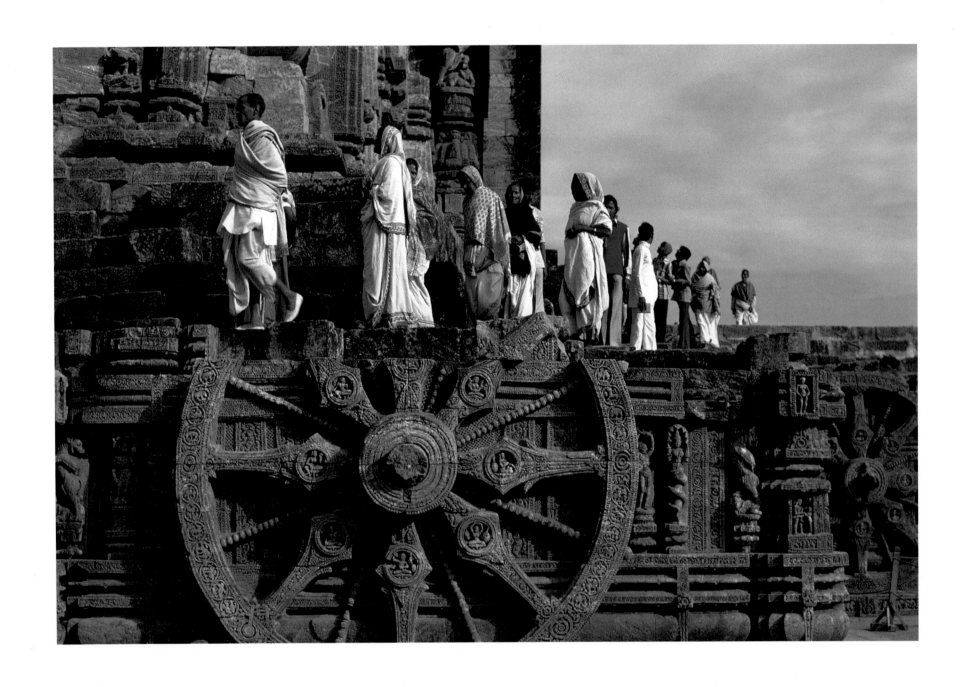

Visitors, Sun Temple, Konarak, Orissa, 1985

Babasaheb Bhimrao Ambedkar, Ferozabad outskirts, Uttar Pradesh, 1991

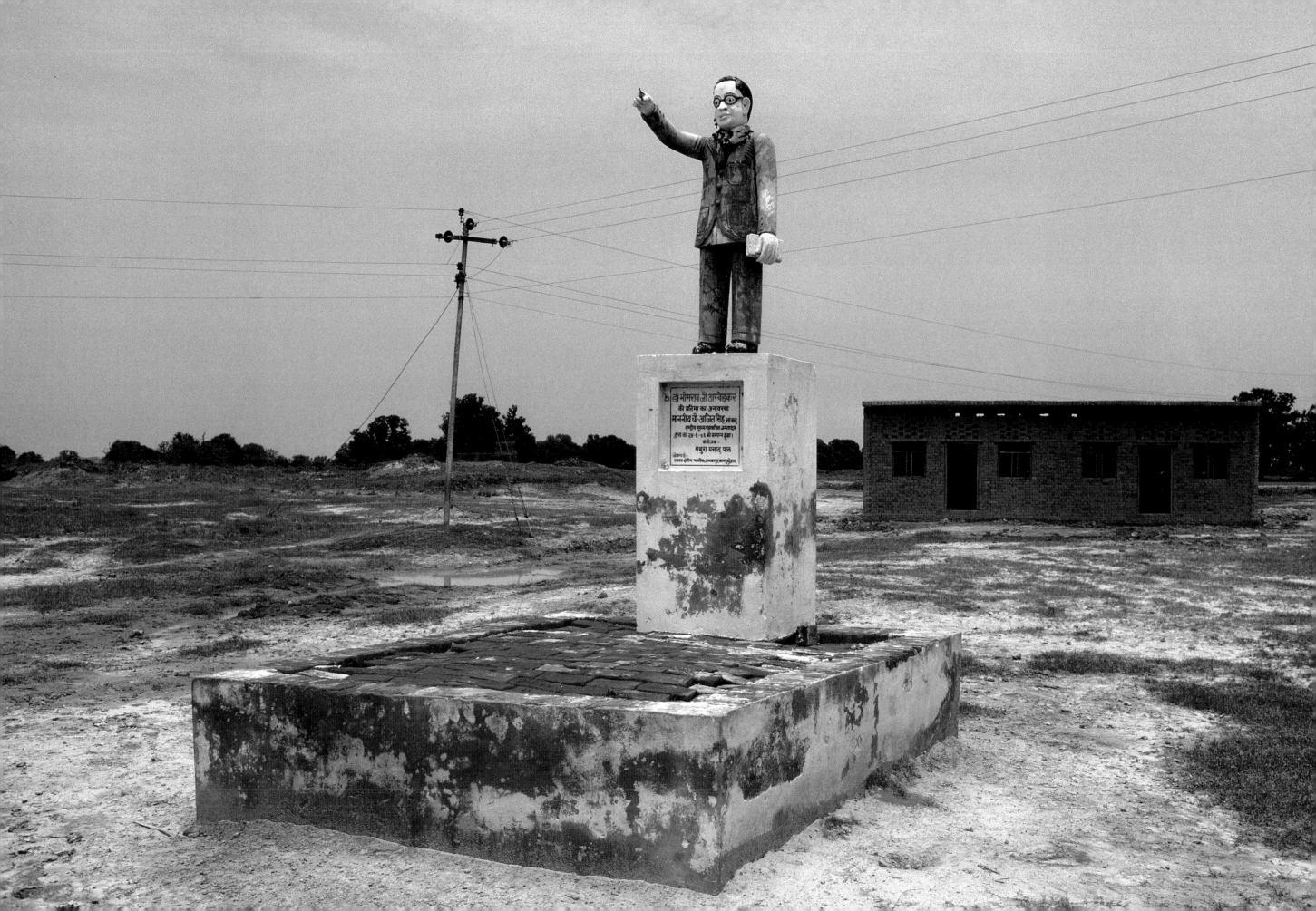

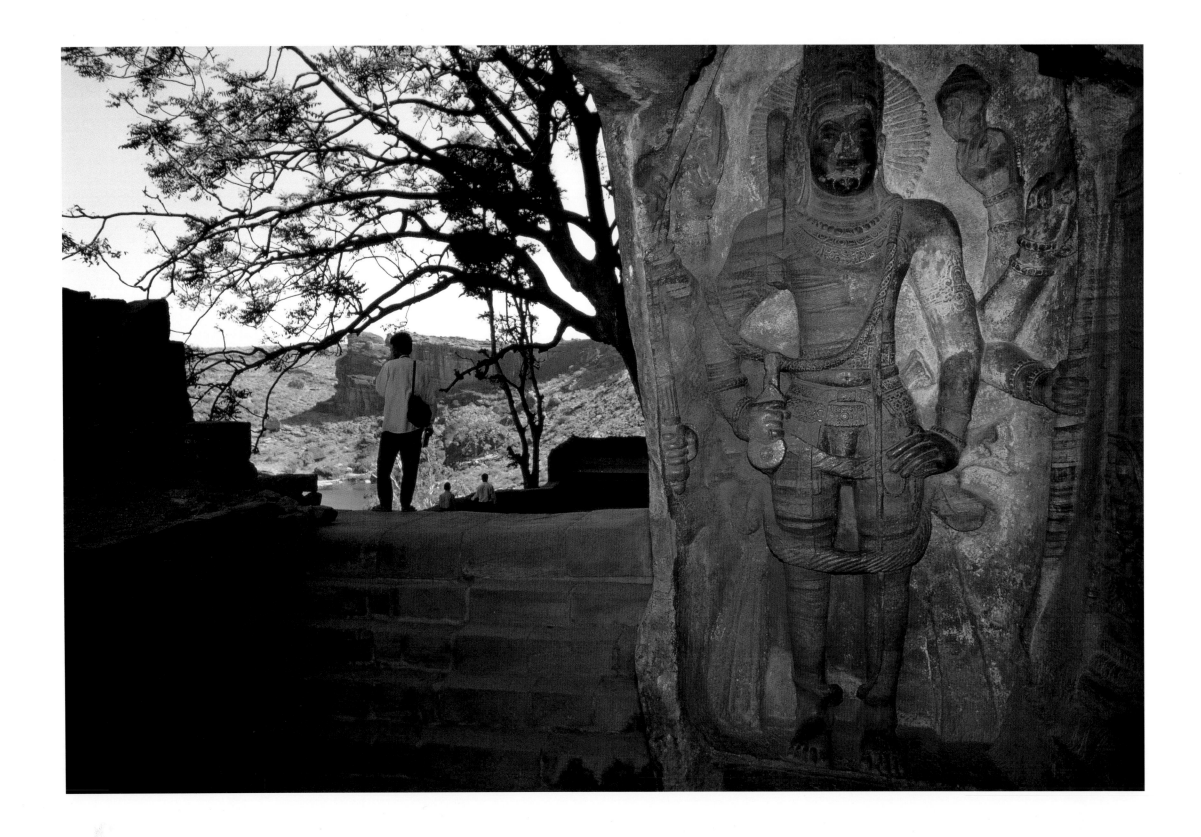

A guardian figure, Badami, Karnataka, 1995

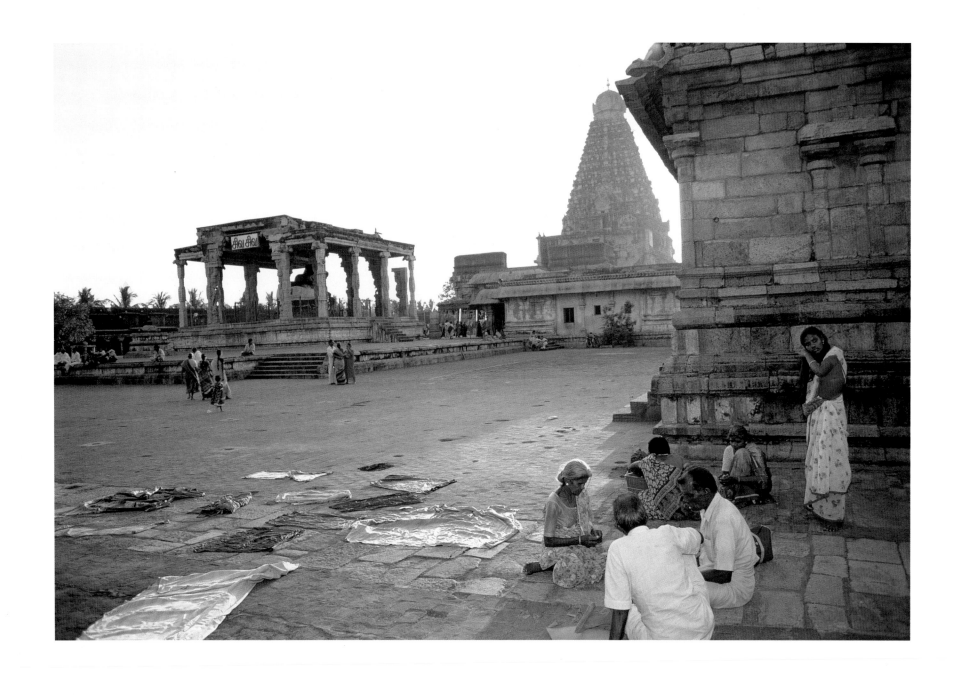

Brihadisvara Temple, Thanjavur, Tamil Nadu, 1995

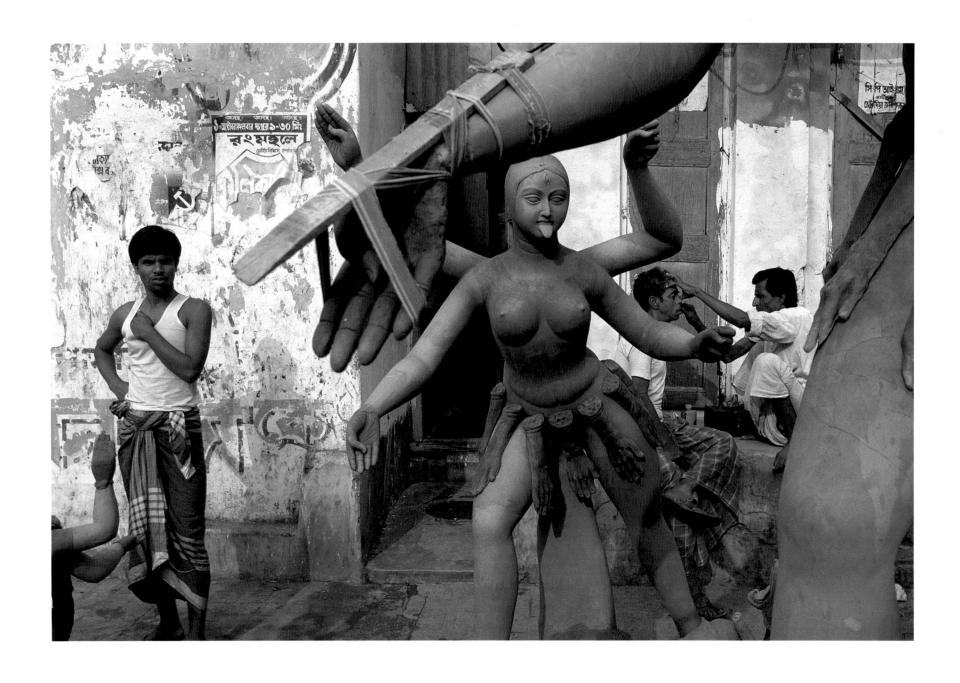

Barber and goddess Kali, Calcutta, West Bengal, 1987

Subhas Chandra Bose statue, Calcutta, West Bengal, 1986

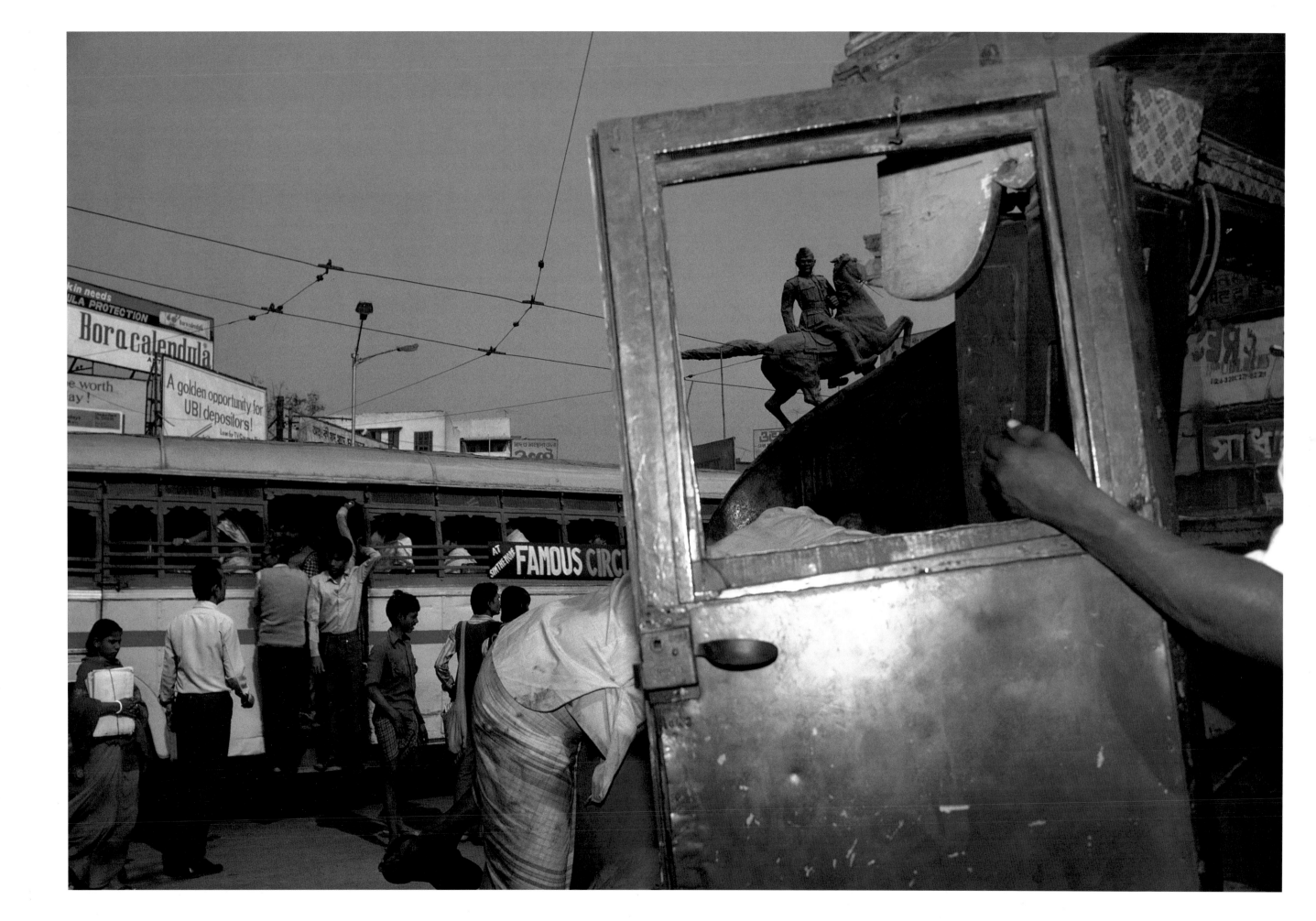

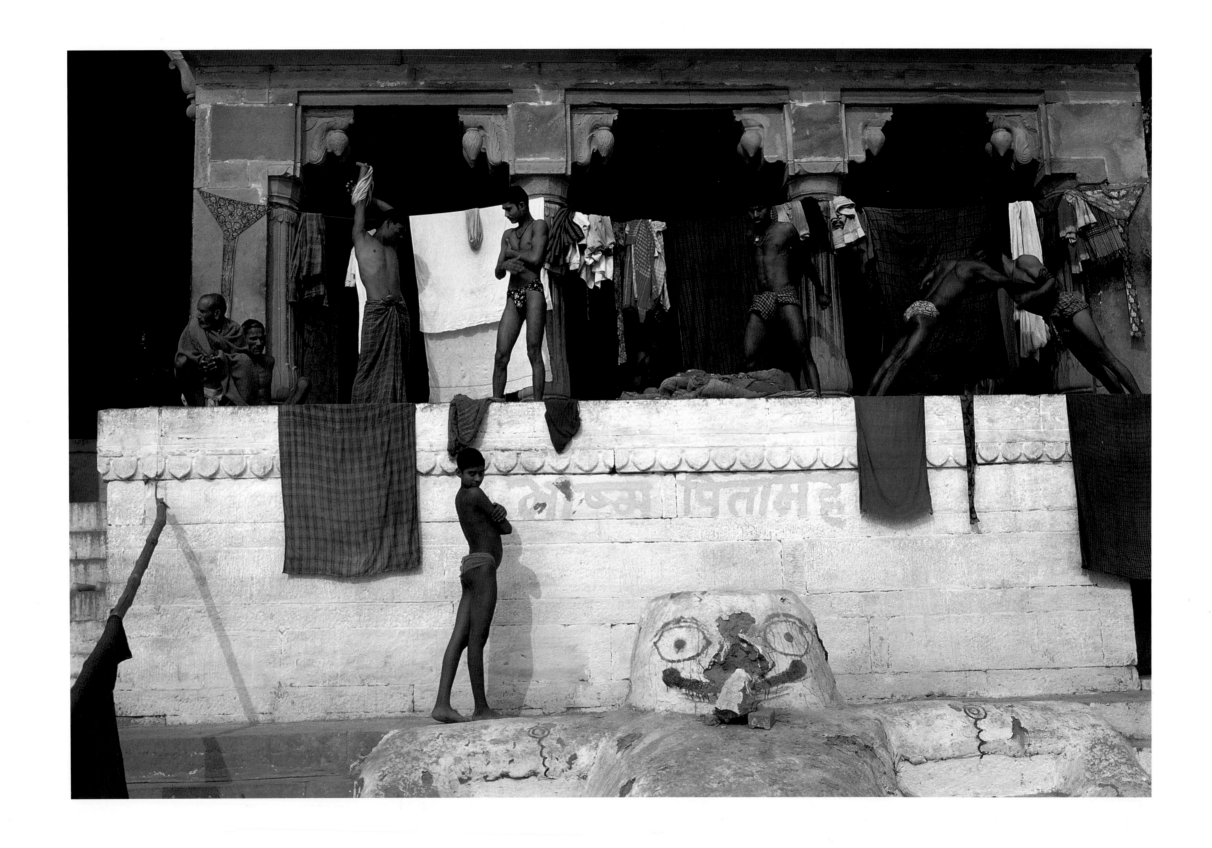

Wrestlers exercise, statue of Bhima, Rama Ghat, Benares, Uttar Pradesh, 1983

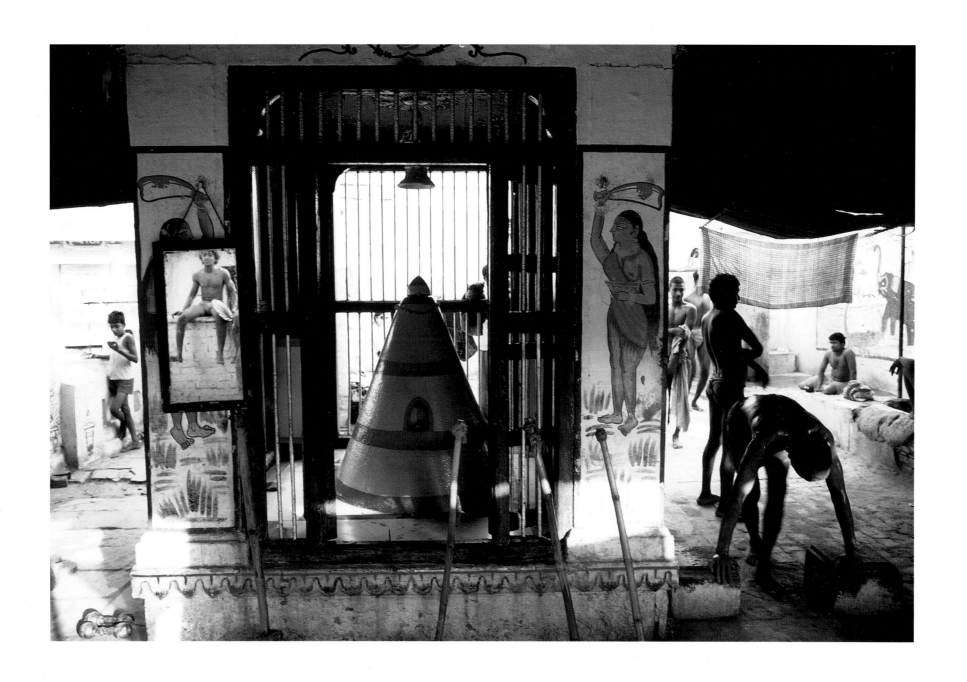

Wrestlers exercise, Hanuman shrine, Benares, Uttar Pradesh, 1983

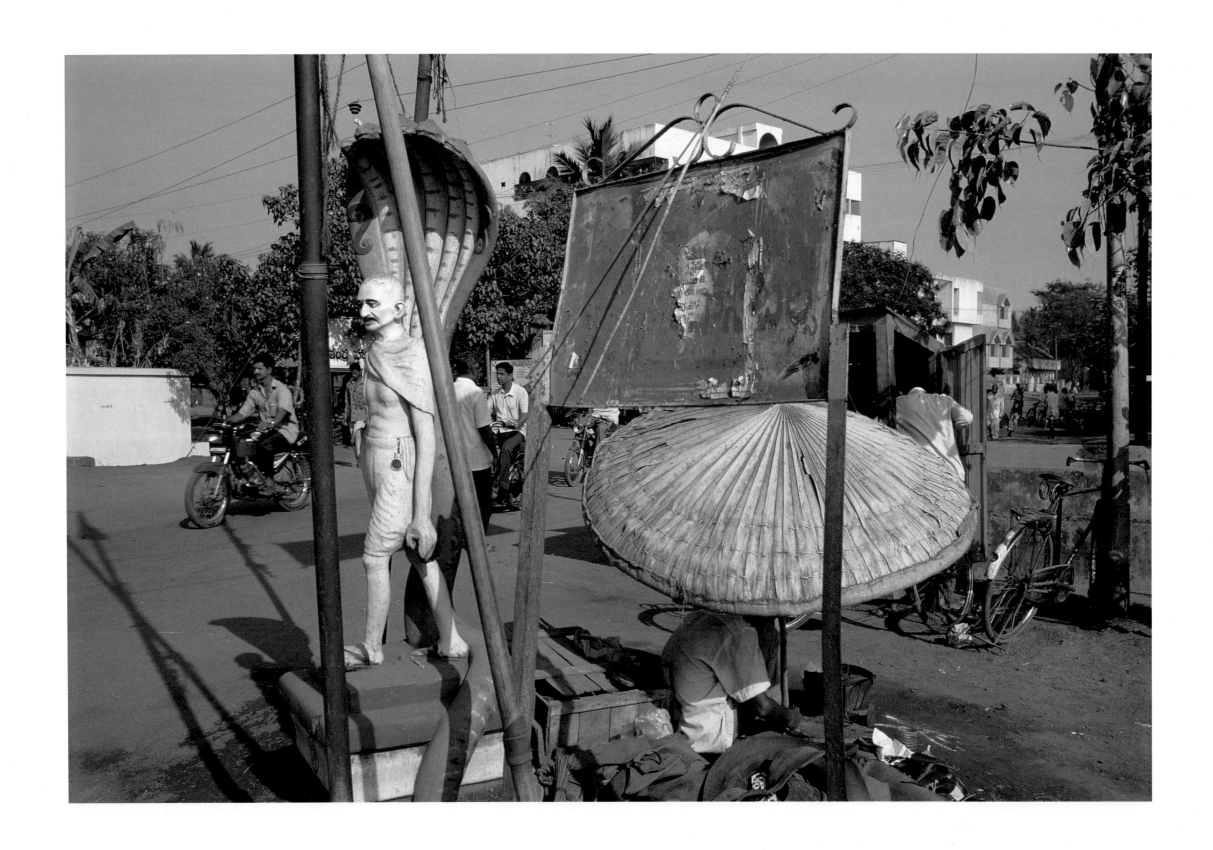

Mahatma Gandhi, Rajahmundry, Andhra Pradesh, 1996
Siva as rider of the bull, Thanjavur, Tamil Nadu, 1993

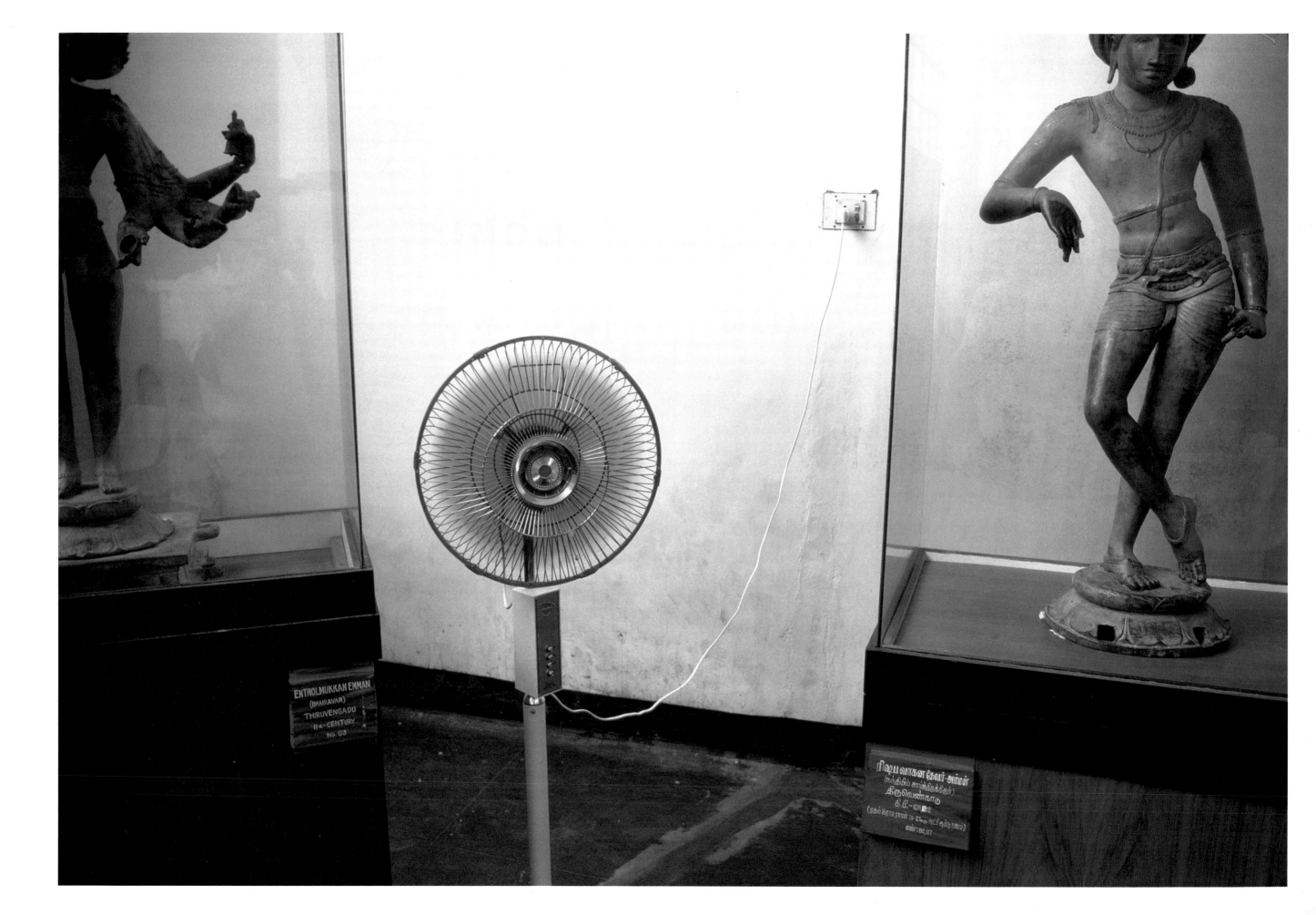

ரிஷப வாகன தேவர்-அம்மன்
(நாந்தியில் சாய்ந்திருக்கின்றார்)
திருவெண்காடு
கி.பி.-மயிலை
(முகல்கால ராஜா 11-ஏழாம் பட்டிசிஆண்டுகாலம்)
எண்:86,87

And now we come to the Big Road...the Great Road which is the backbone of all Hind...such A RIVER OF LIFE as nowhere else exists in the world.

Kim by Rudyard Kipling

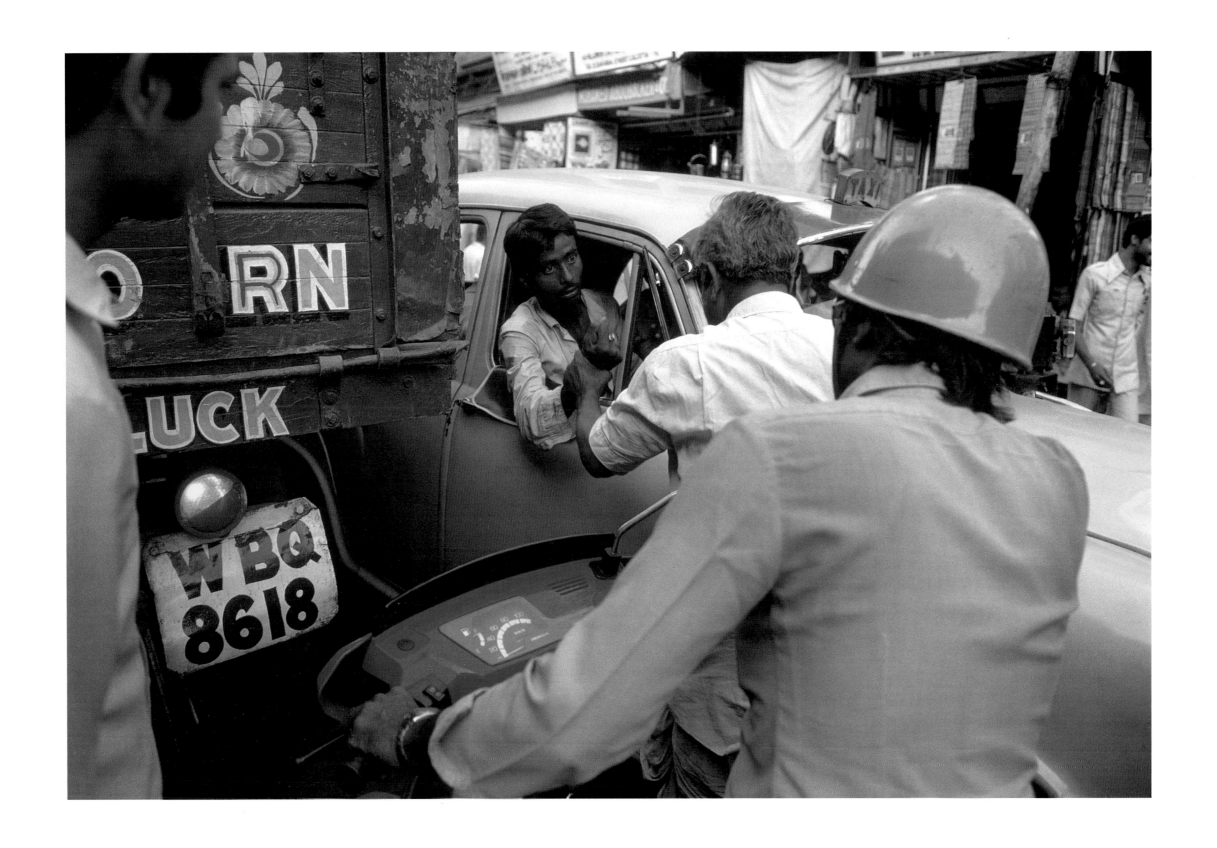

A taxi driver, Calcutta, West Bengal, 1987

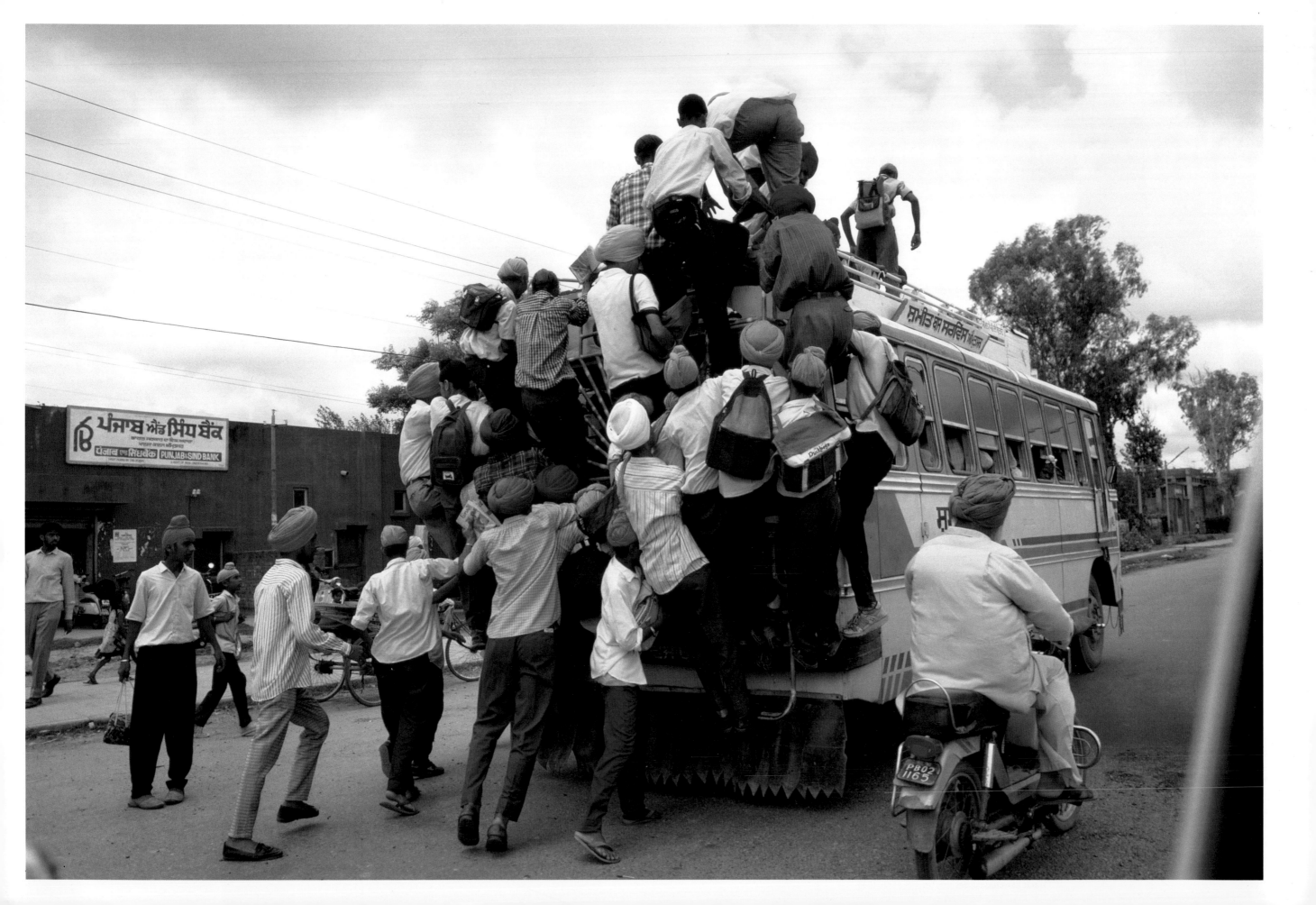

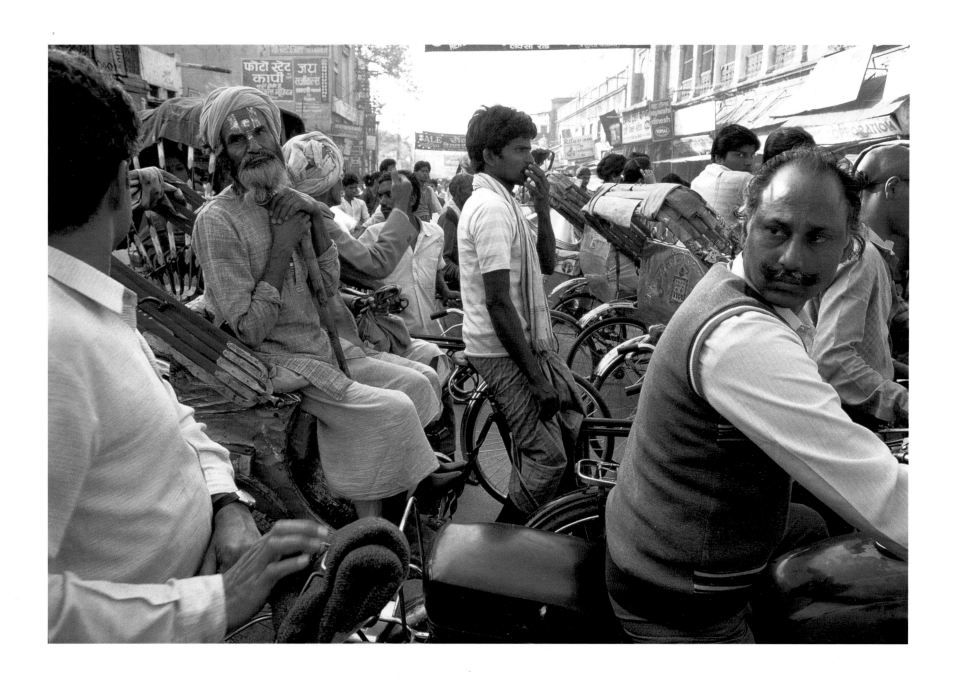

Students on a bus, Amritsar, Punjab, 1991

Traffic at a crossing, Benares, Uttar Pradesh, 1991

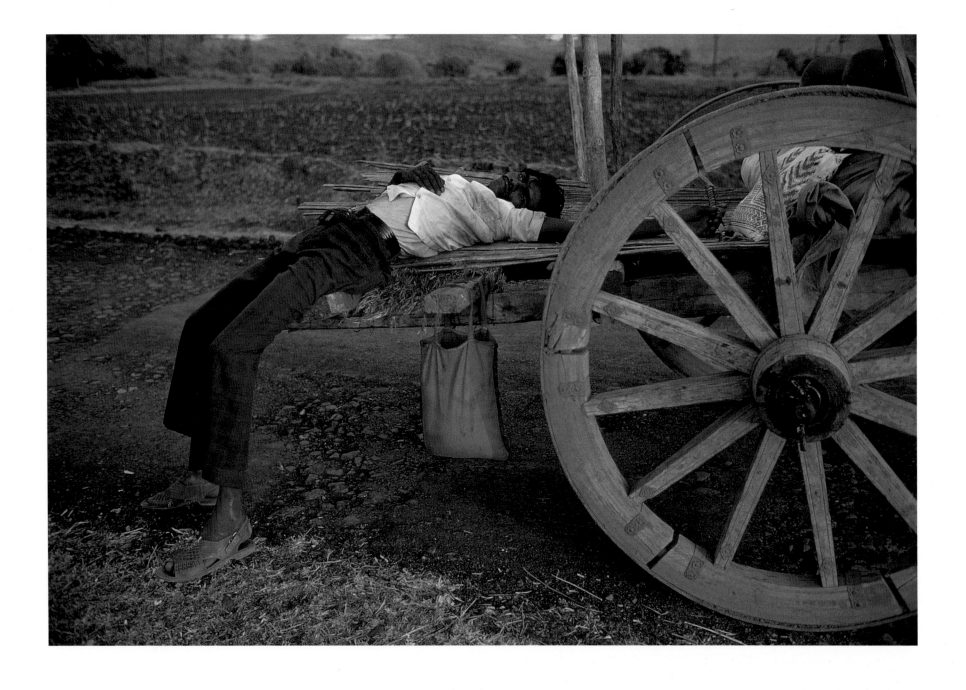

A tribesman, Gujarat-Madhya Pradesh border, 1980

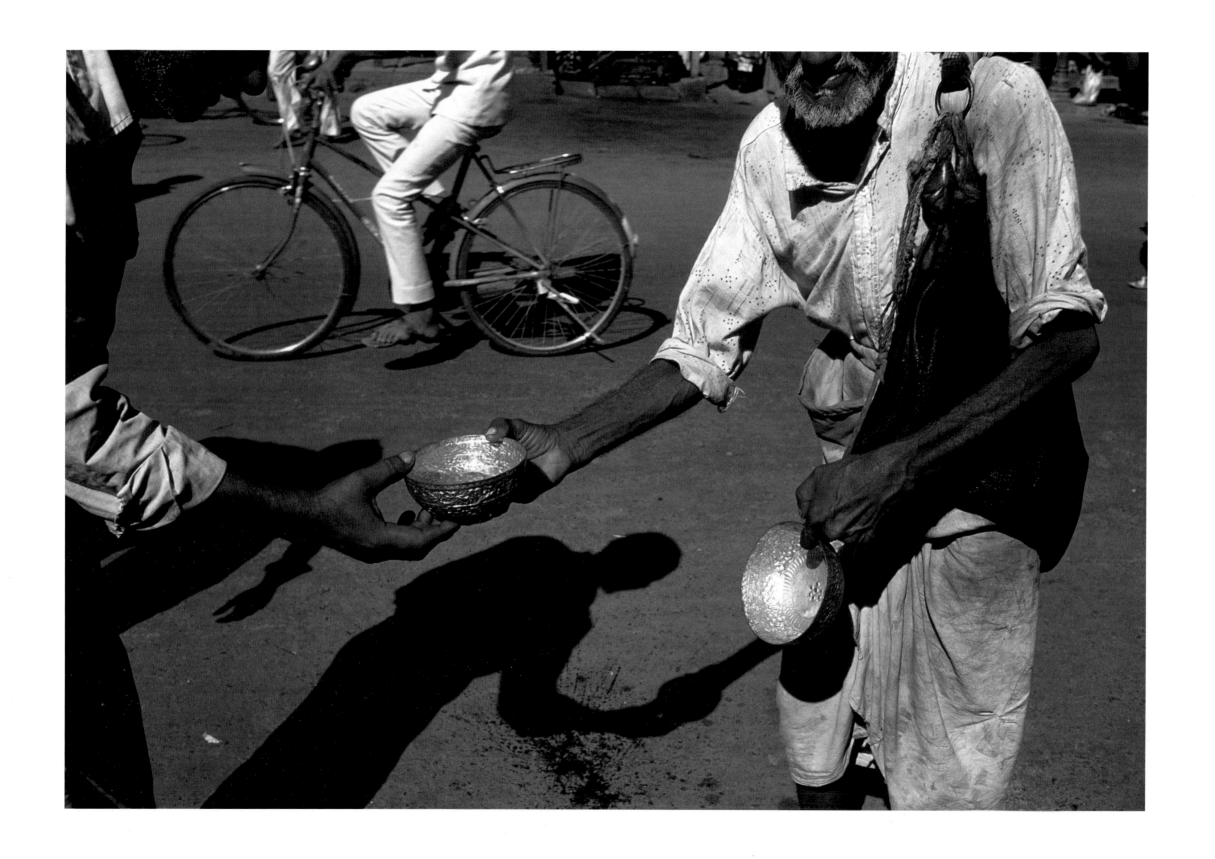

A bhisti, or water-seller, Delhi, 1987

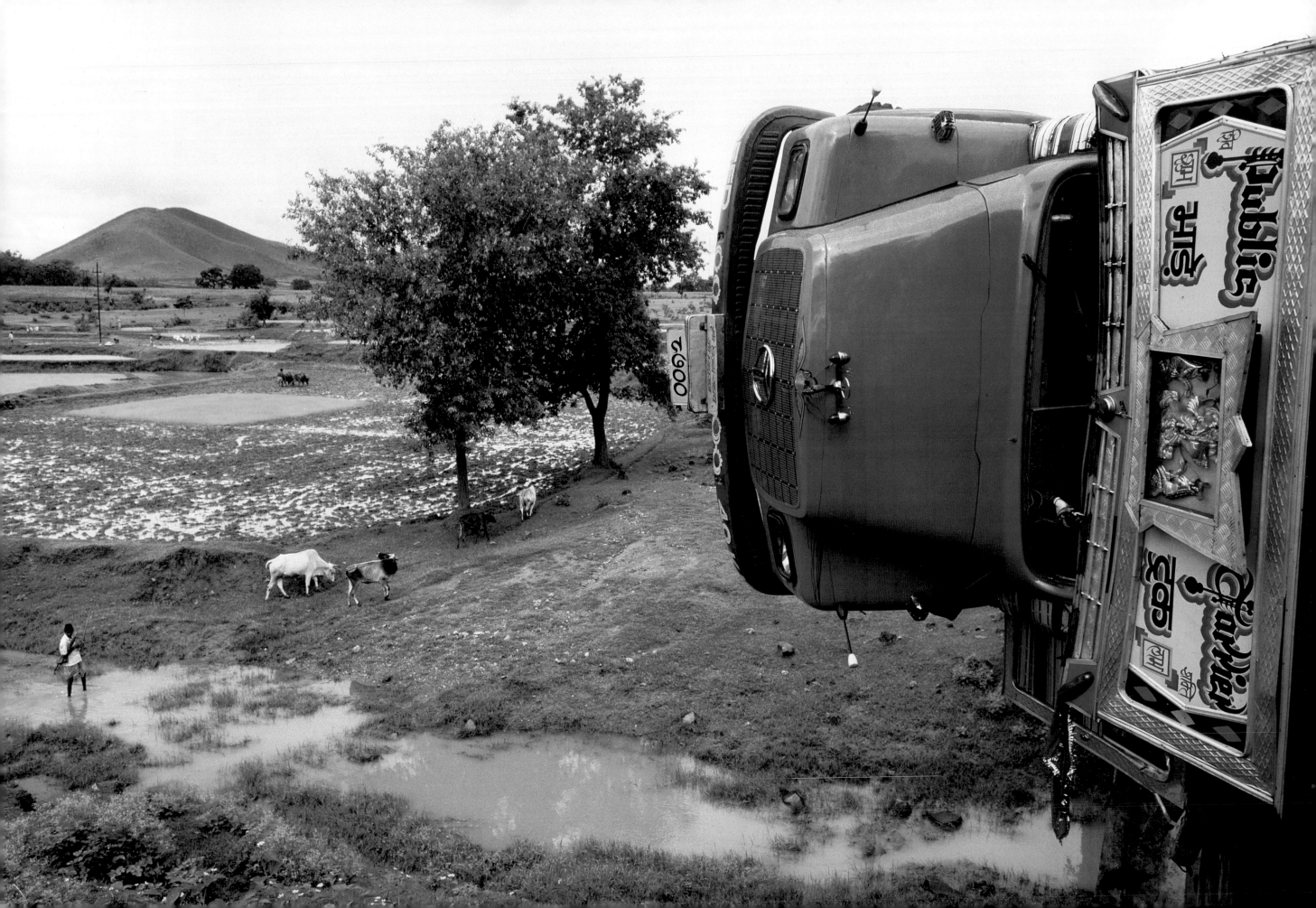

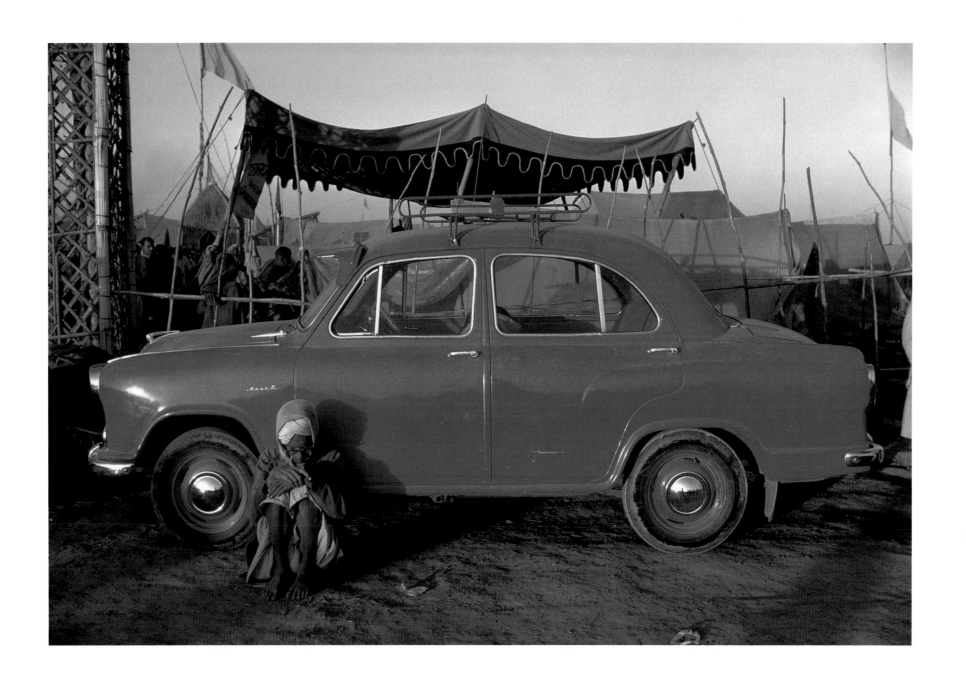

After an accident, Grand Trunk Road, Bihar, 1991

Pilgrim and Ambassador car, Kumbh Mela, Prayag, Uttar Pradesh, 1977

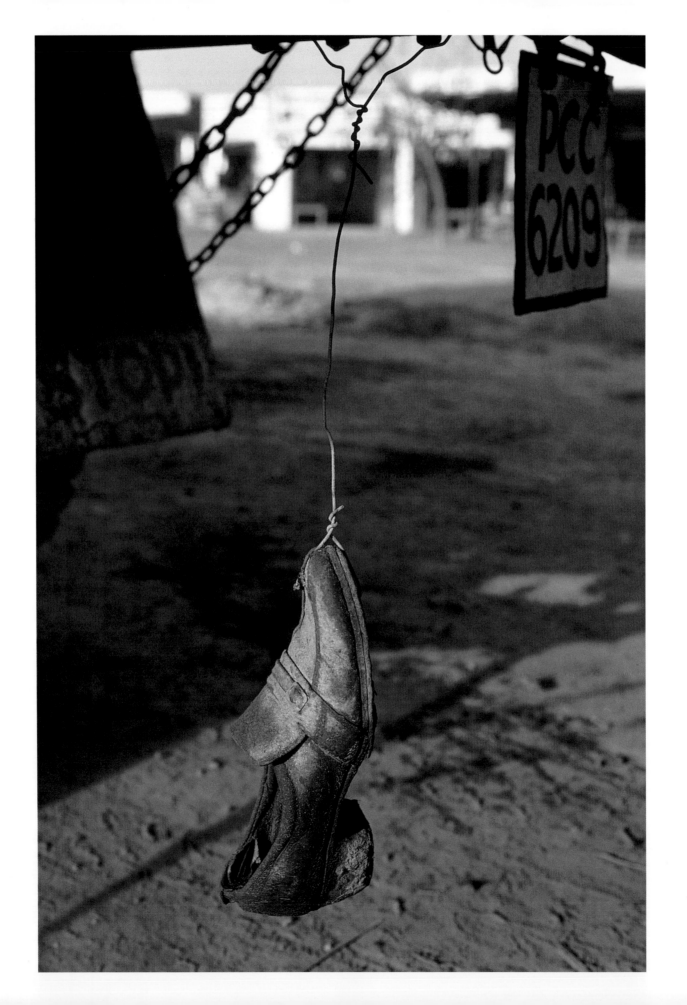

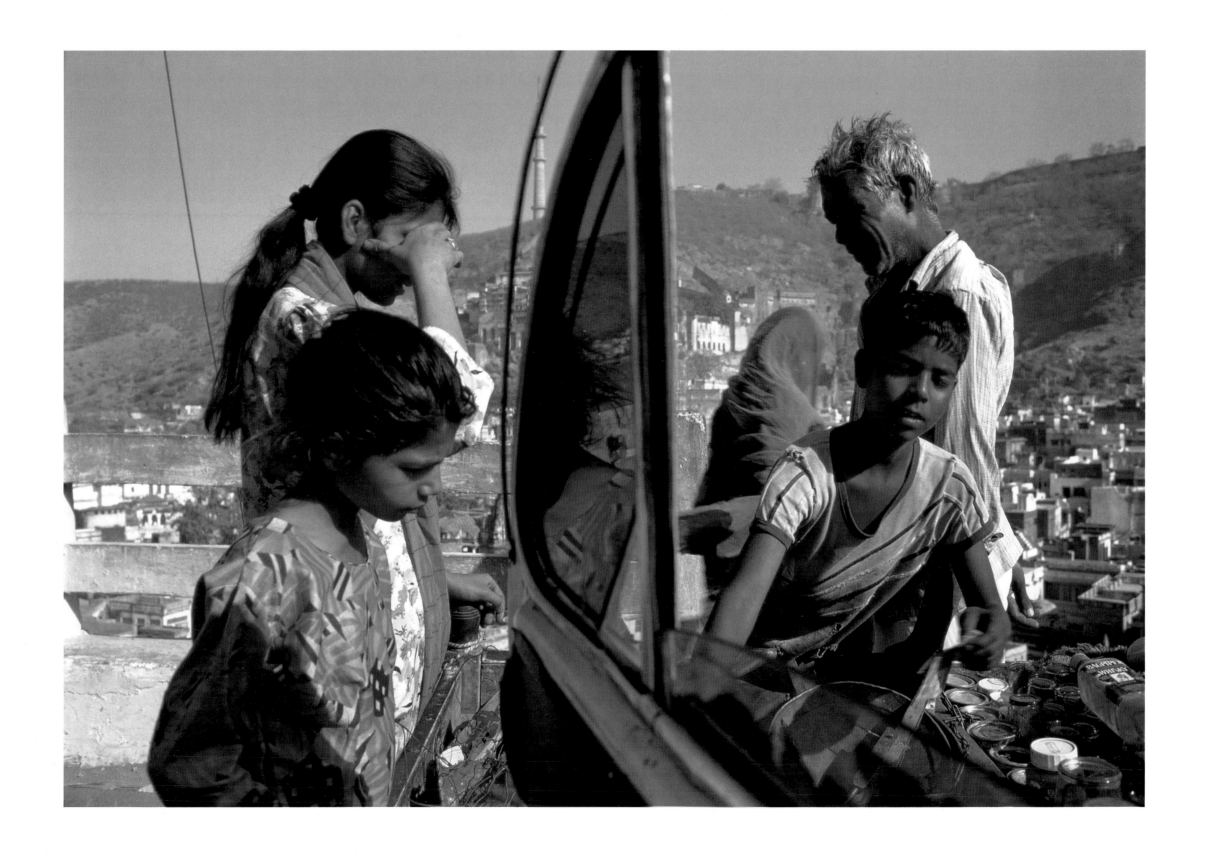

Vendor and clients, Bundi, Rajasthan, 1997

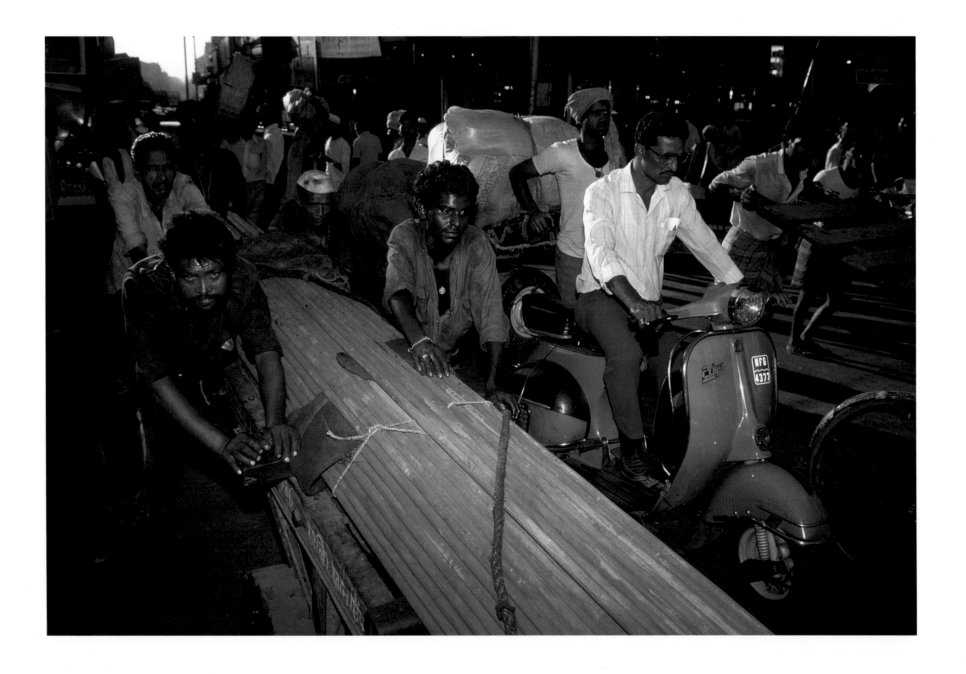

Cartpullers, Mumbai, Maharashtra, 1989

Bharatiya Janta Party procession, Haryana, 1991

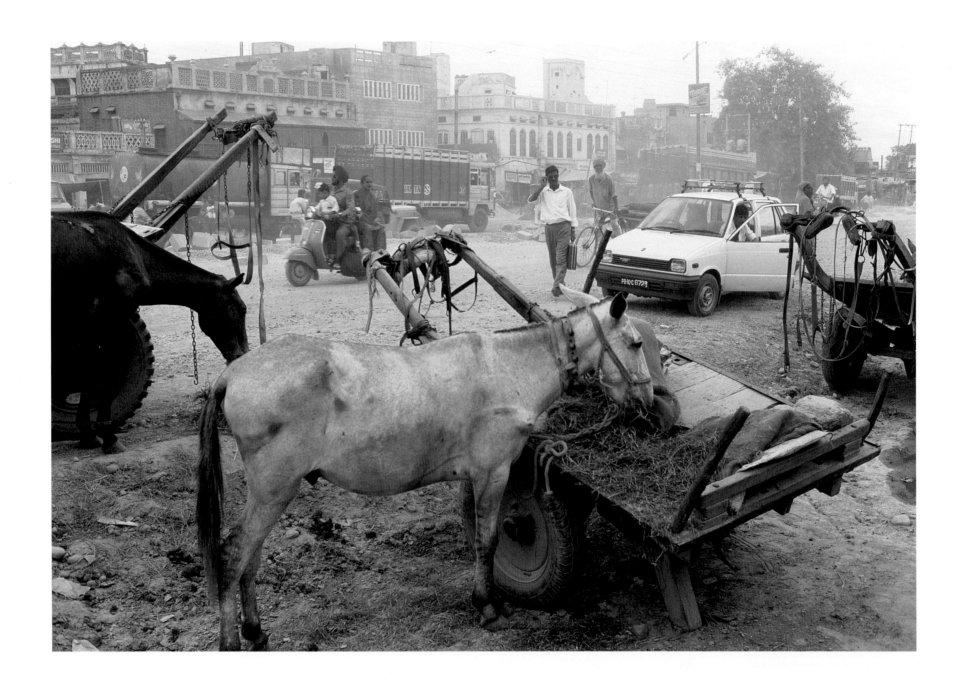

Grand Trunk Road, Khanna, Punjab, 1989

Driver and Ambassador car, Jaipur, Rajasthan, 1997

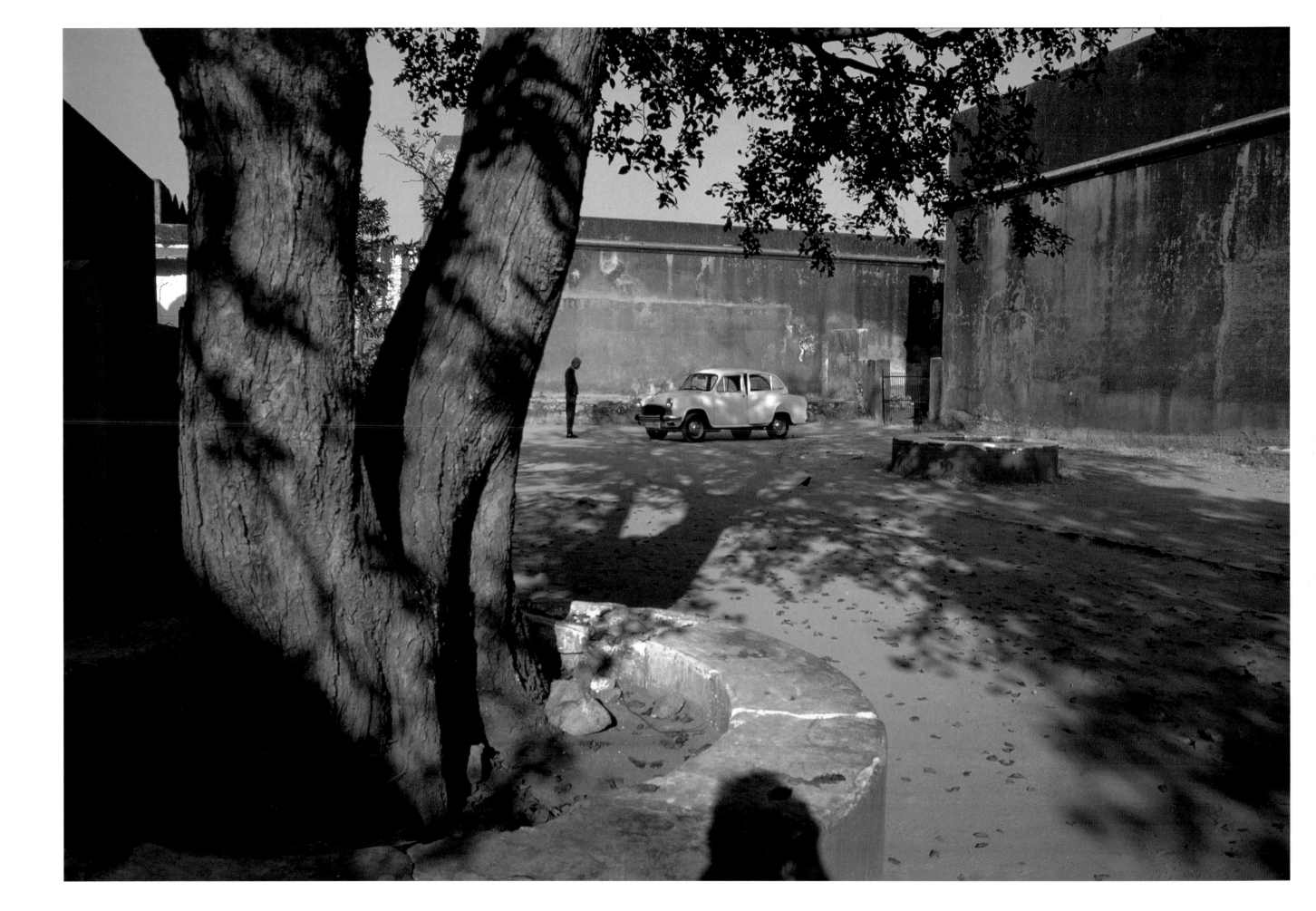

We cannot see ourselves as we really are, truly and completely, except in a mirror as a reflection, flattering or otherwise. We have to stand back to look at ourselves, our conduct and our actions – THE TWO WORLDS – HUMAN AND NON-HUMAN – dialogue with each other.

Introduction to *The Pancatantra* by Chandra Rajan

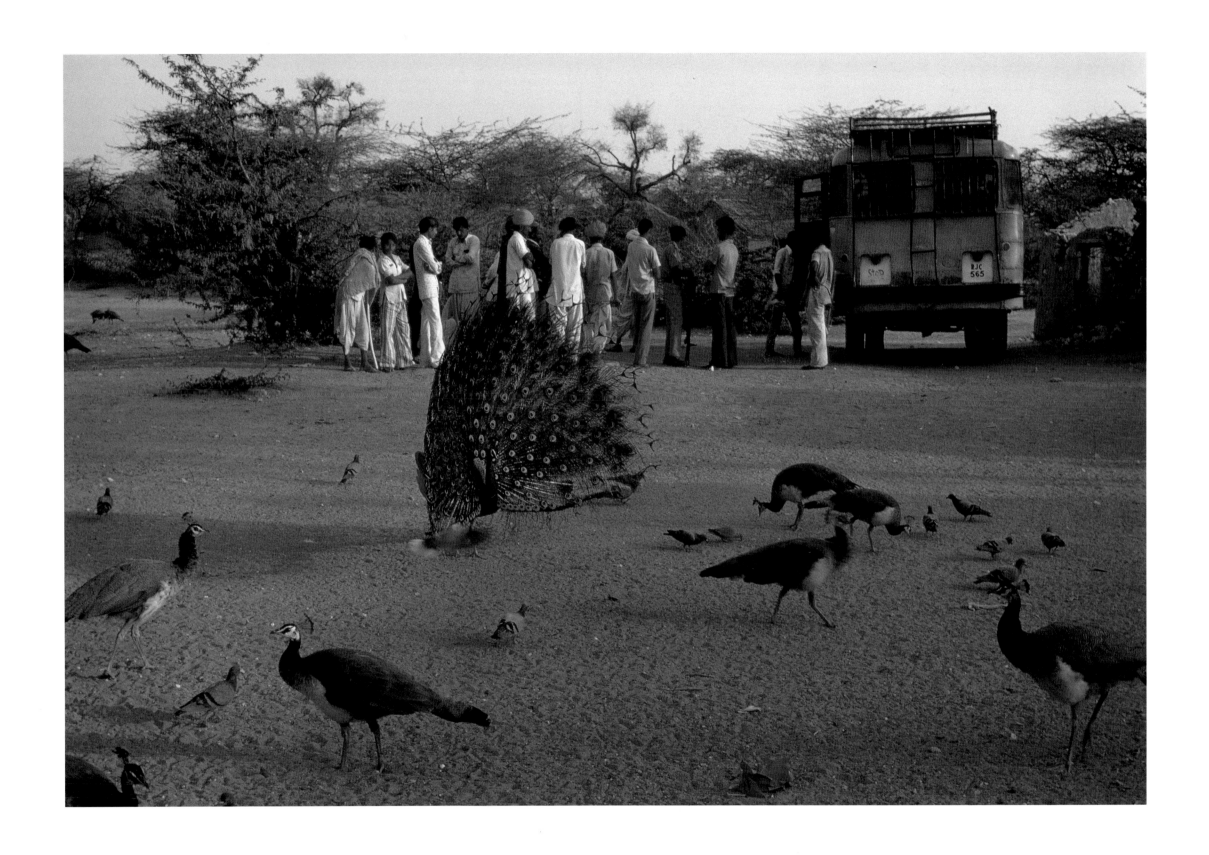

A village bus stop, Barmer, Rajasthan, 1974

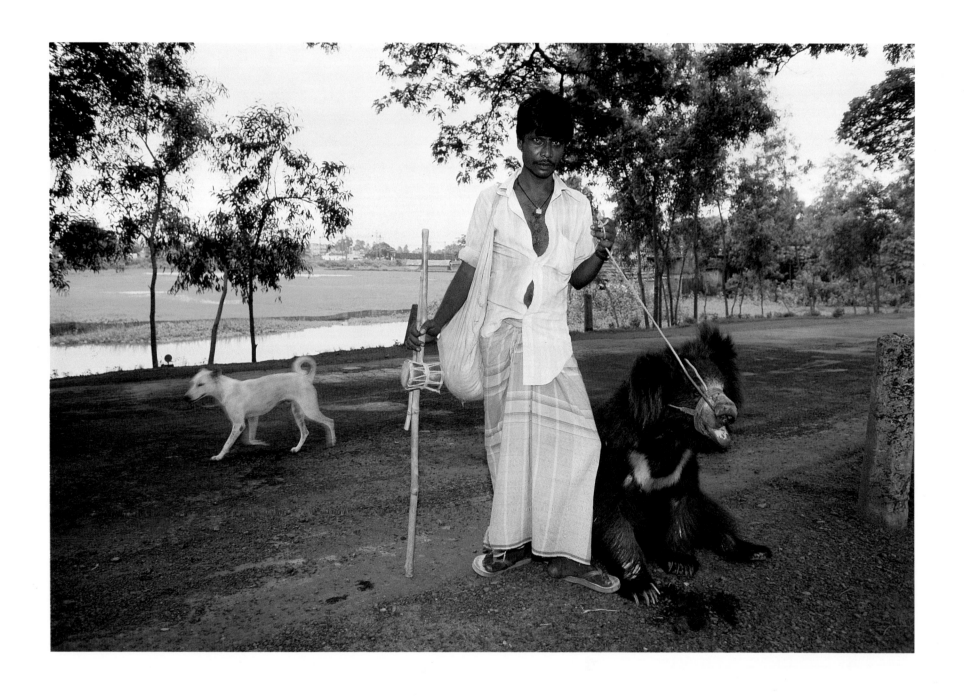

Performing bear and owner, Burdwan outskirts, West Bengal, 1991

Worshippers and temple elephant, Srirangam, Tamil Nadu, 1994

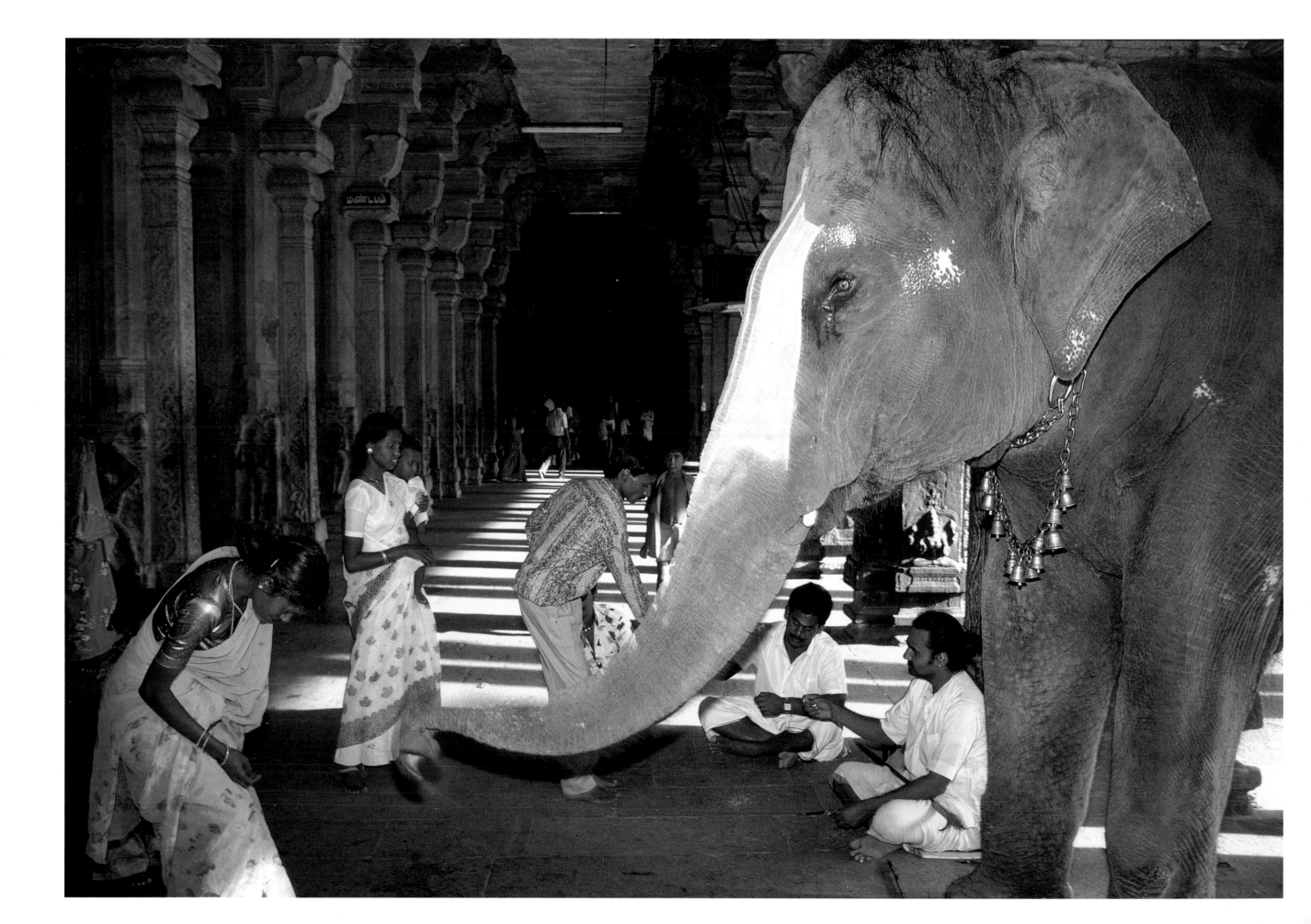

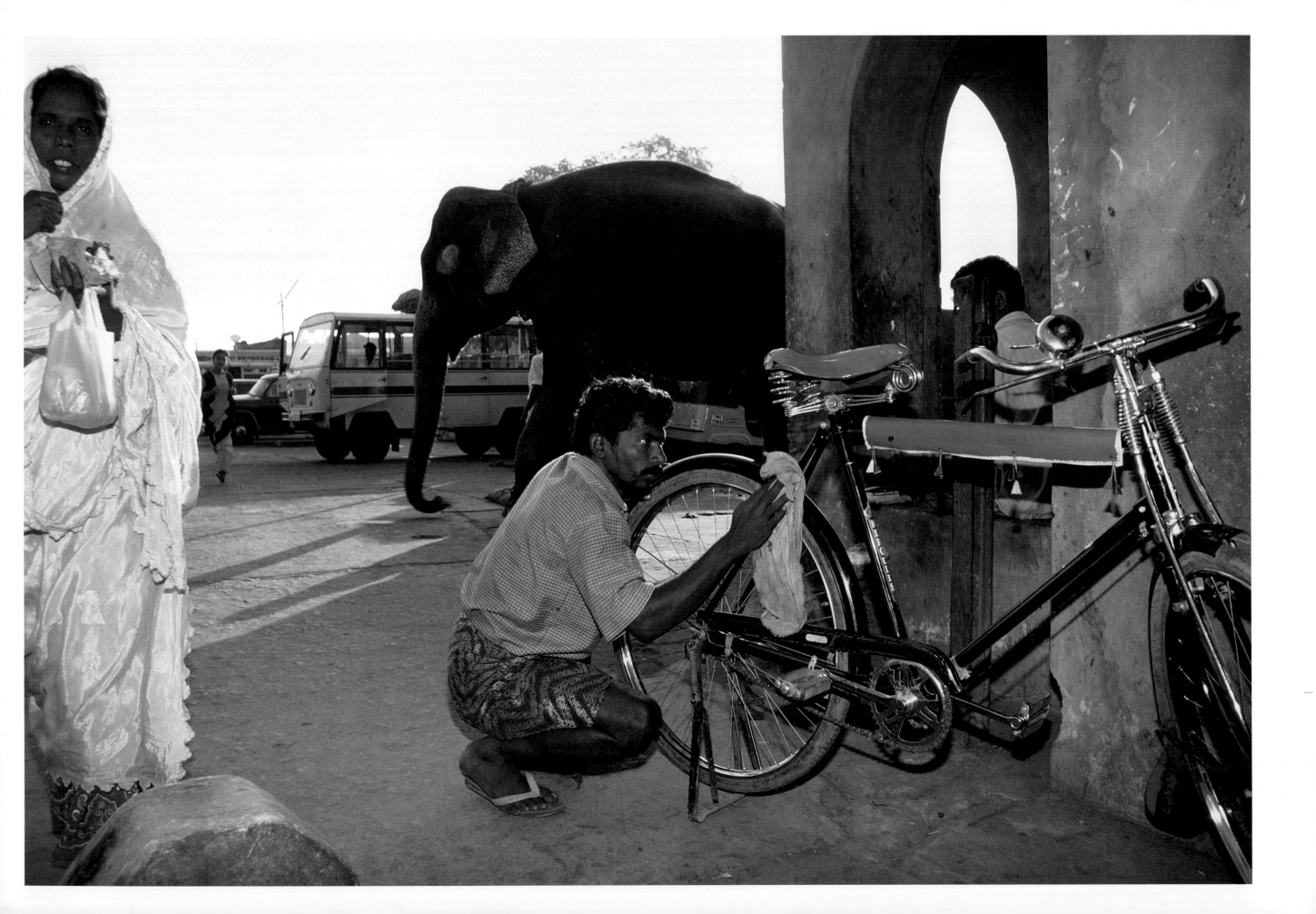

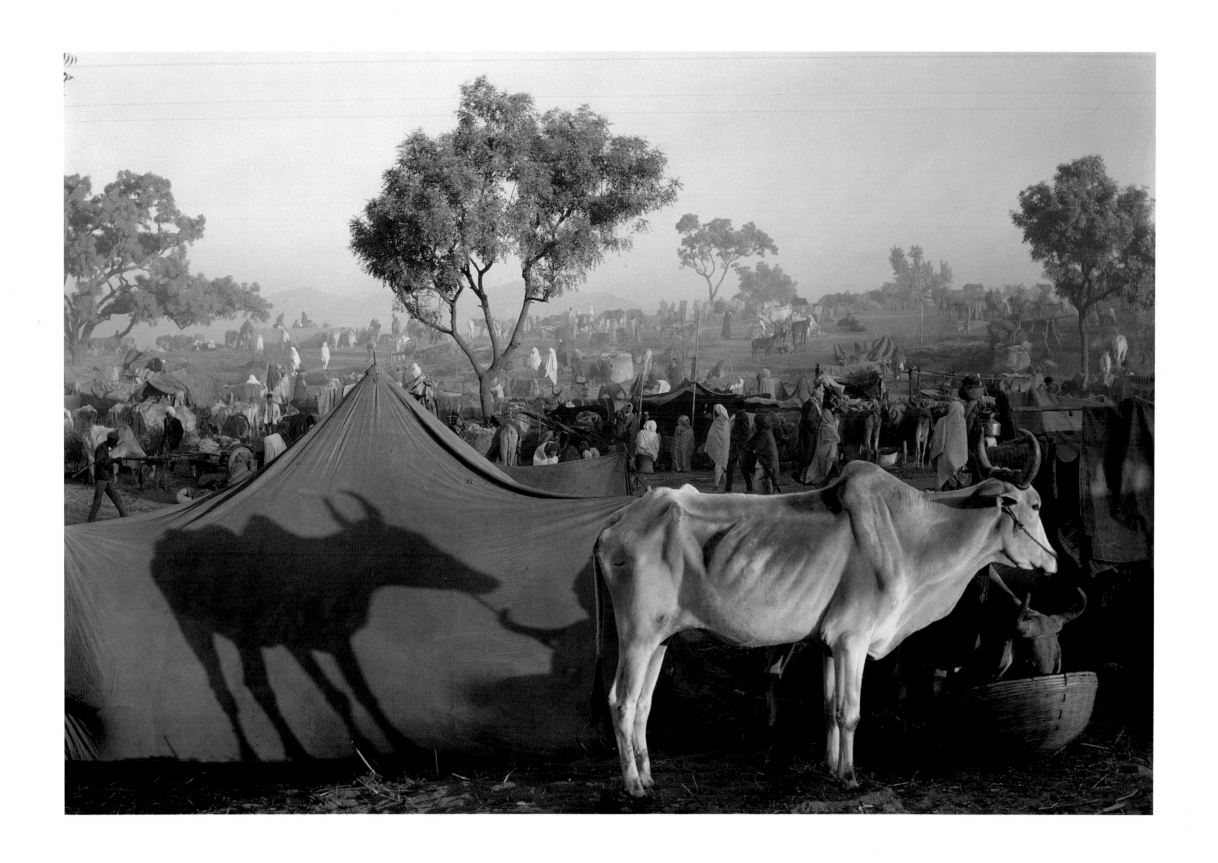

Cleaning a bicycle, Thanjavur, Tamil Nadu, 1994
Bullocks for sale, Pushkar Fair, Rajasthan, 1974

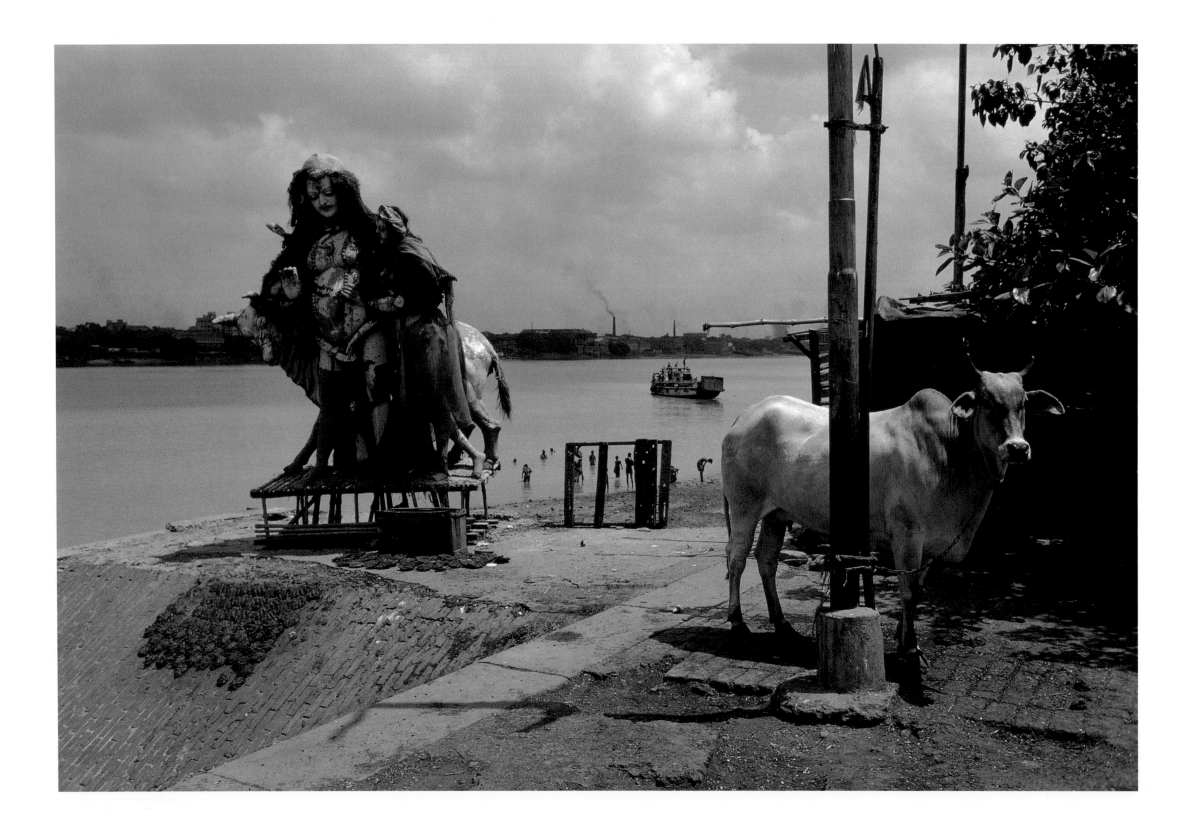

Siva and bull effigy, Calcutta, West Bengal, 1998

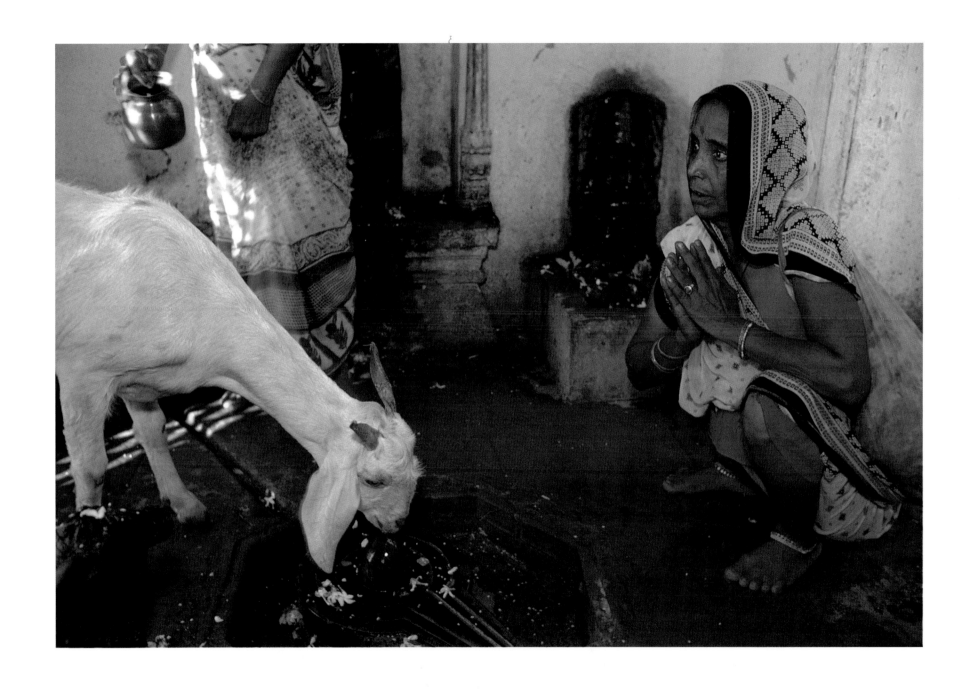

A devotee at a Siva shrine, Benares, Uttar Pradesh, 1984

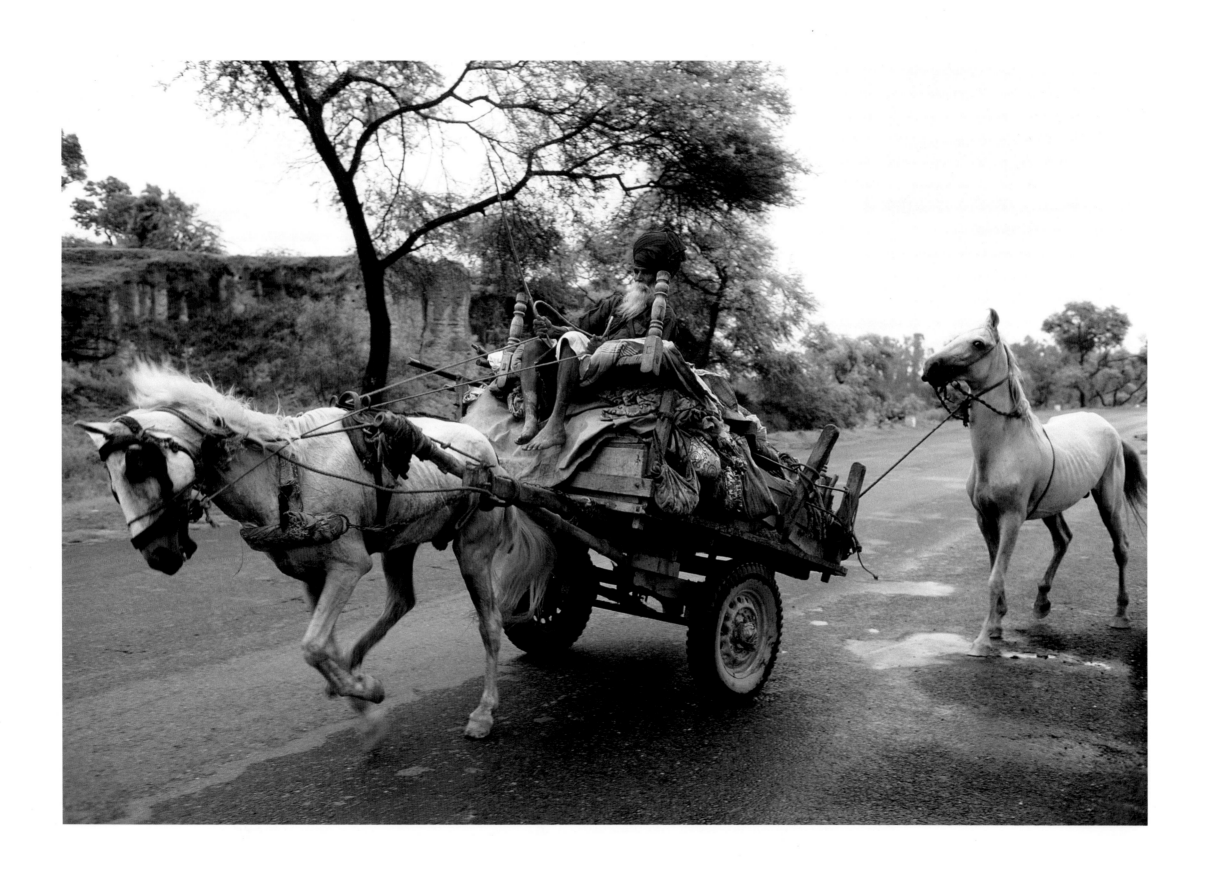

Nihang Sikh and baggage cart, Amritsar outskirts, Punjab, 1991

A bridegroom, Jaisalmer, Rajasthan, 1974

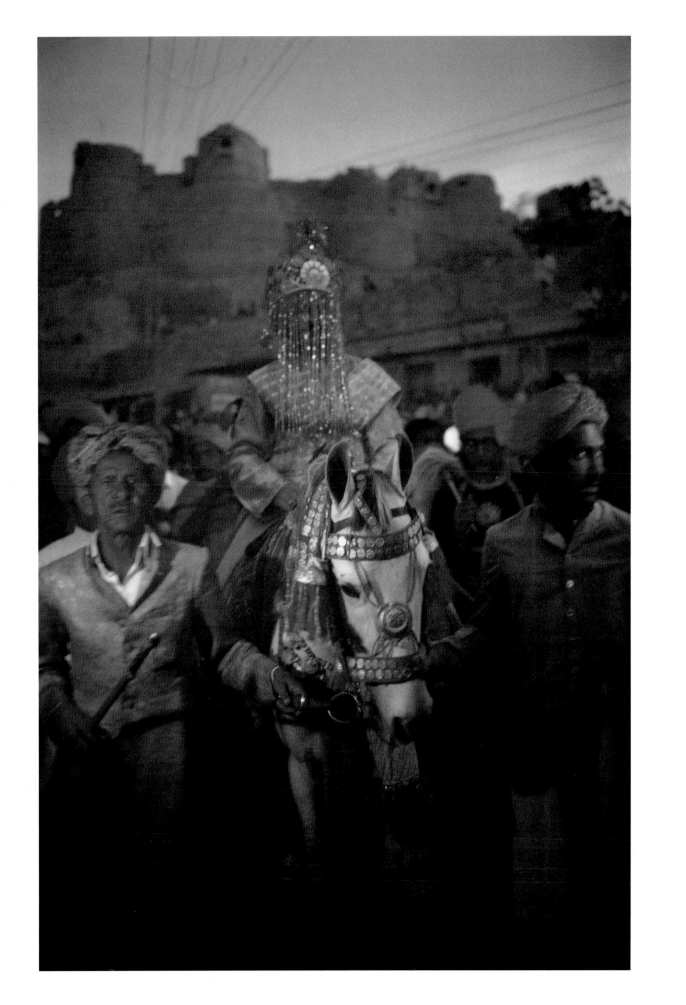

I looked at their faces and their figures and watched their movements. There was many a sensitive face and many a sturdy body, straight and clean-limbed; and AMONG THE WOMEN there was grace and suppleness and dignity and poise...

The Discovery of India by Pandit Jawaharlal Nehru

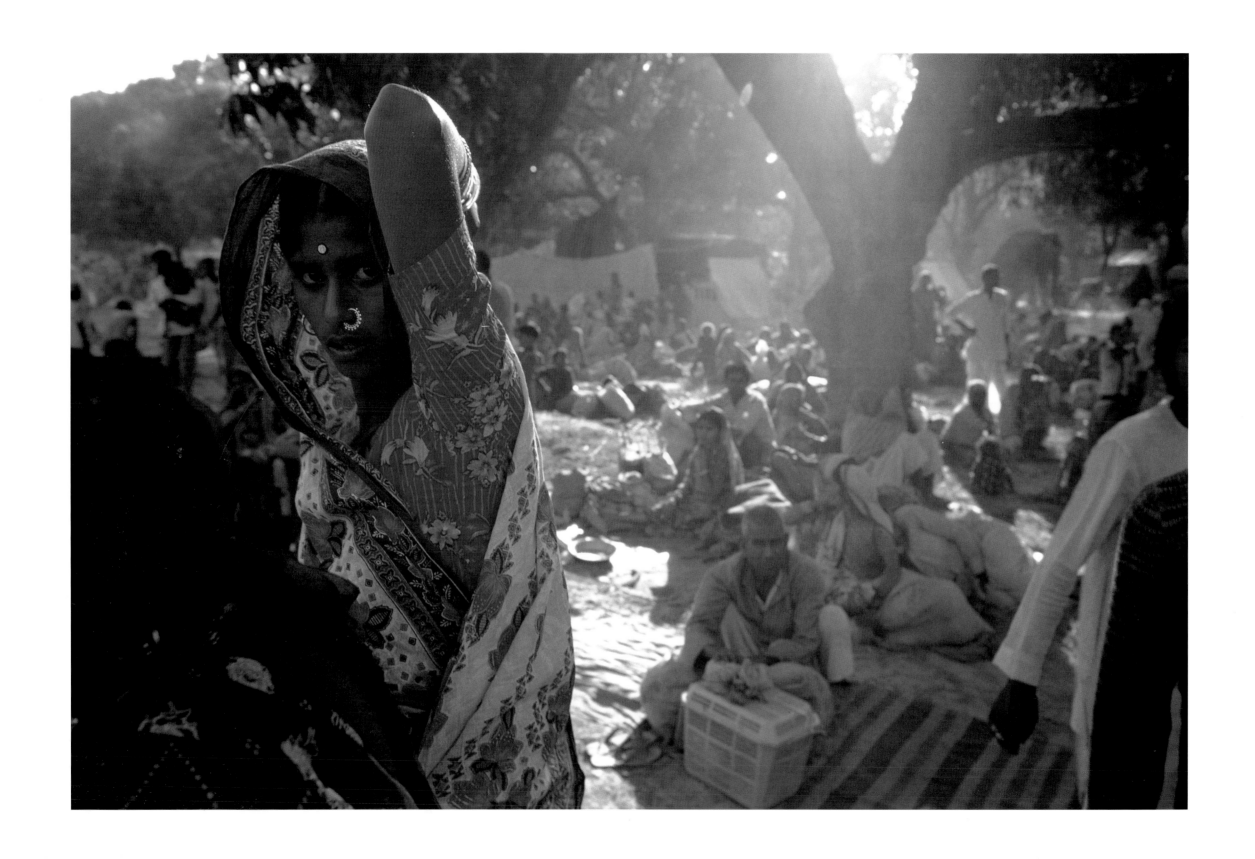

Pilgrims, Sonepur Fair, Bihar, 1989

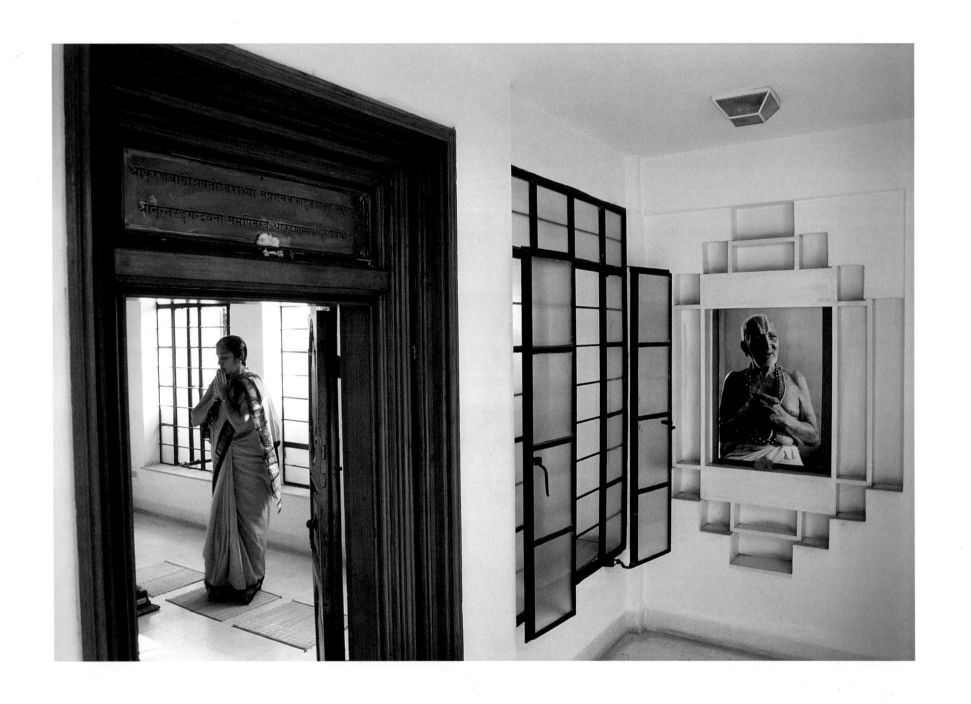

Devotee, Chennai, Tamil Nadu, 1994

Employees in a household, Calcutta, West Bengal, 1986

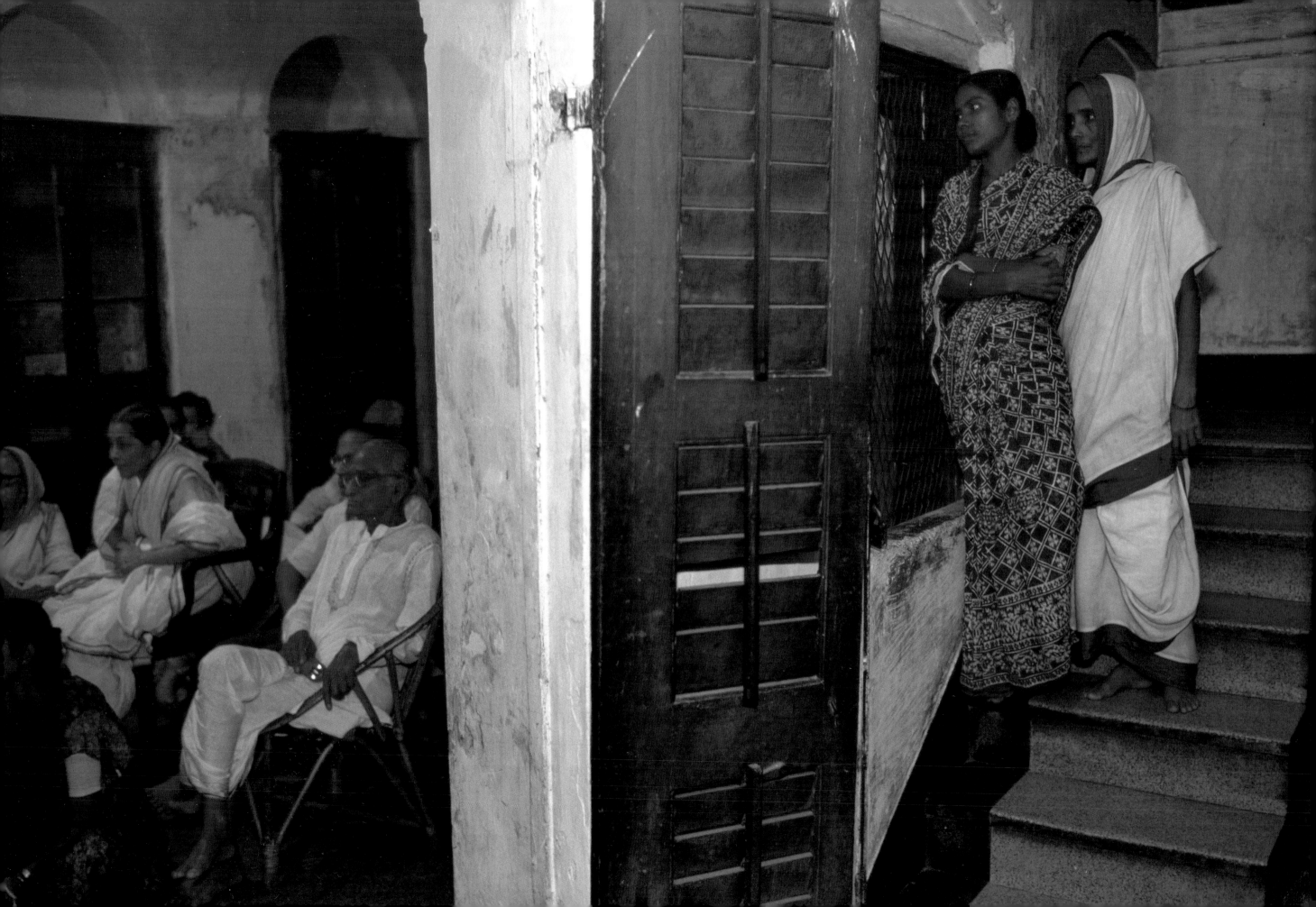

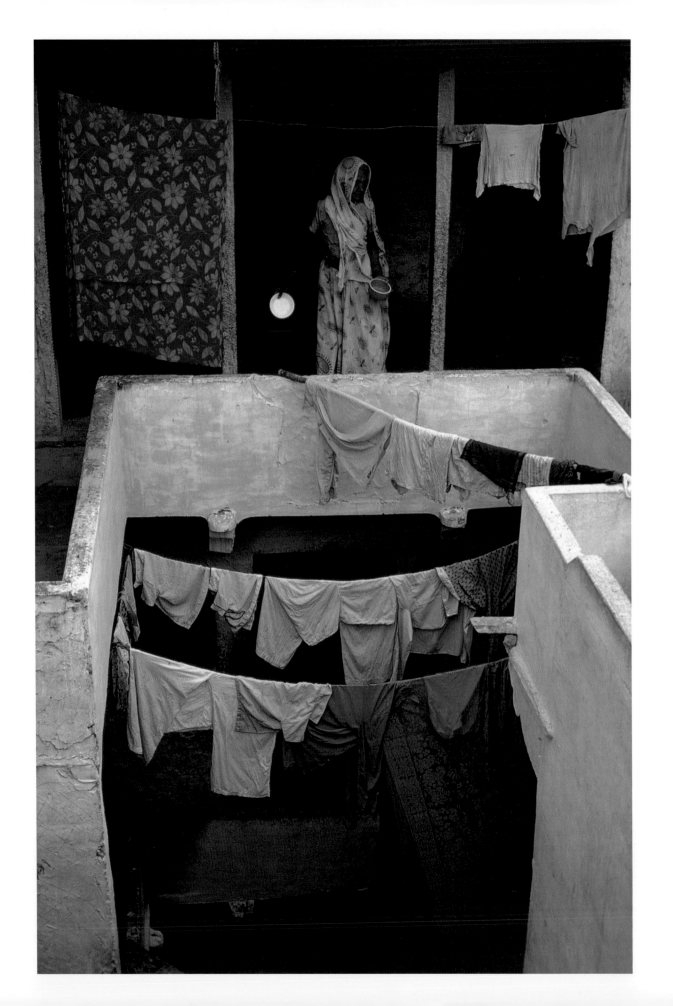

Housewife, Jaipur, Rajasthan, 1974

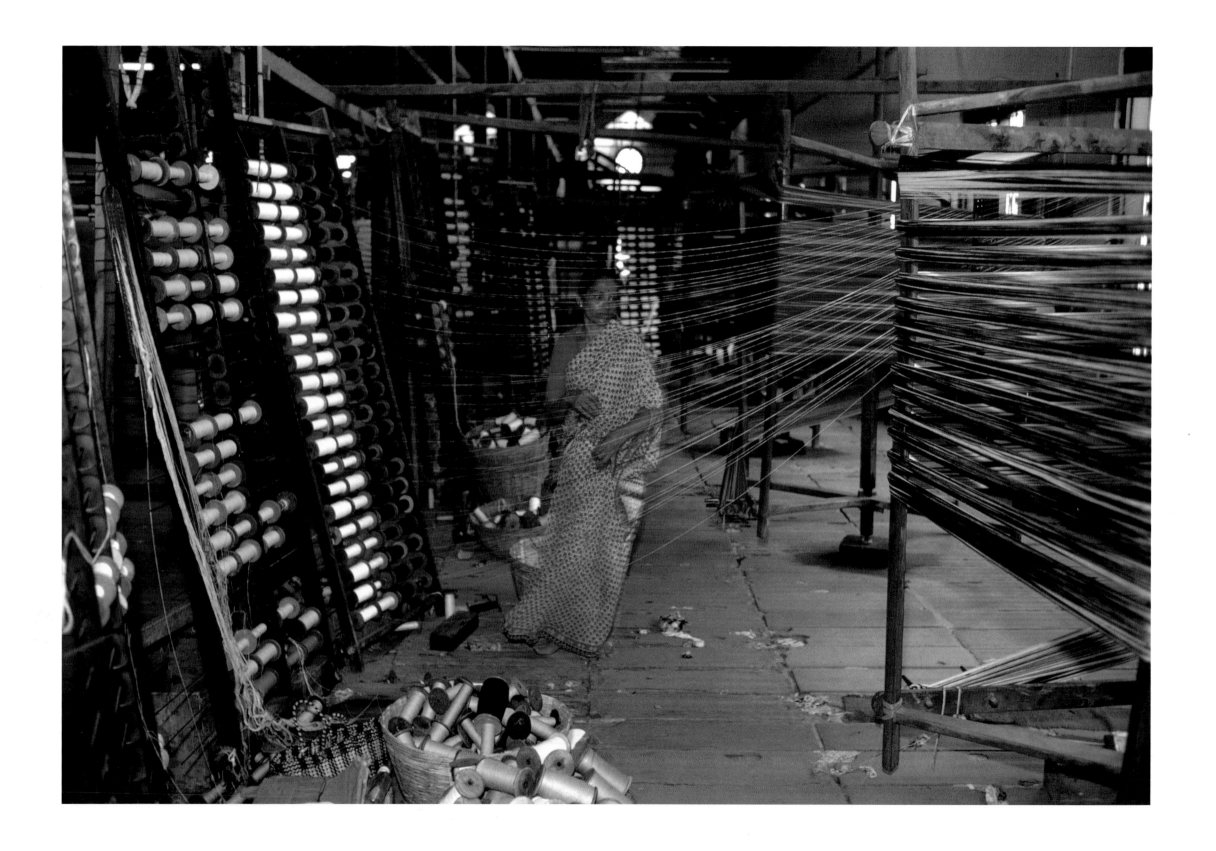

Worker, textile factory, Kozhikode, Kerala, 1983

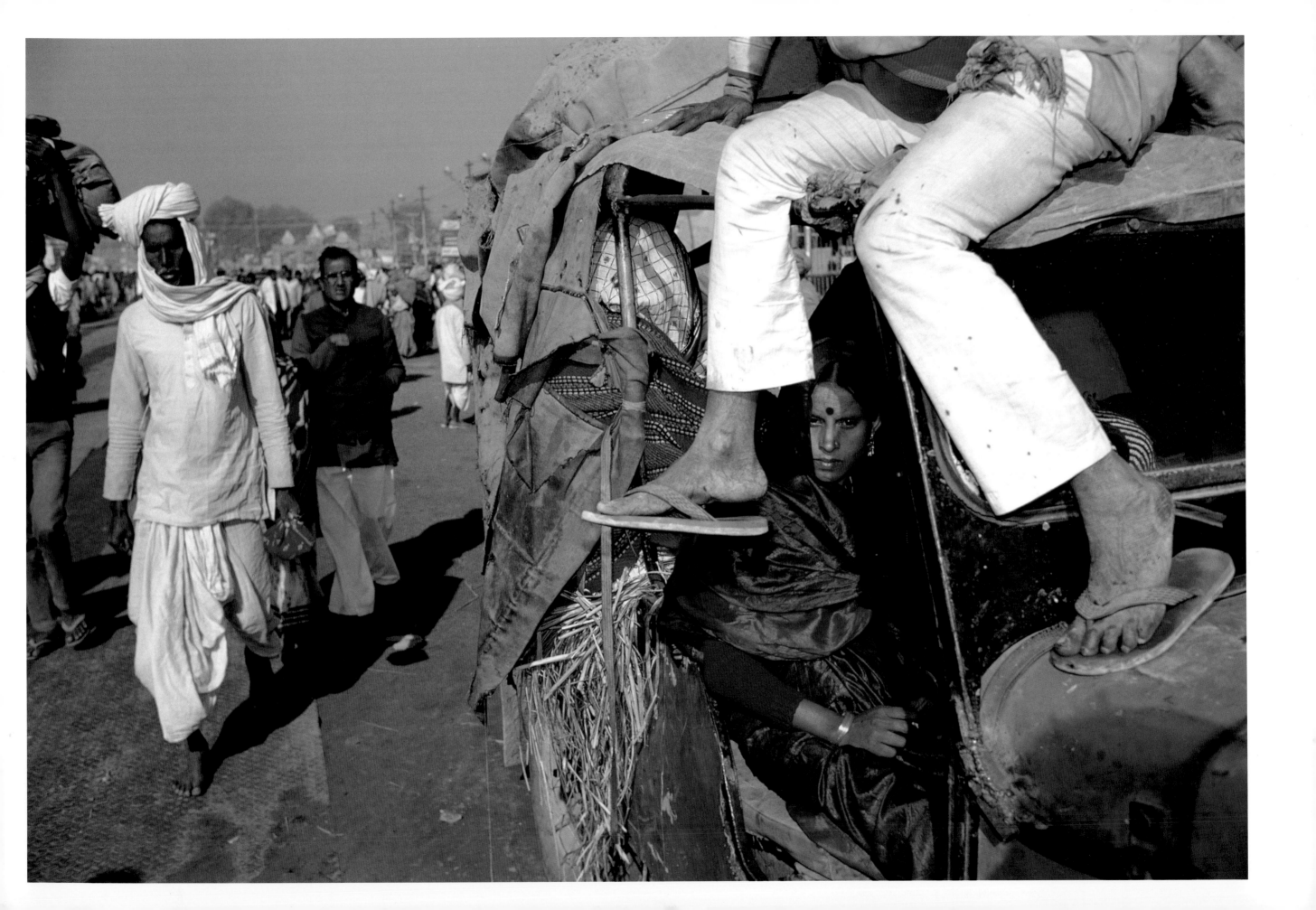

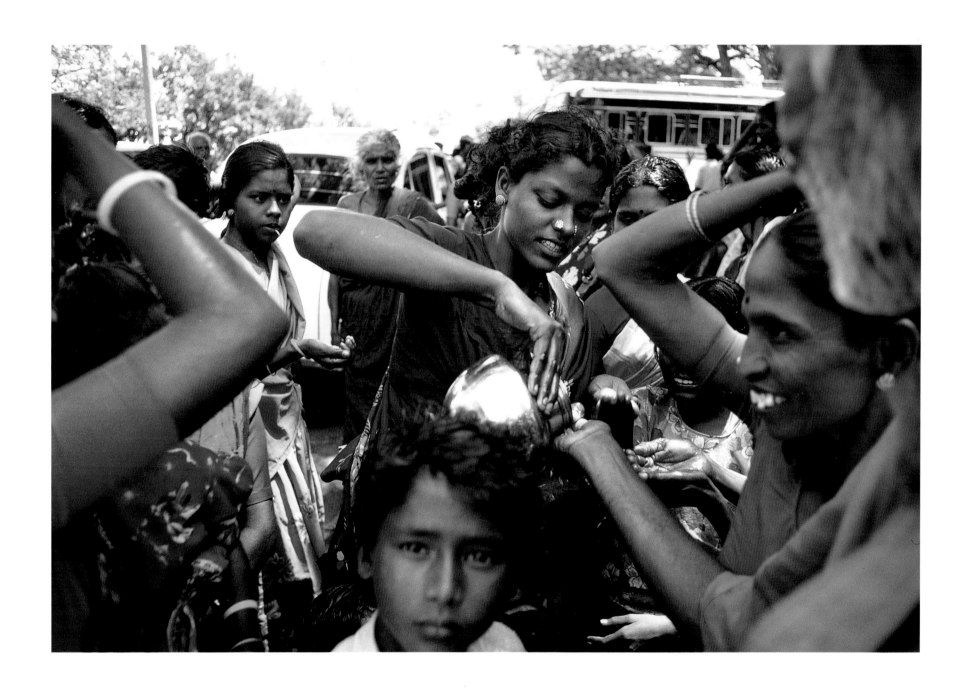

Pilgrims, Kumbh Mela, Prayag, Uttar Pradesh, 1989

Pilgrims distribute holy water, Kuttalam, Tamil Nadu, 1994

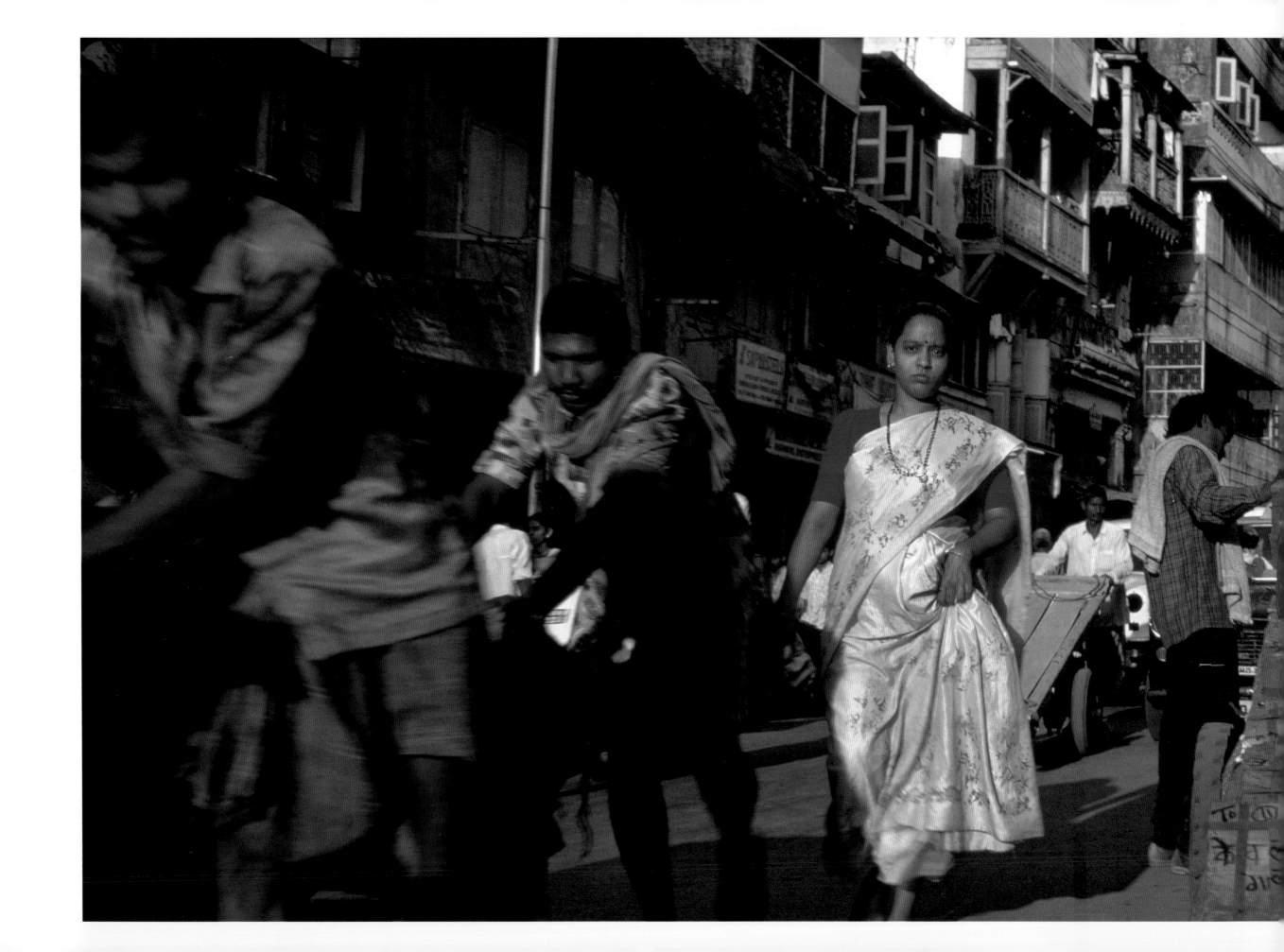

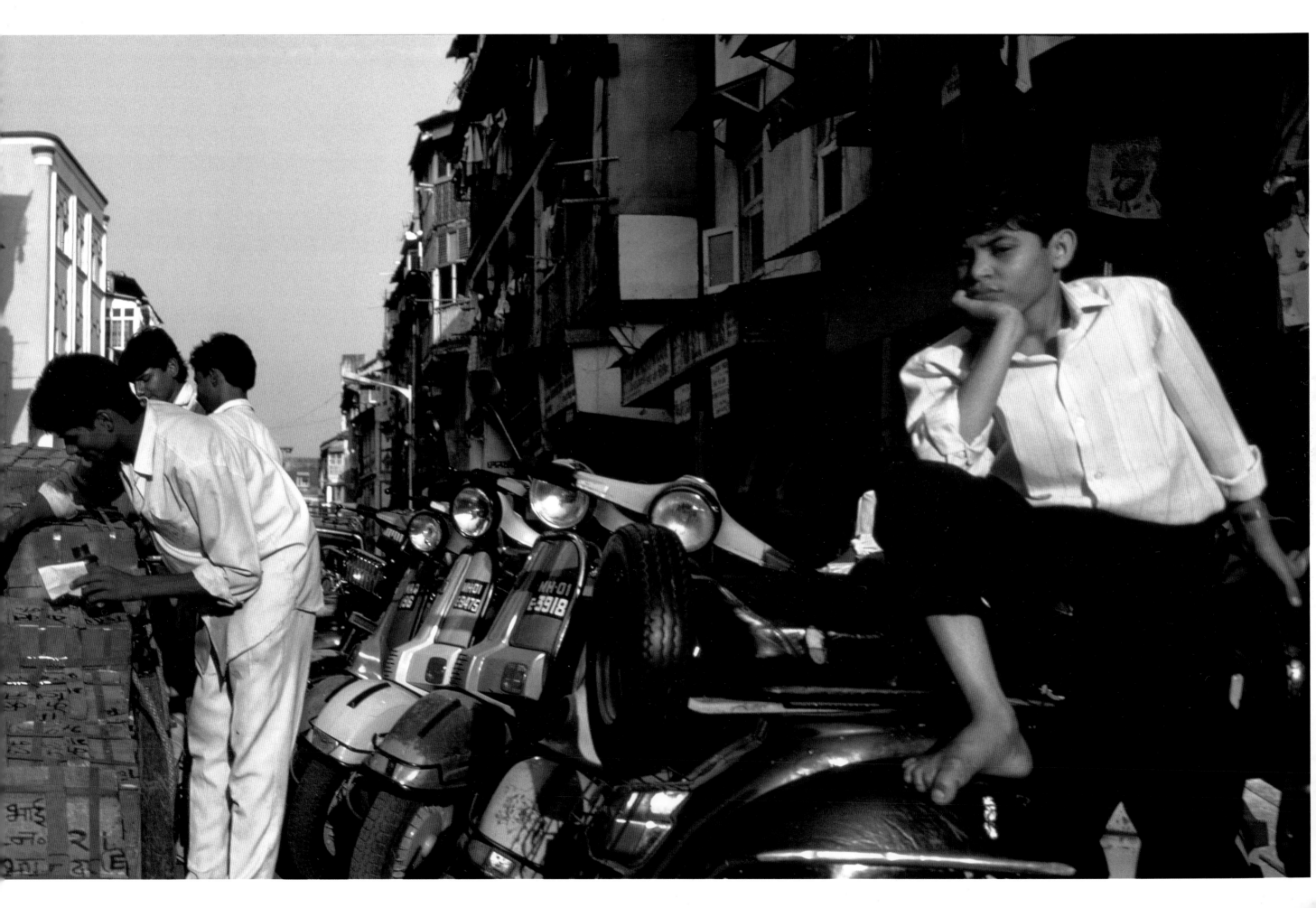

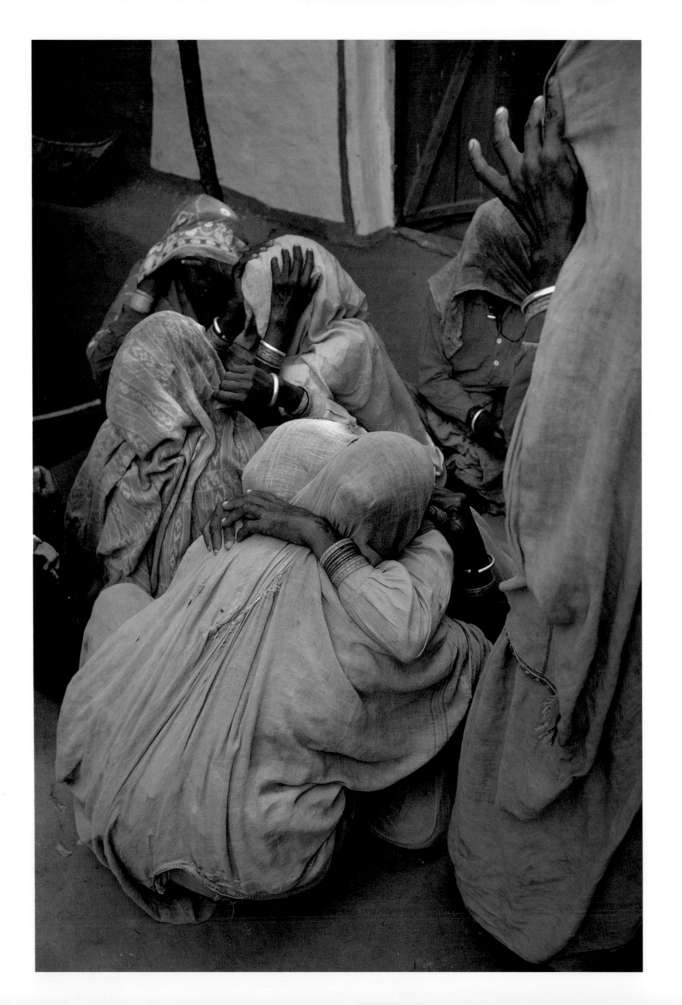

102 Housewife, Tambha Khata, Mumbai, Maharashtra, 1992
 A mourning, Bharatpur, Rajasthan, 1975

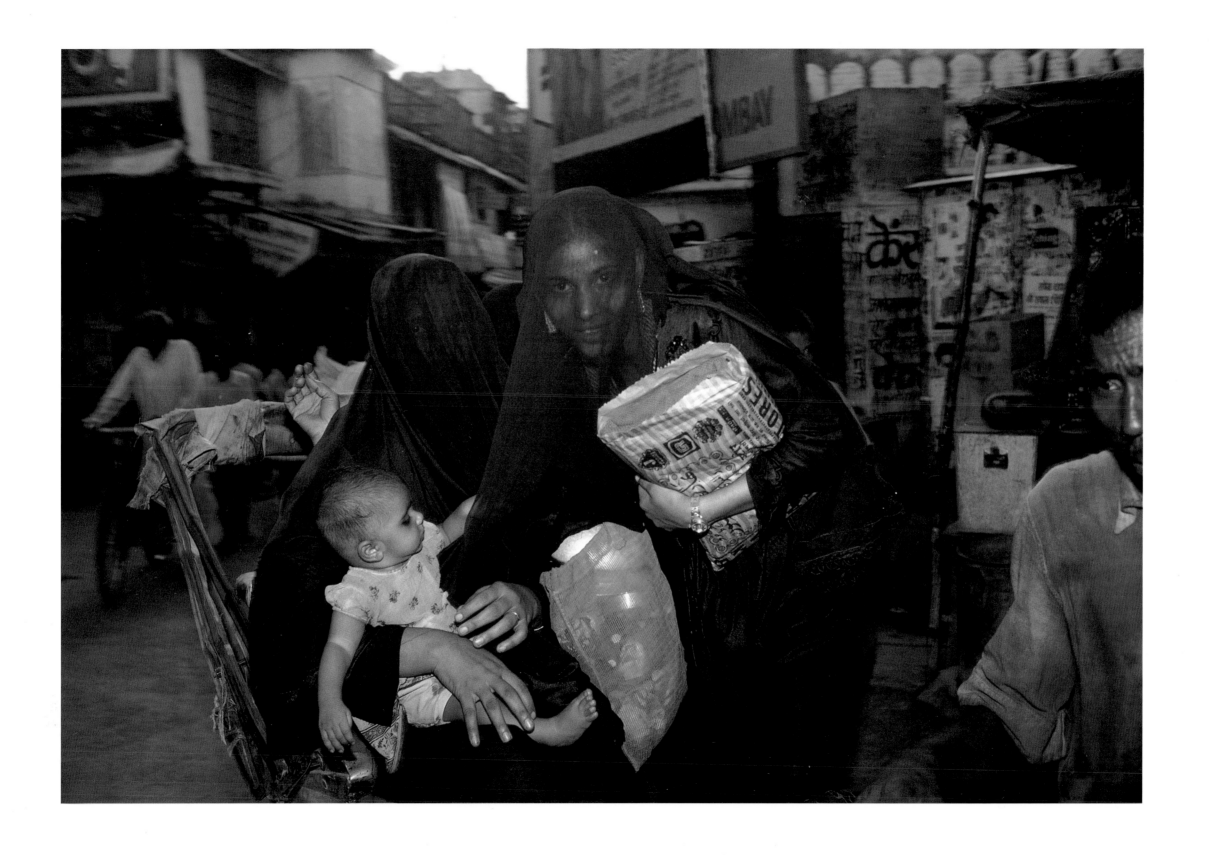

Women and rickshaw driver, Benares, Uttar Pradesh, 1984

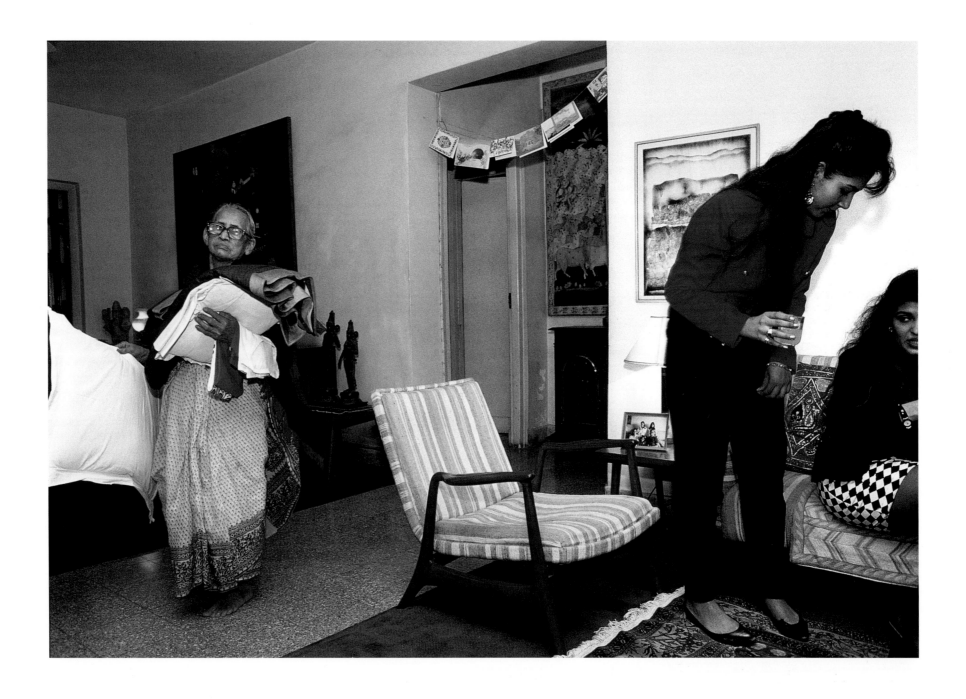

Employee in a household, Mumbai, Maharashtra, 1992

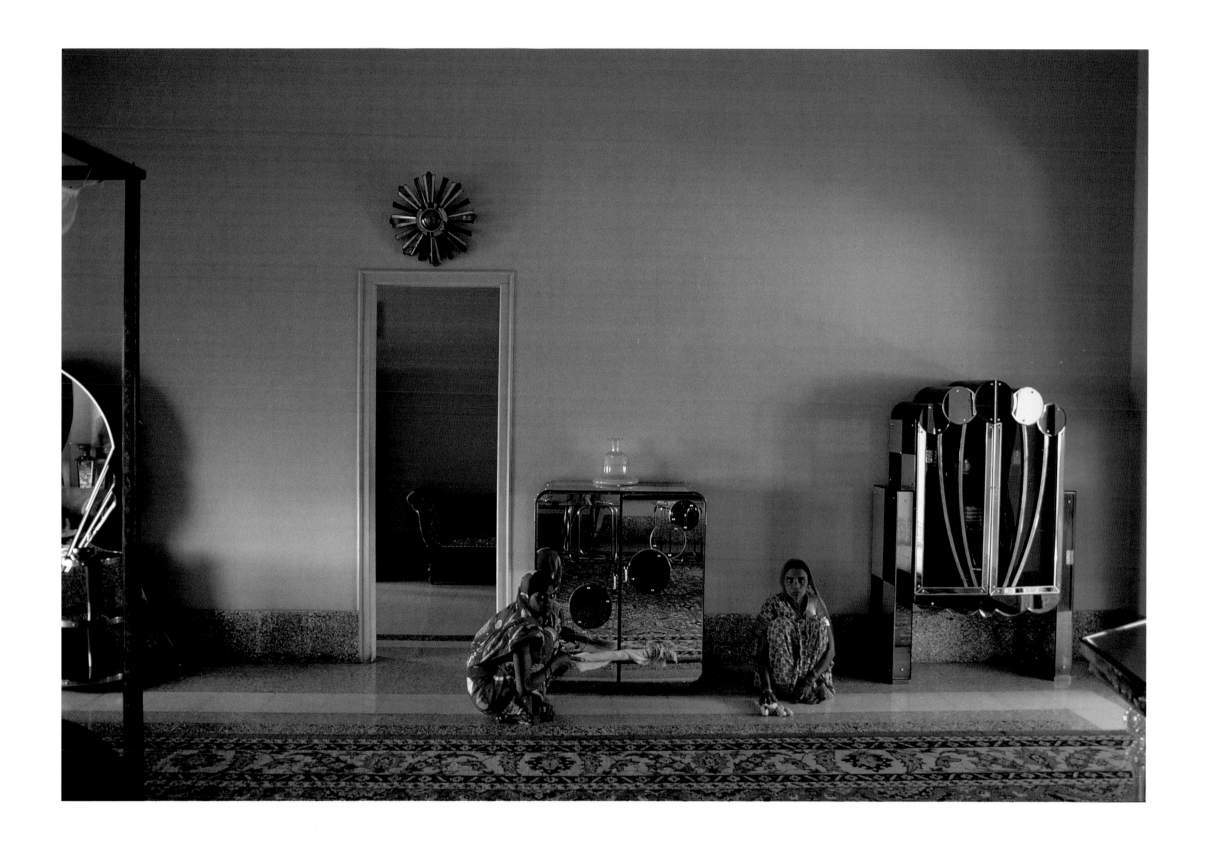

Employees, Morvi Palace, Gujarat, 1982

Women gossip, Chennai, Tamil Nadu, 1995

A wedding party, Jodhpur-Jaisalmer road, Rajasthan, 1988

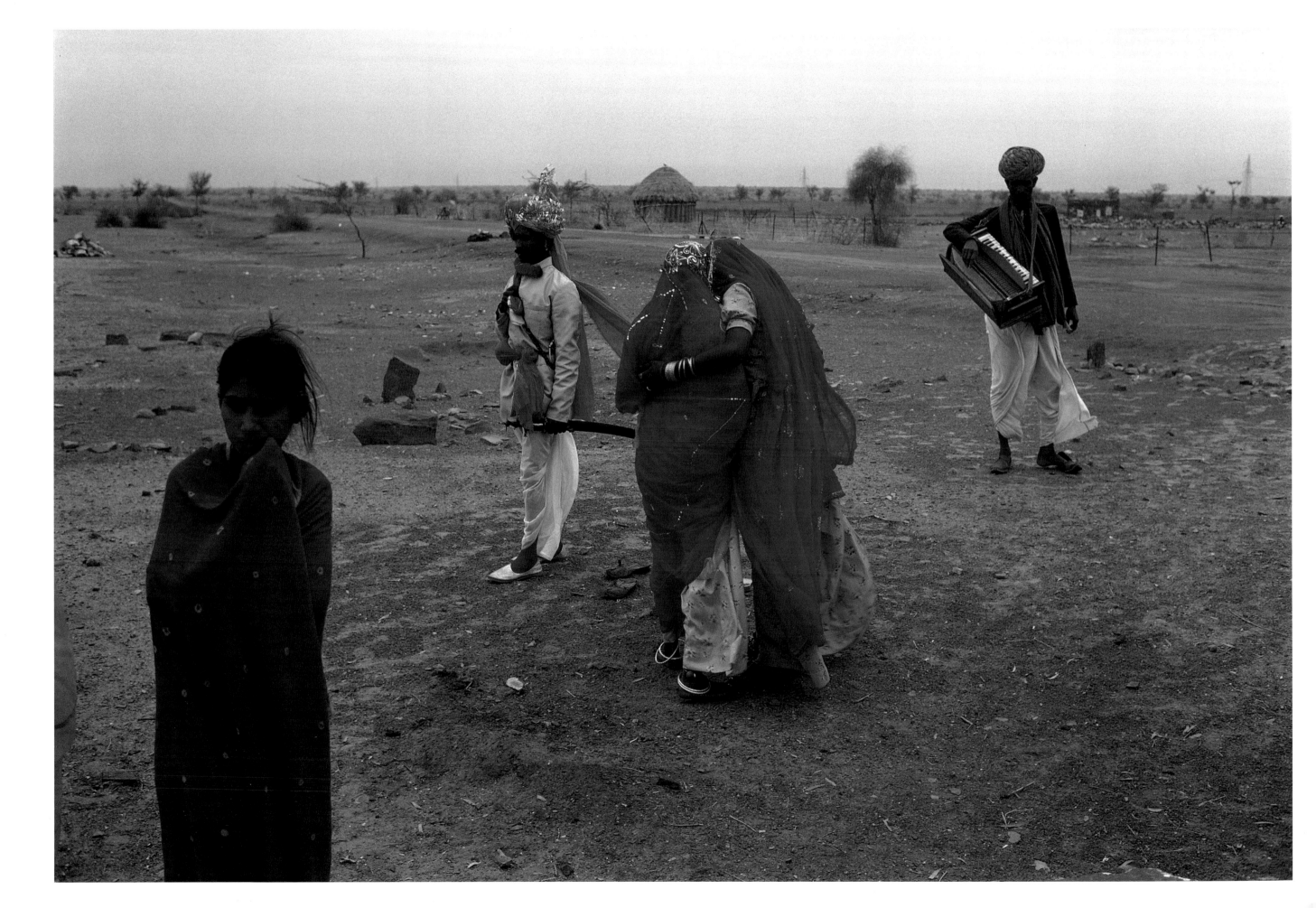

For a nation of…millions to make any kind of sense, it must base itself firmly on the concept of multiplicity, of plurality and tolerance, of devolution and decentralization wherever possible. There can be no one way – religious, cultural, or linguistic – of being an Indian; LET DIFFERENCE REIGN .

Imaginary Homelands by Salman Rushdie

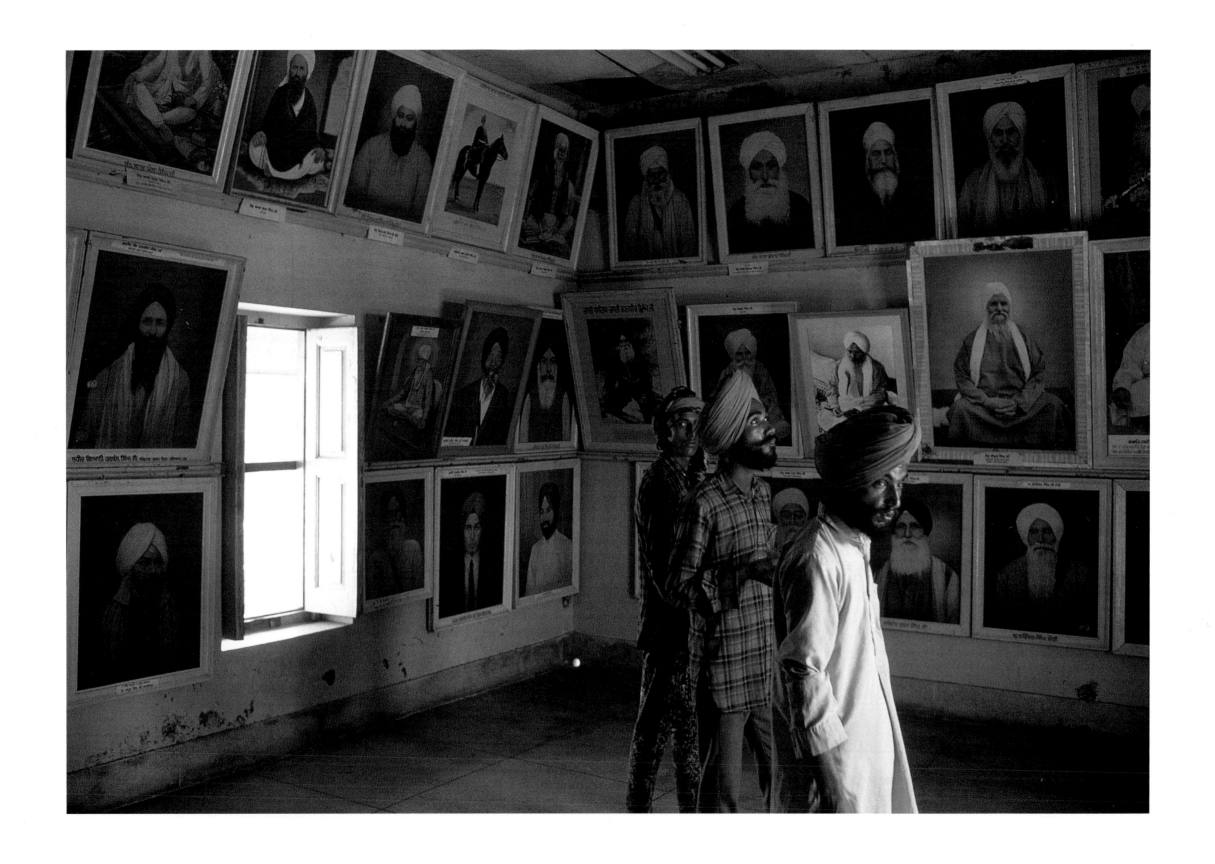

Visitors to the museum, Golden Temple, Amritsar, Punjab, 1987

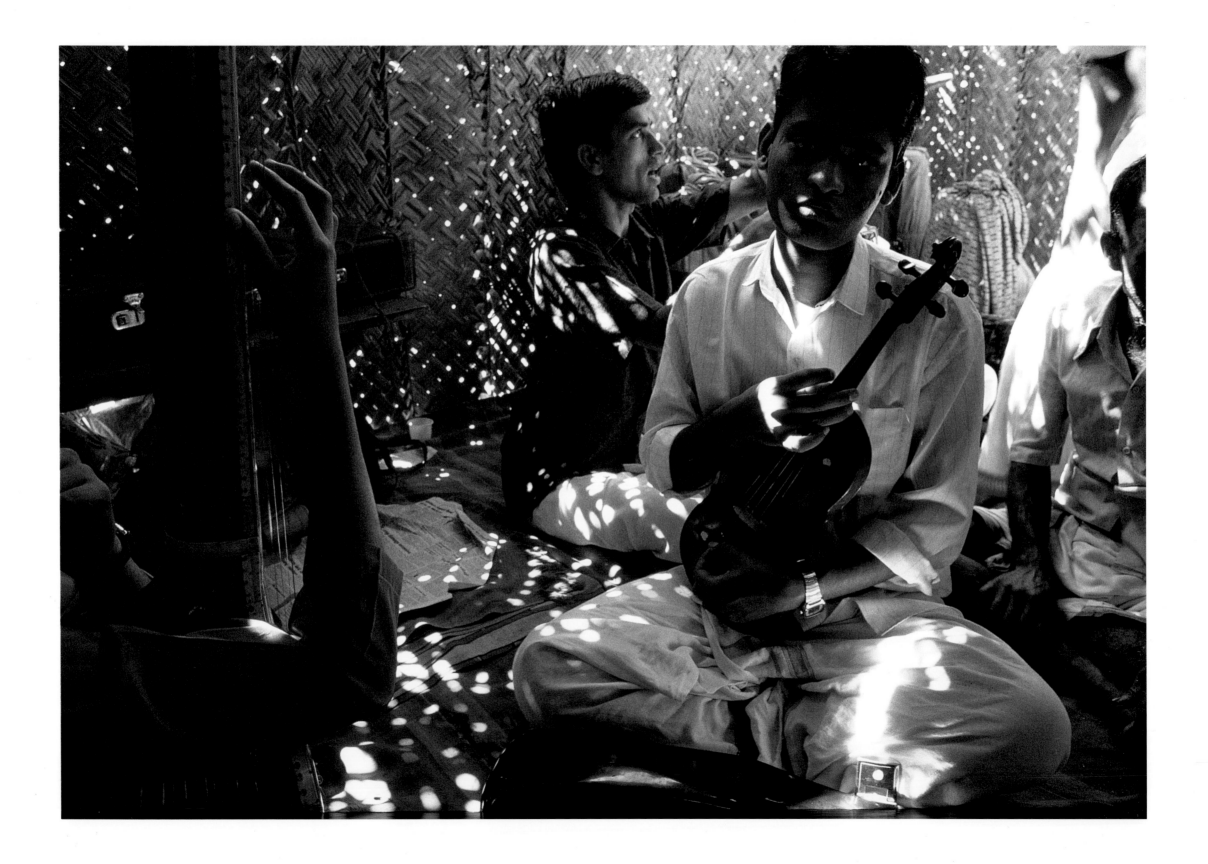

A musician, Thyagaraj Festival, Thiruvaiyaru, Tamil Nadu, 1994
Dhabawallah, or professional lunch distributor, Mumbai, Maharashtra, 1992

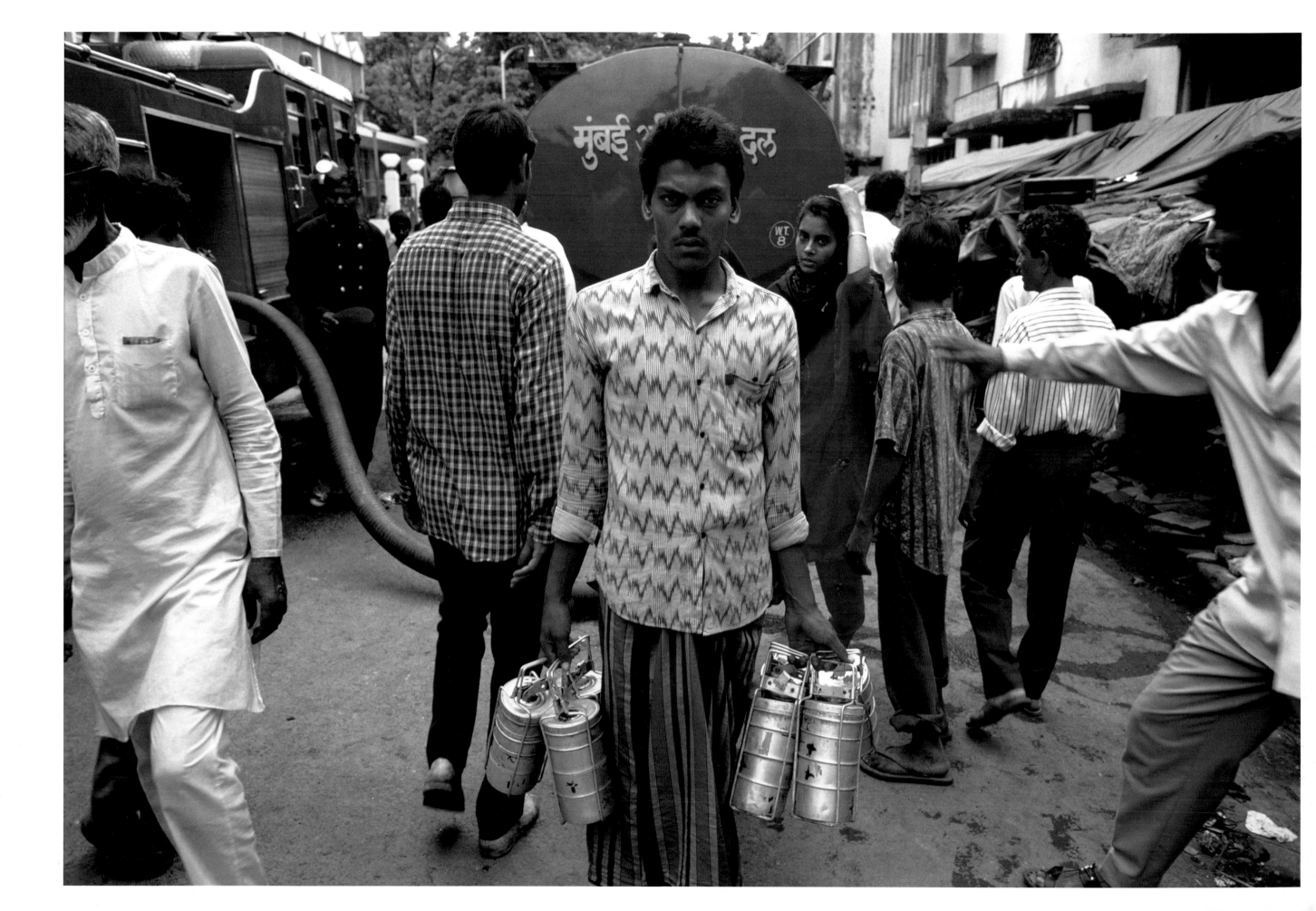

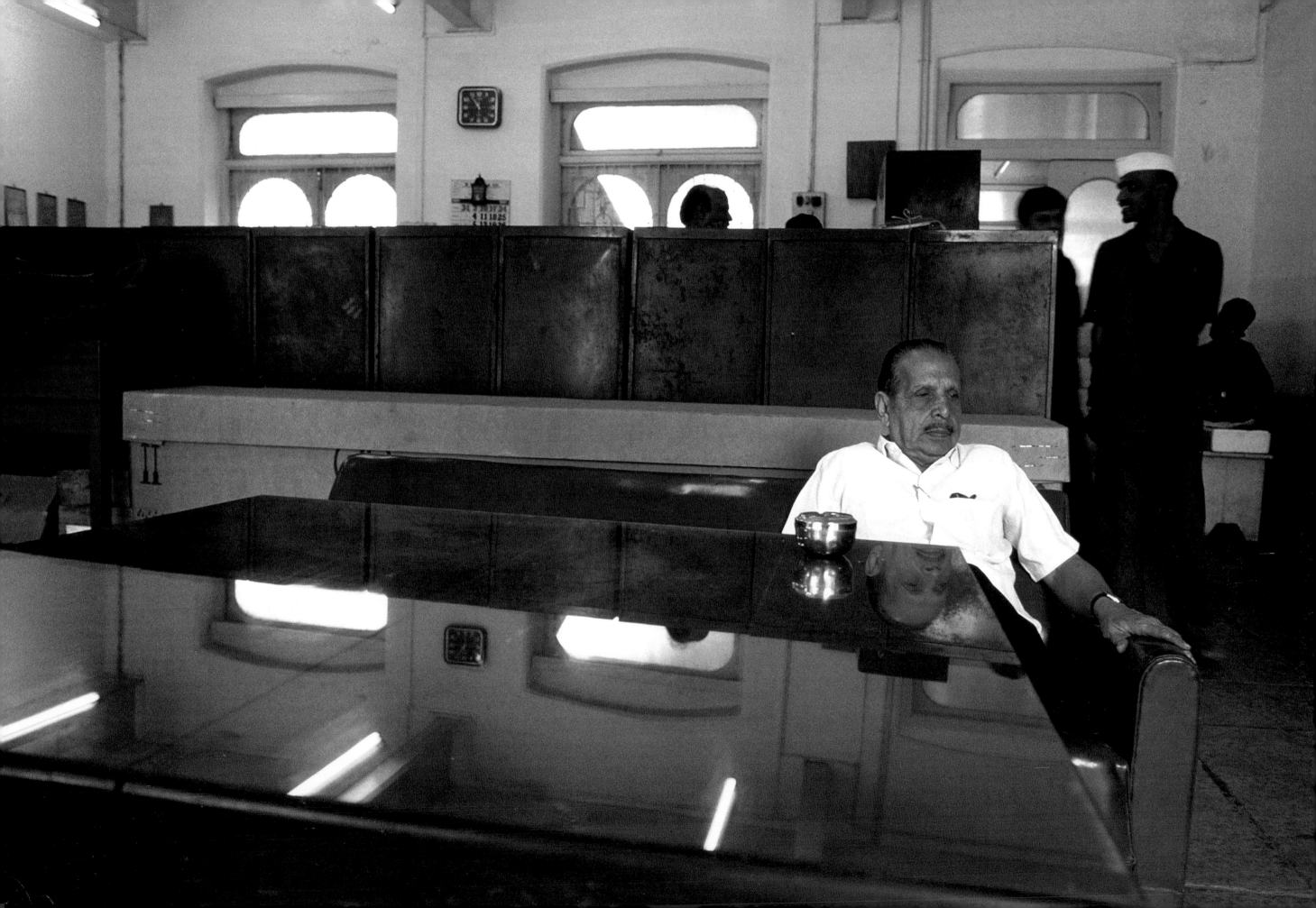

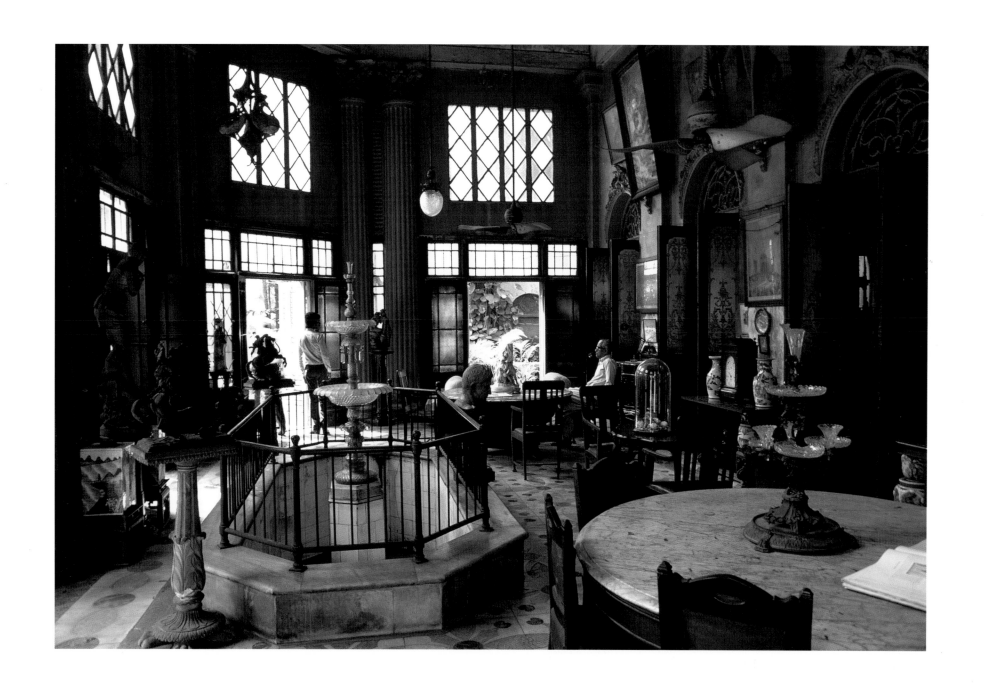

Visitor, Bombay Dyeing Office, Mumbai, Maharashtra, 1989
Dr Mihir Mitra at home, Jhamapukur, Calcutta, West Bengal, 1986

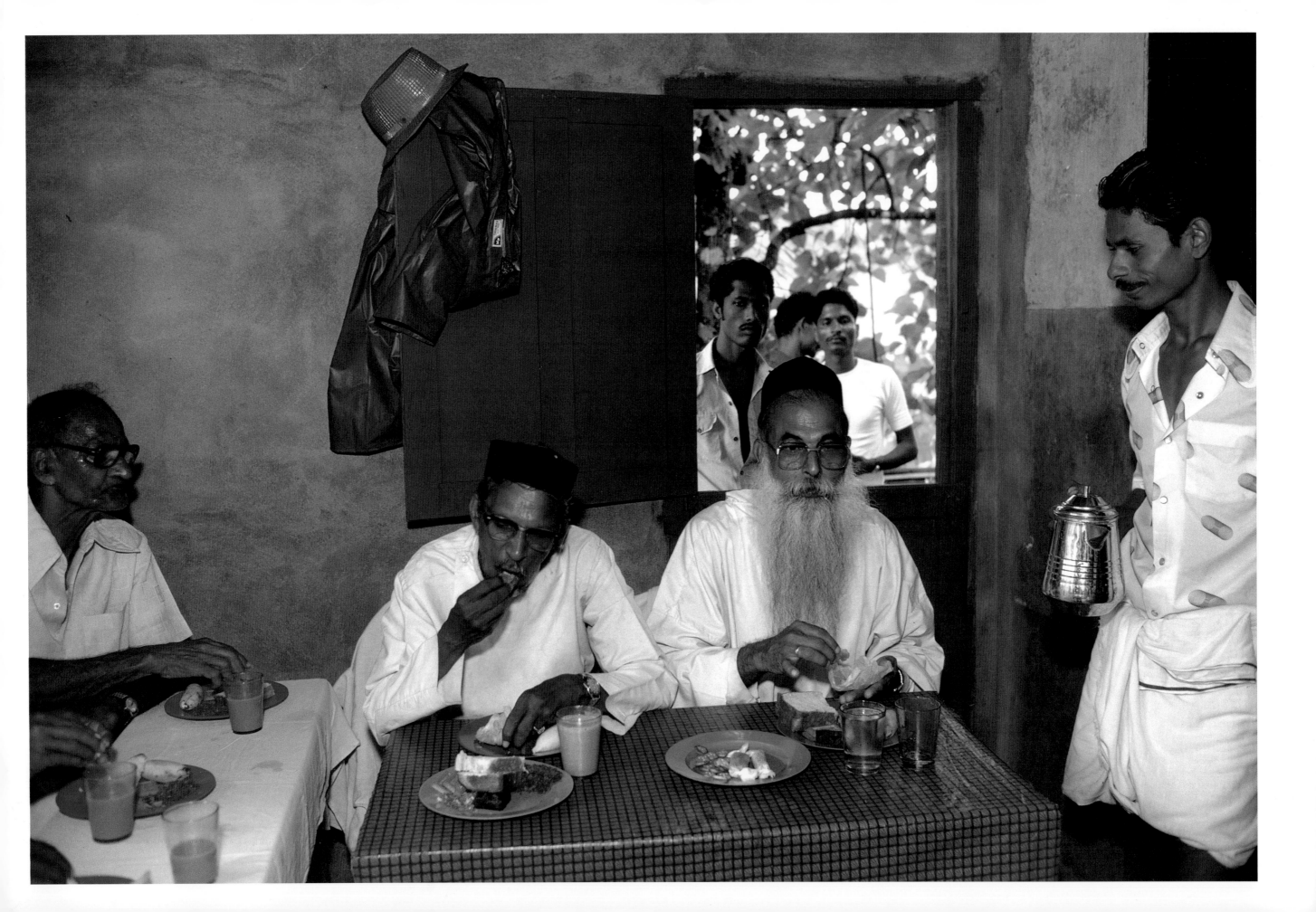

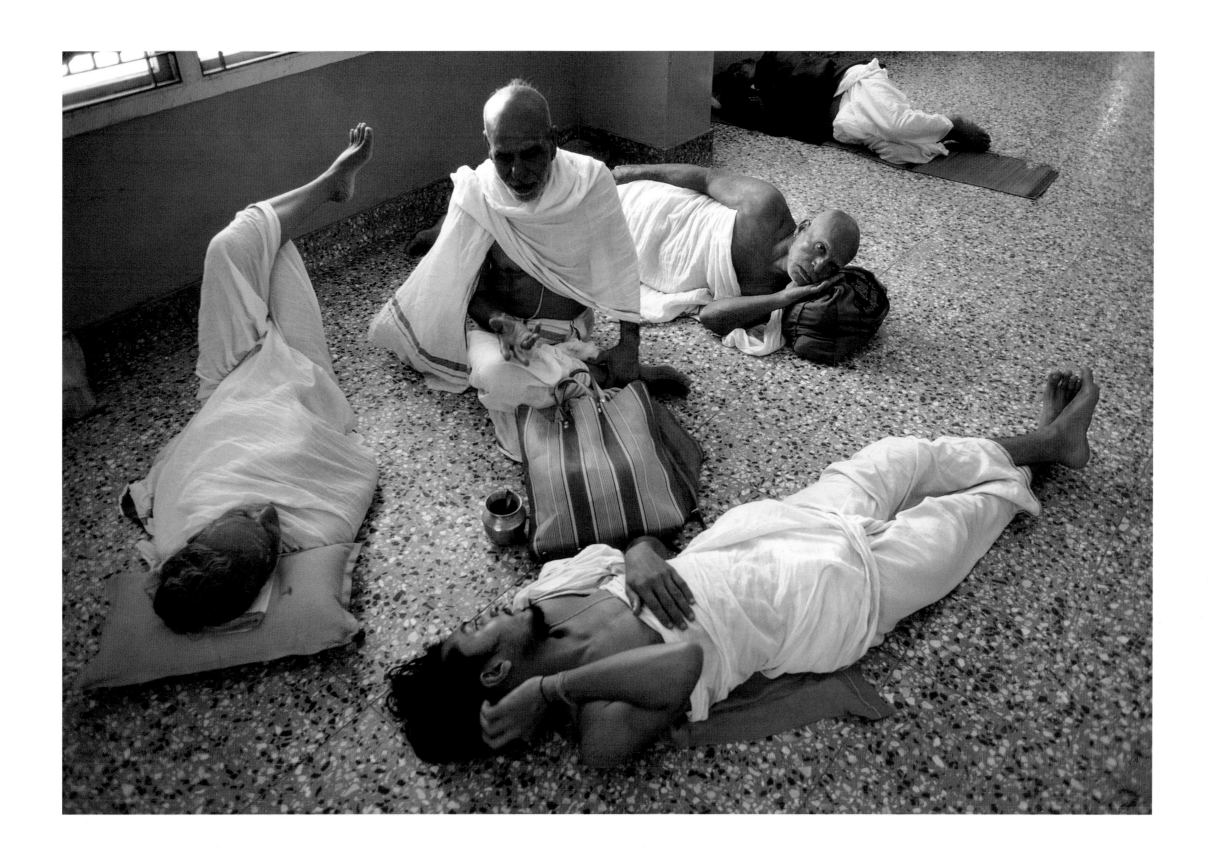

Syrian Christian priests, Kottayam, Kerala, 1984

Brahmins at a yoga conference, Chennai, Tamil Nadu, 1993

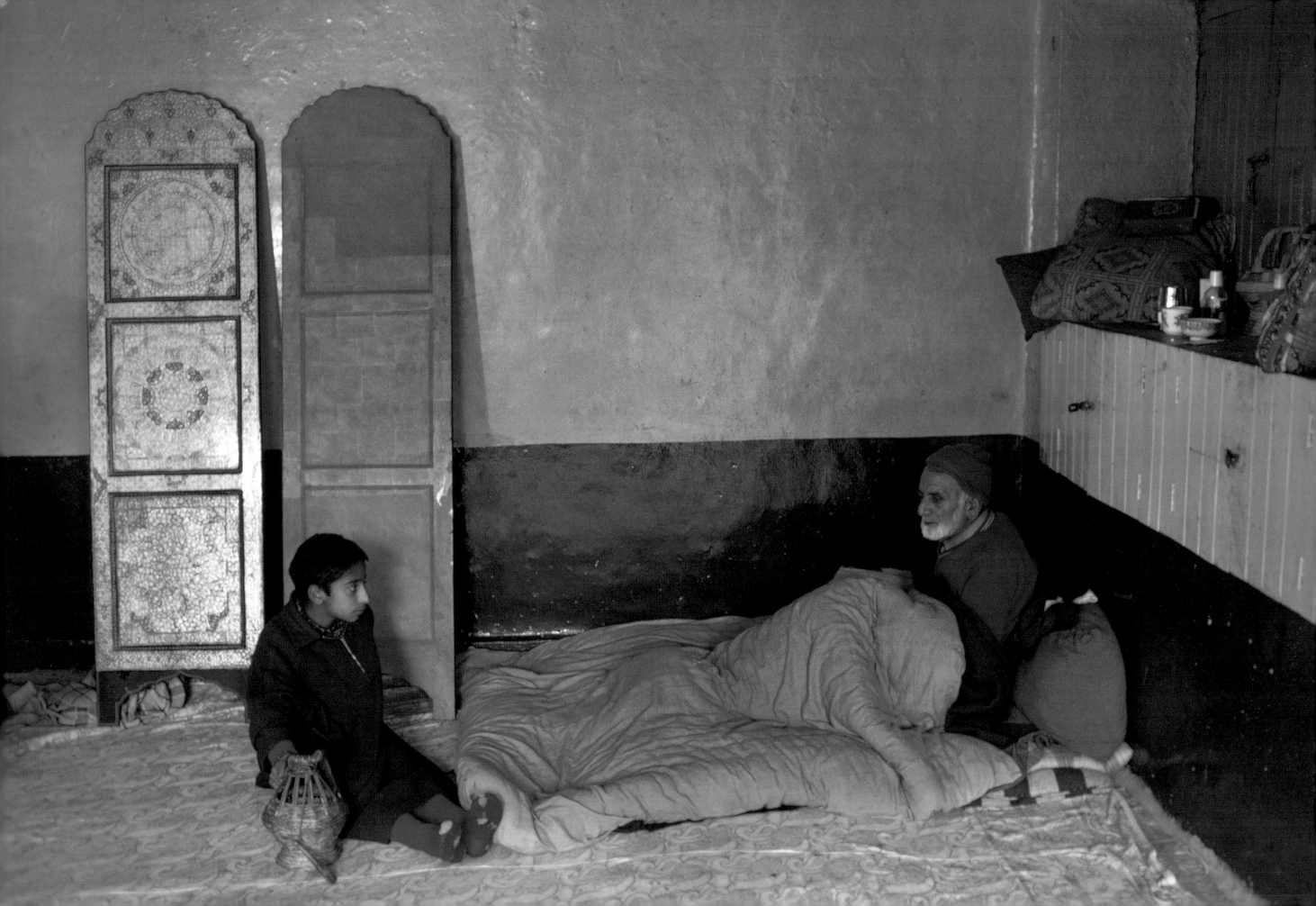

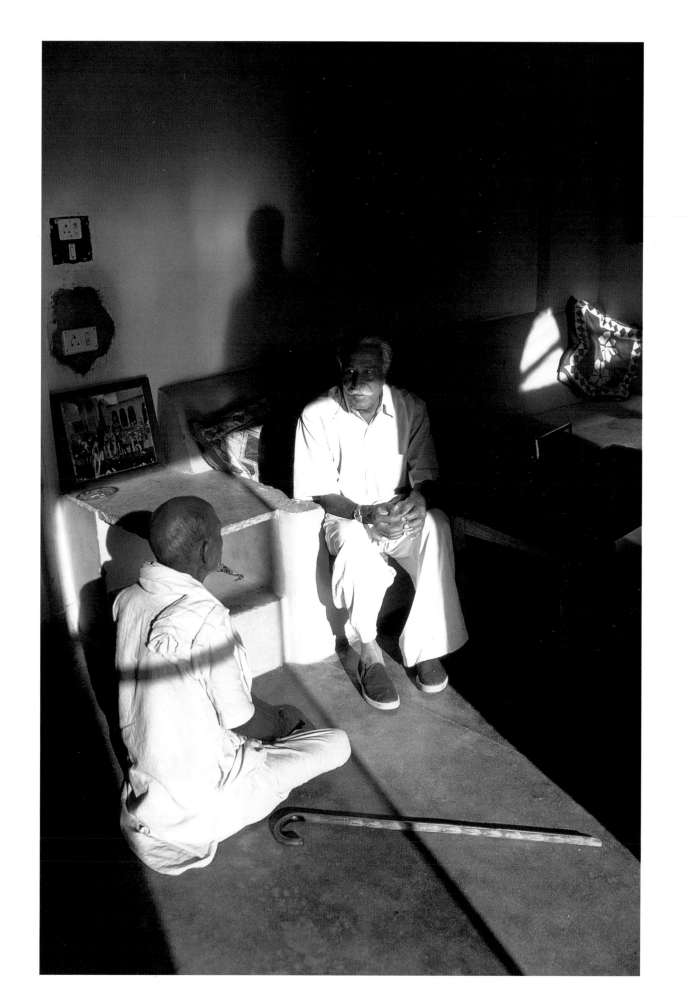

Craftsman Ghulam Hussain Mir and grandson, Srinagar, Kashmir, 1980
Landowner, Barwara village, Sawai Madhopur, Rajasthan, 1976

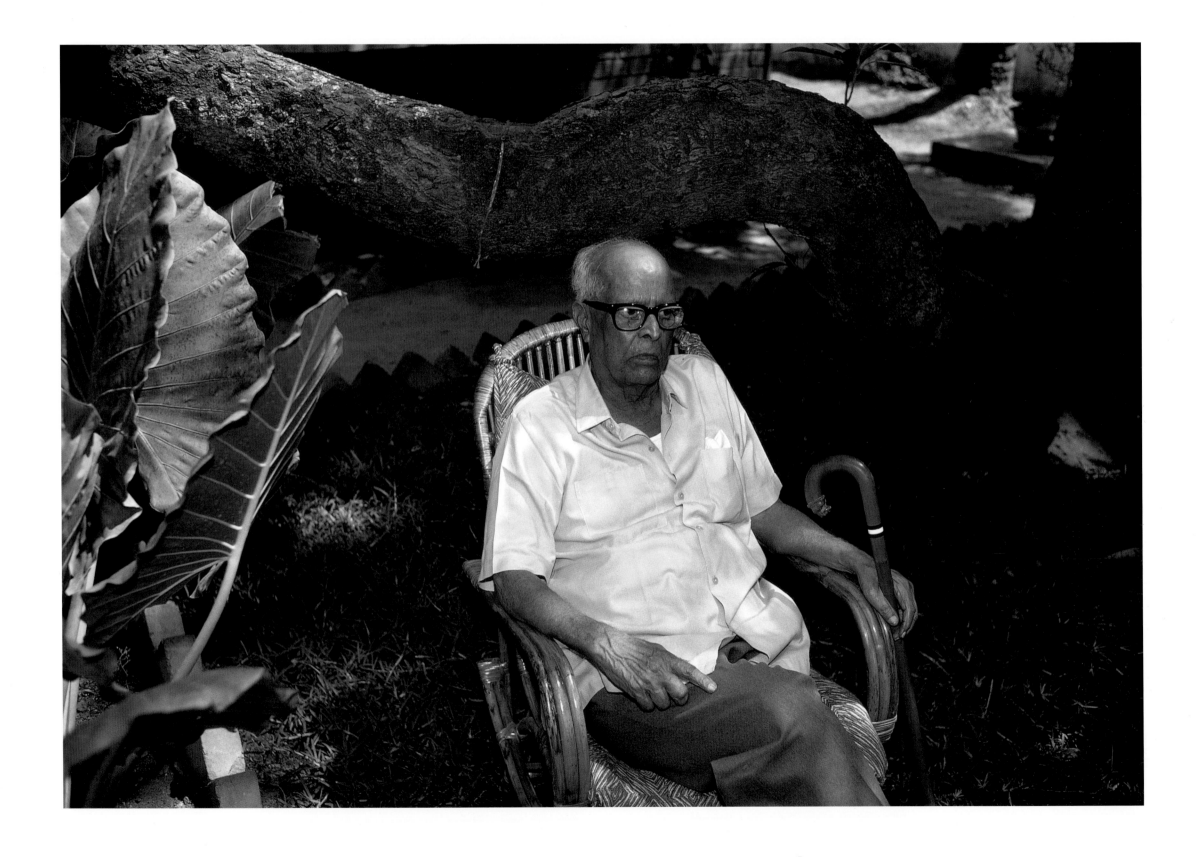

R.K. Narayan, Chennai, Tamil Nadu, 1989

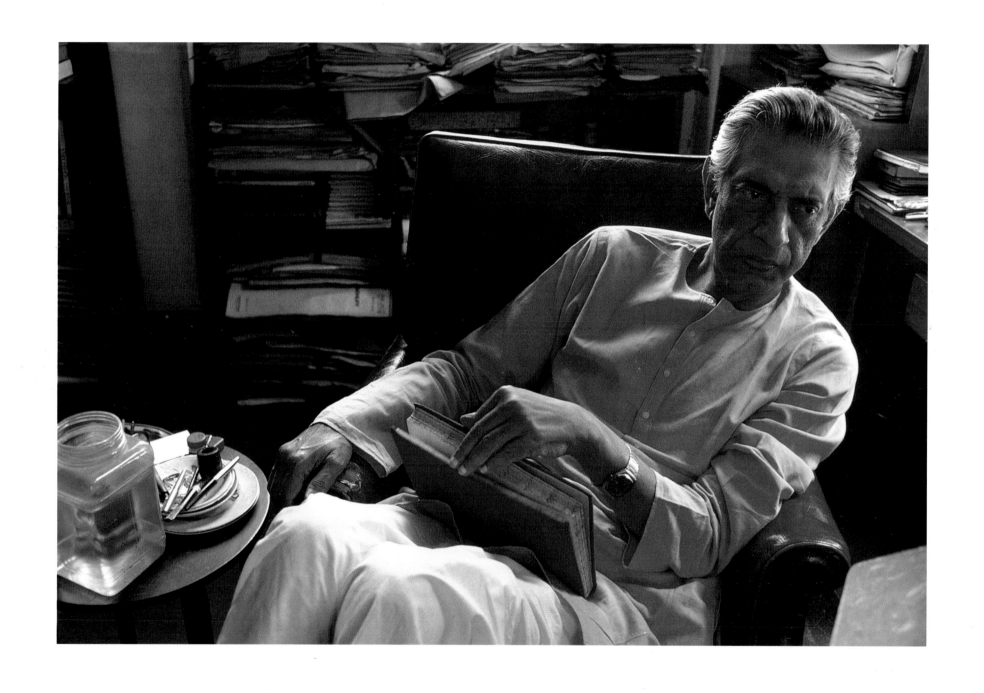

Satyajit Ray, Calcutta, West Bengal, 1989

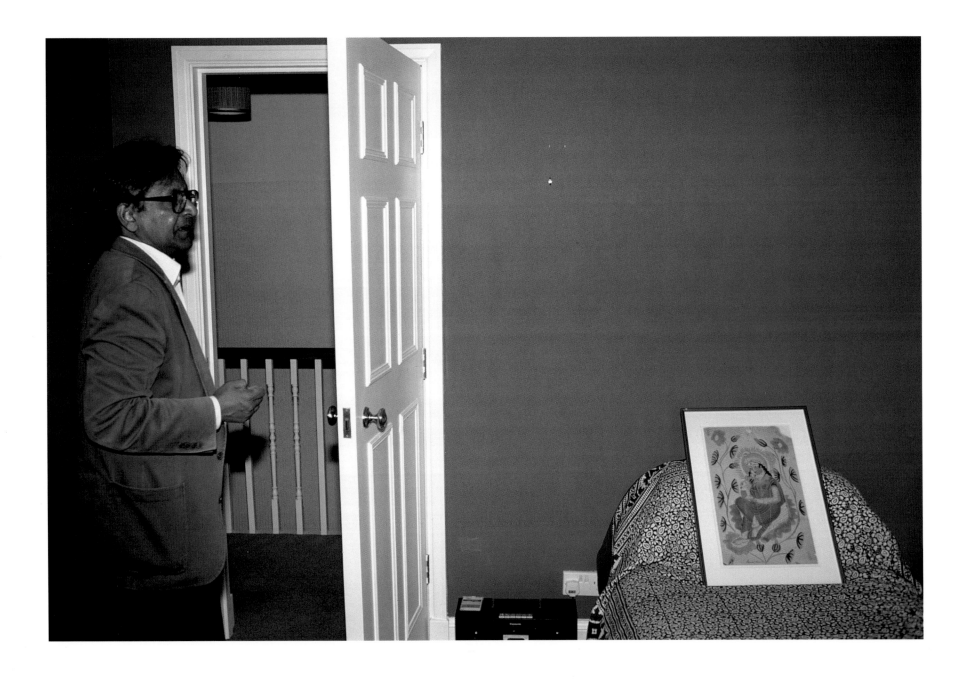

V. S. Naipaul at home, England, 1990

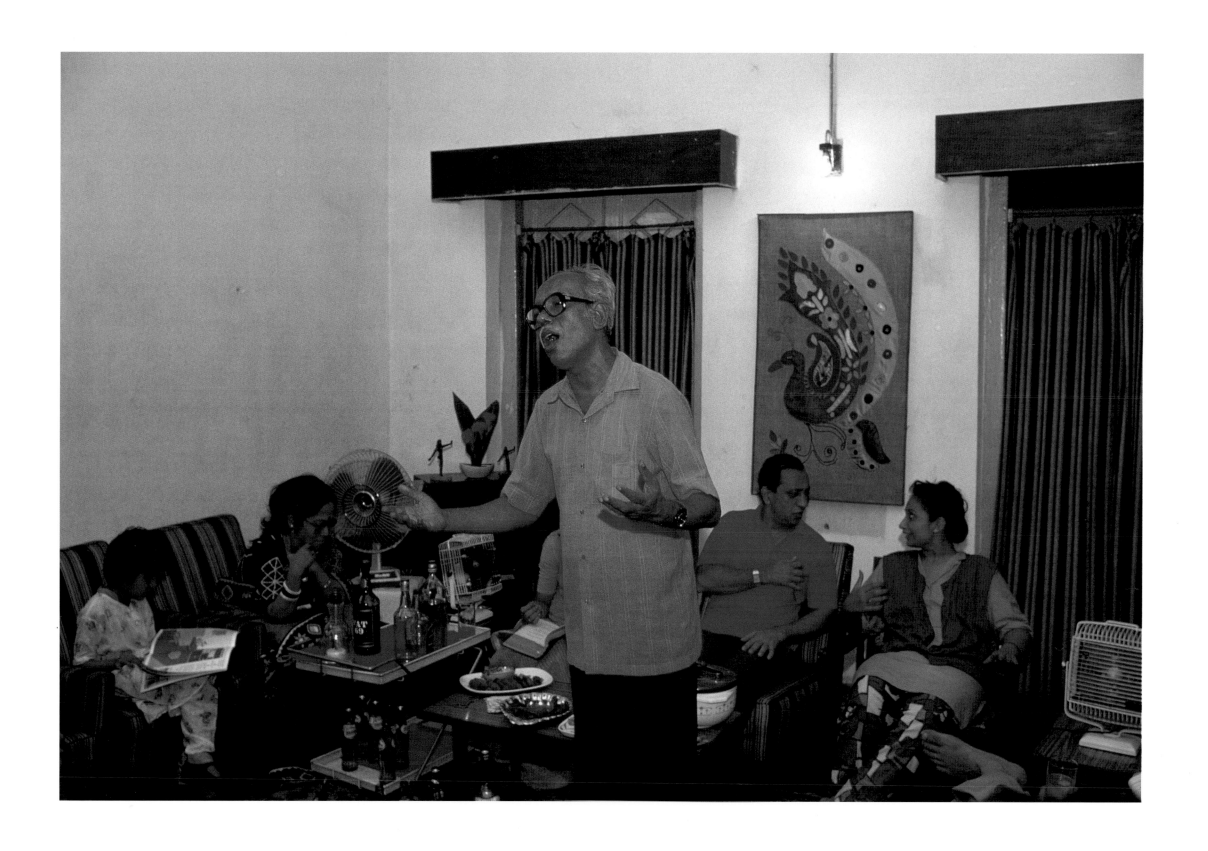

Shakti Chattopadya recites at a party, Calcutta, West Bengal, 1987

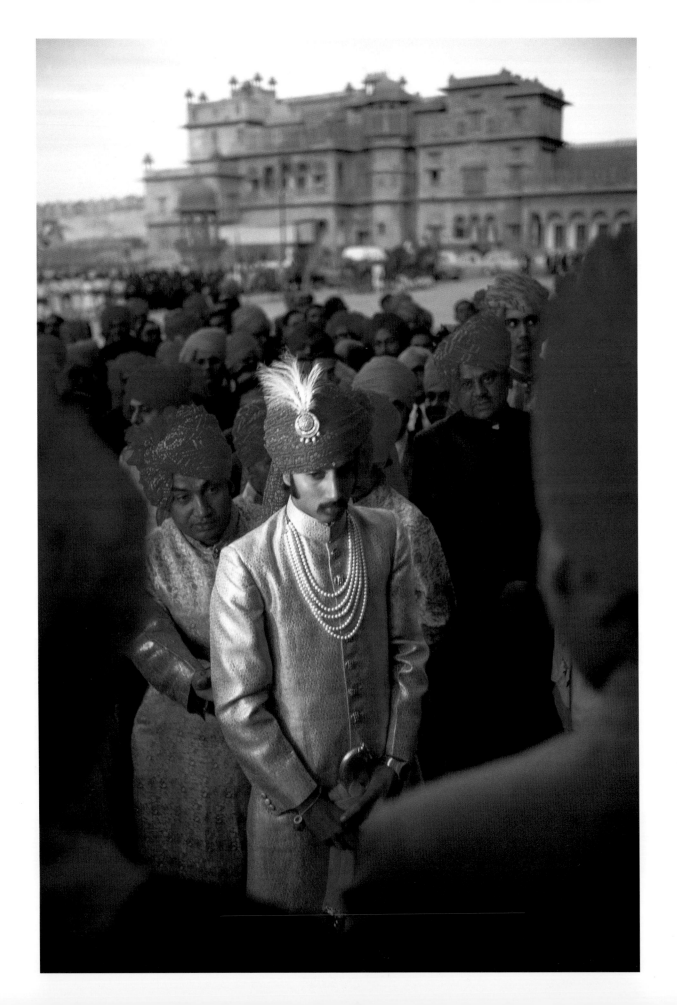

Bridegroom, Bikaner Fort, Rajasthan, 1974
Dr Karni Singh, Maharajah of Bikaner, Lalgarh Palace, Rajasthan, 1974

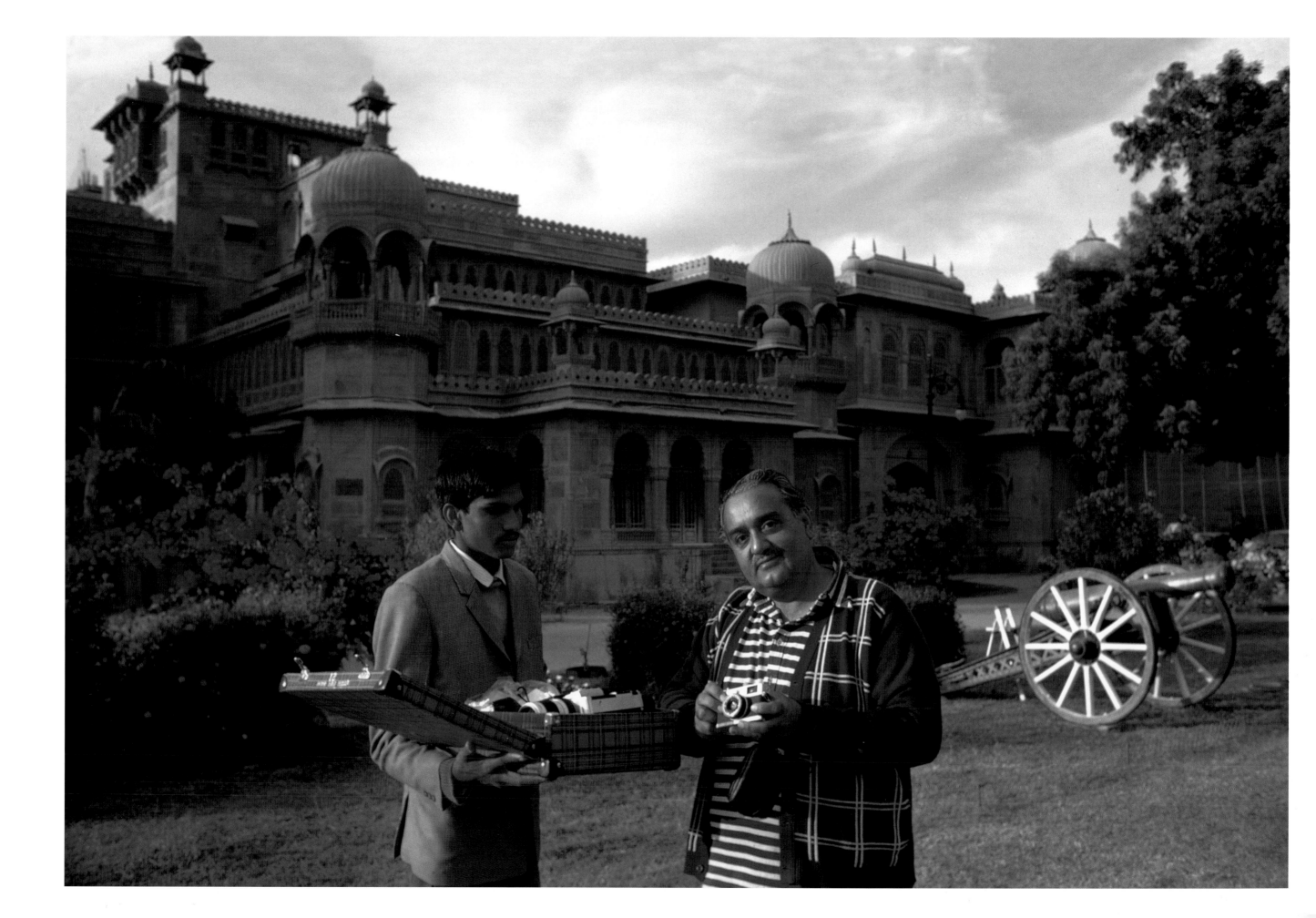

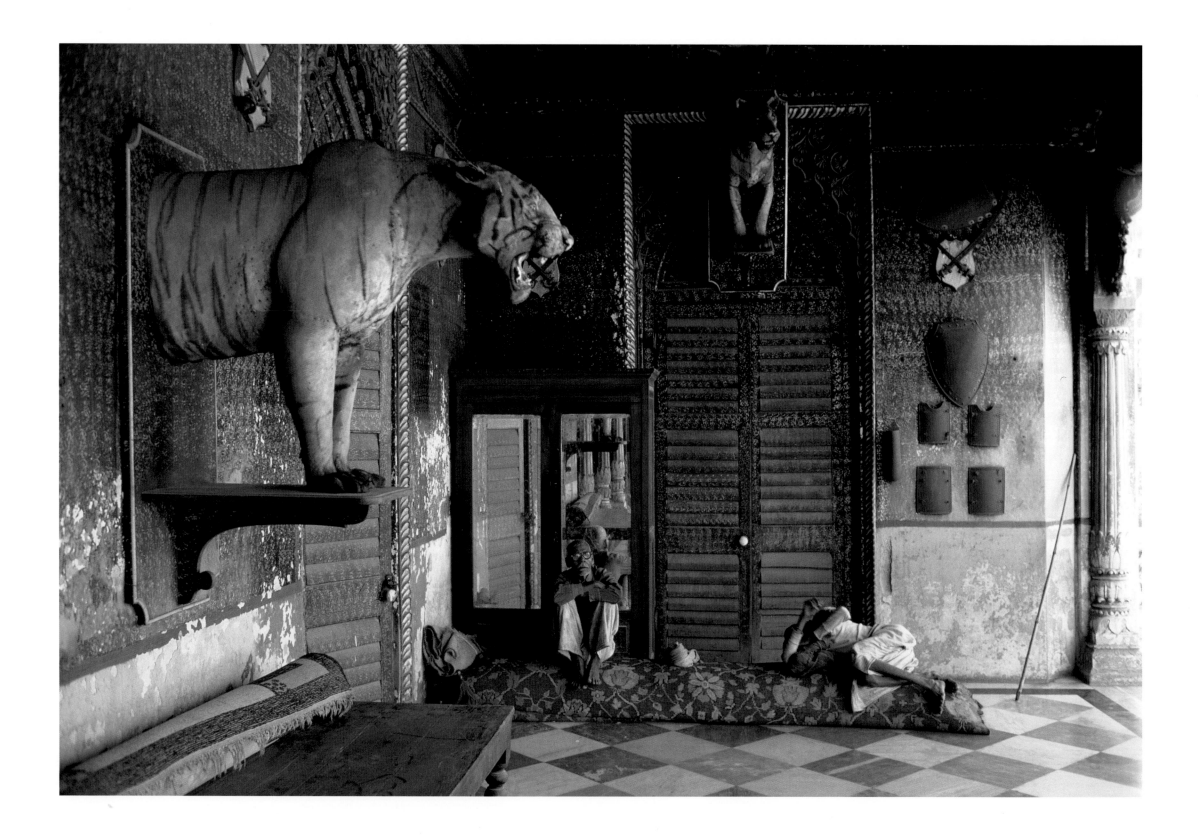

Employees, Vijainagram Palace, Benares, Uttar Pradesh, 1984
Pranlal Bhogilal and daughter, Ahmedabad, Gujarat, 1986

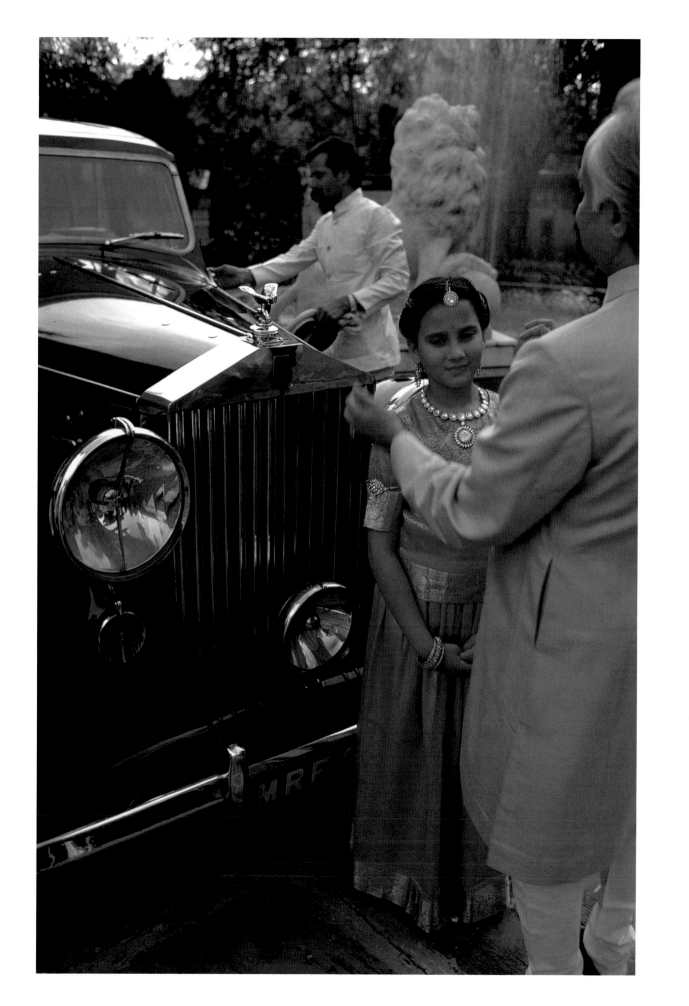

WHEN WE WERE CHILDREN, with our arms around each other's waists, pretending to count the birds on the little island in the middle of the lake…I asked her whether she remembered those days when we were children.

The Shadow Lines by Amitav Ghosh

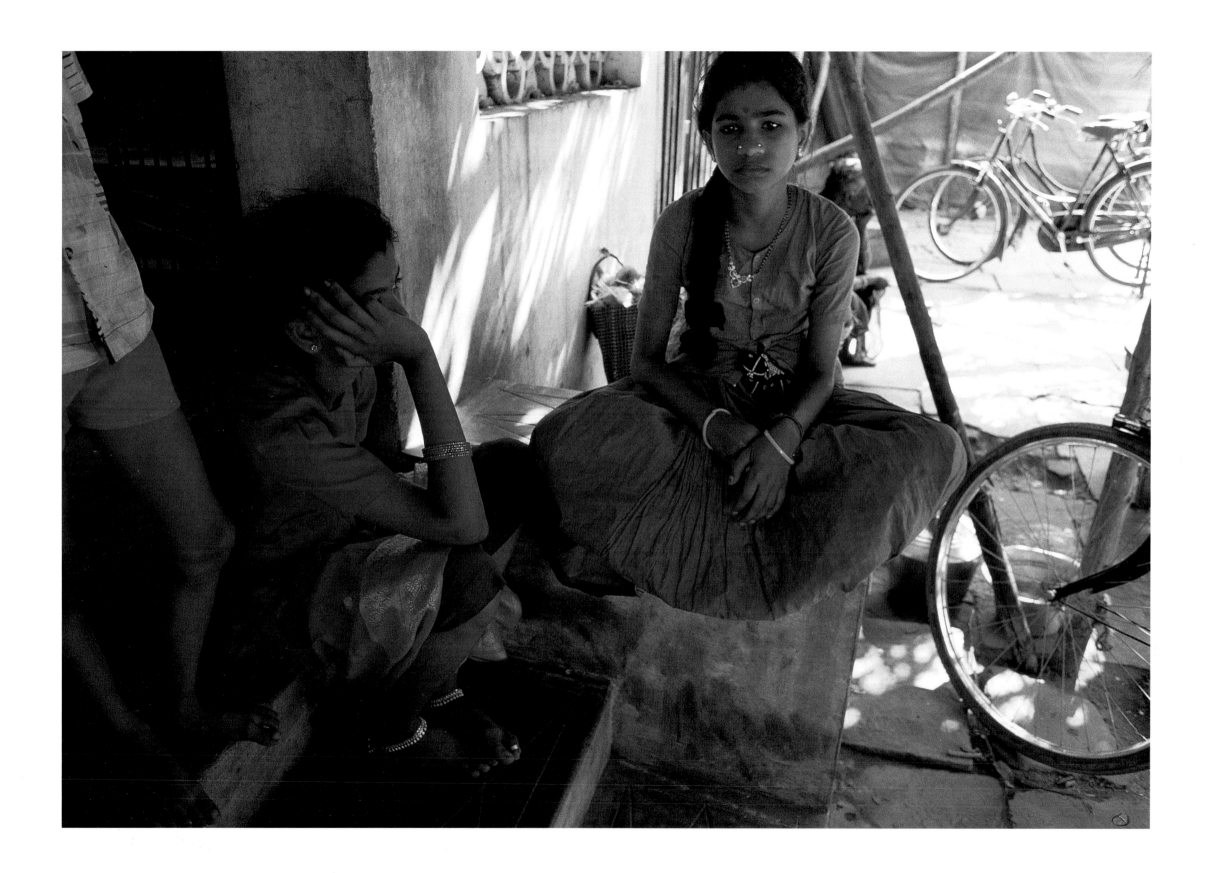

Dikshitar Brahmin children, Chidambaram, Tamil Nadu, 1994

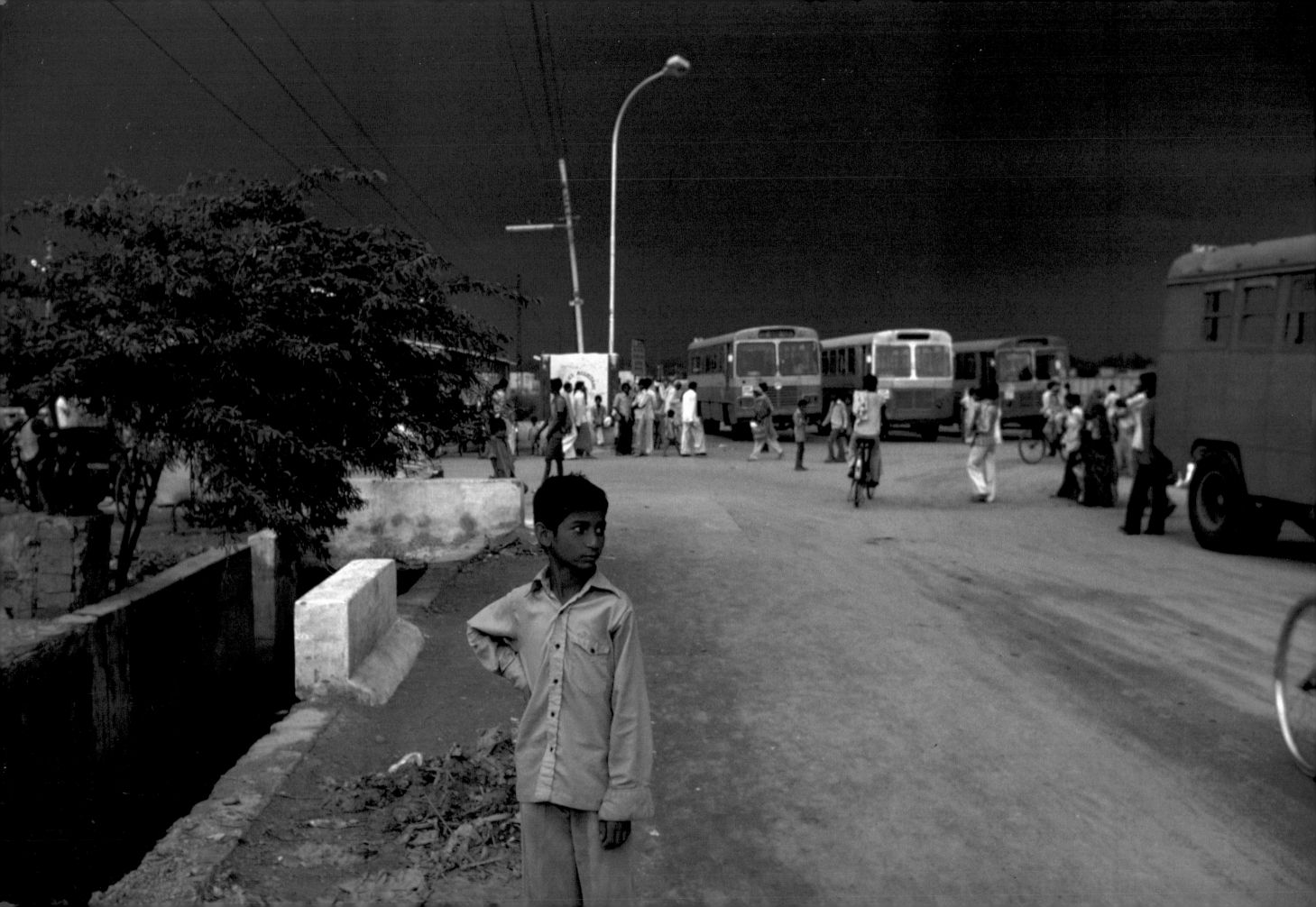

Boy at bus stop, New Delhi, 1982
Teenagers, Kanchipuram, Tamil Nadu, 1994

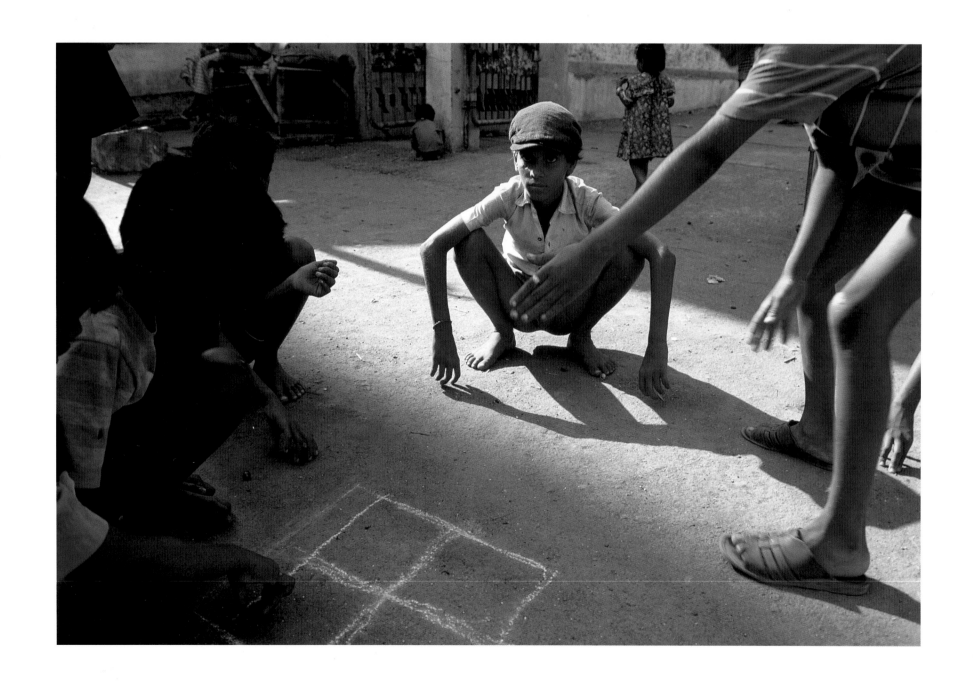

Playing marbles, Mumbai, Maharashtra, 1991

Playing 'Punishment', a marble game, Mumbai, Maharashtra, 1991

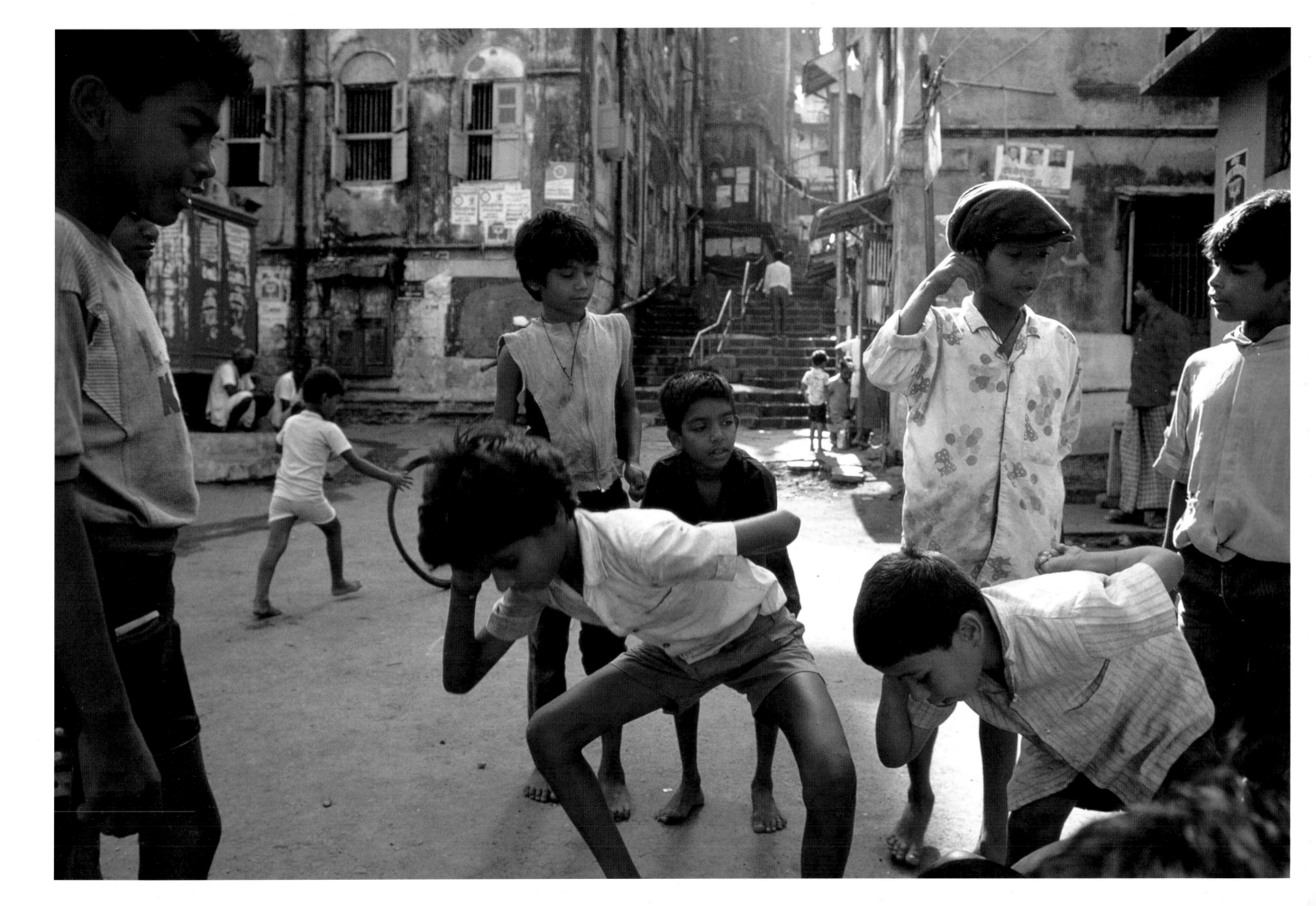

I prowled the streets all day, feeling very strung-up and ready to pounce, determined to 'trap' life... IN THE ACT OF LIVING. Above all, I craved to seize the whole essence, in the confines of one single photograph, of some situation that was in the process of unrolling itself before my eyes.

The Decisive Moment by Henri Cartier-Bresson

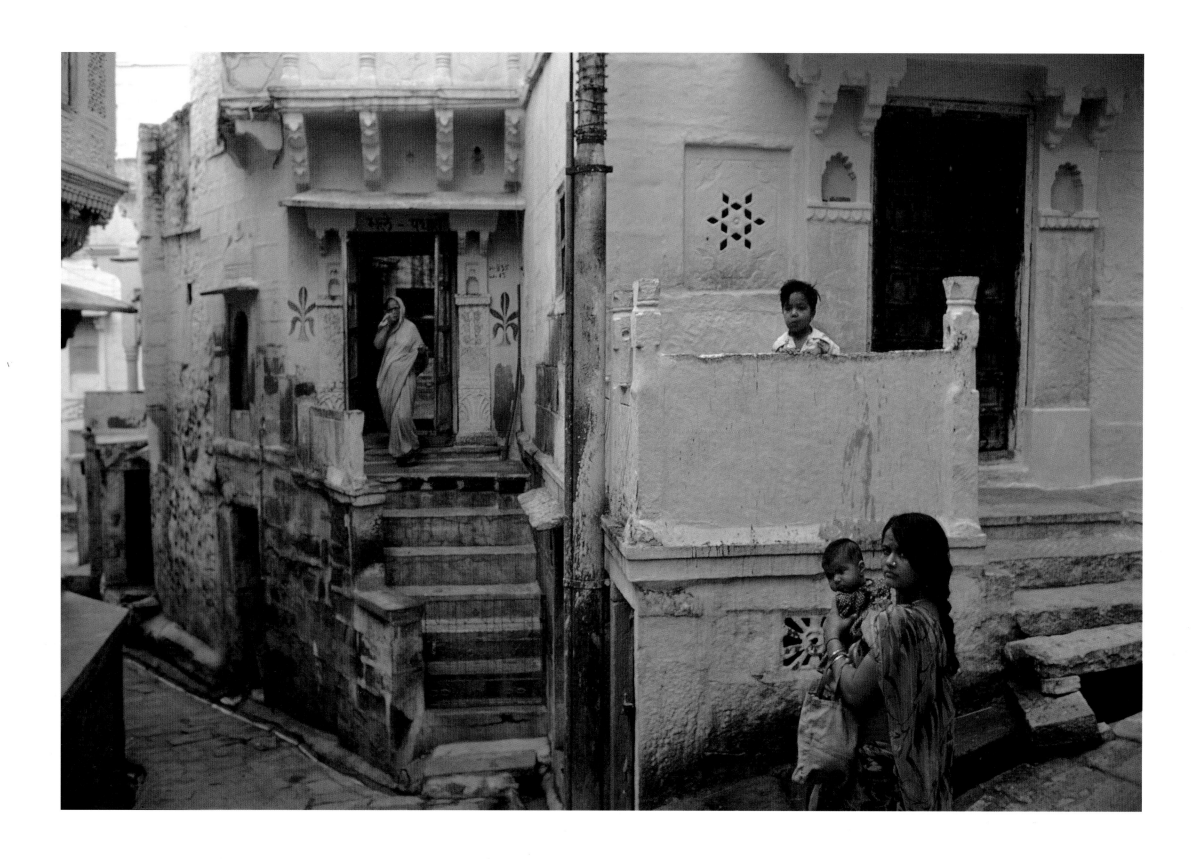

Brahmapuri neighbourhood people, Jodhpur, Rajasthan, 1975

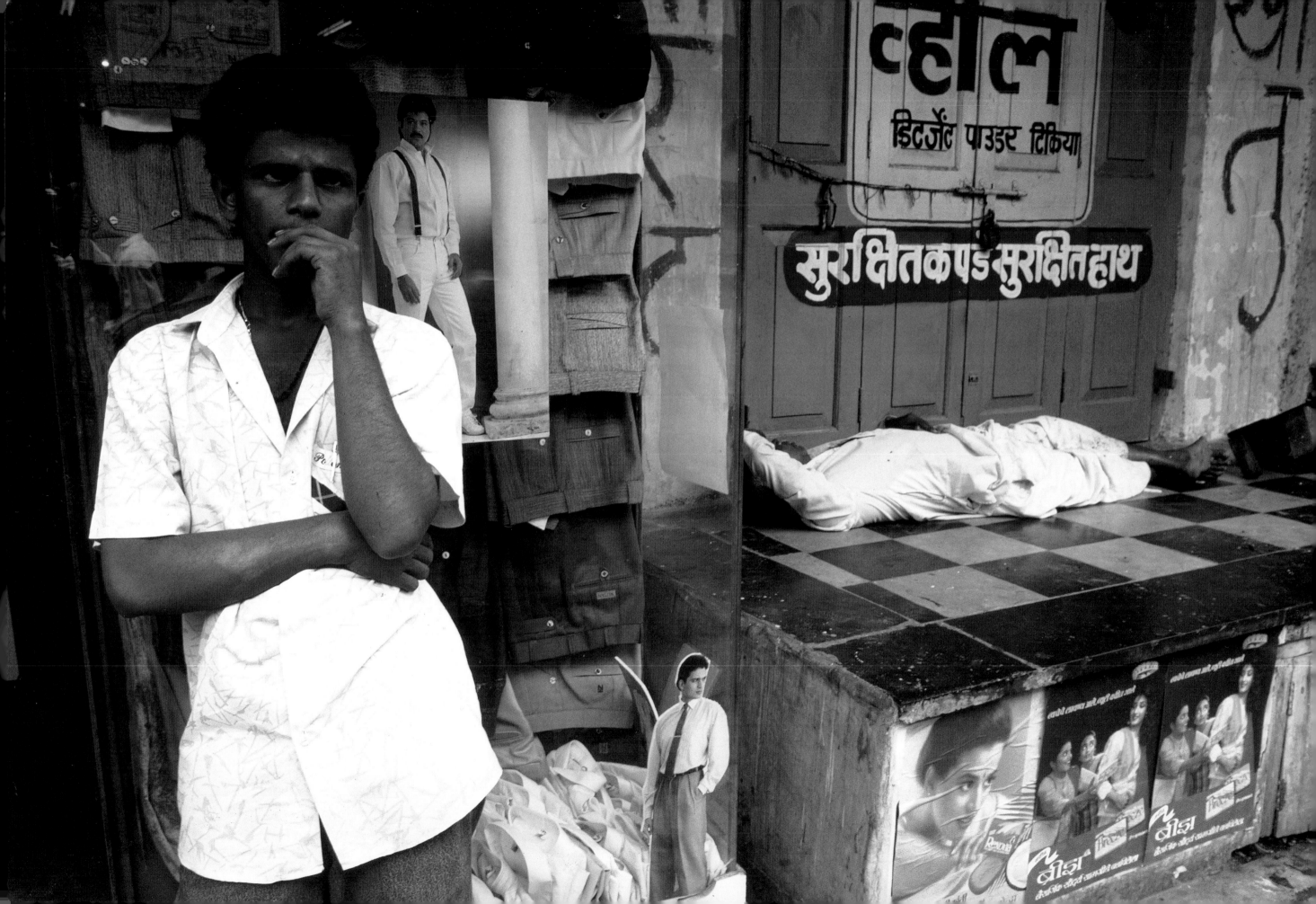

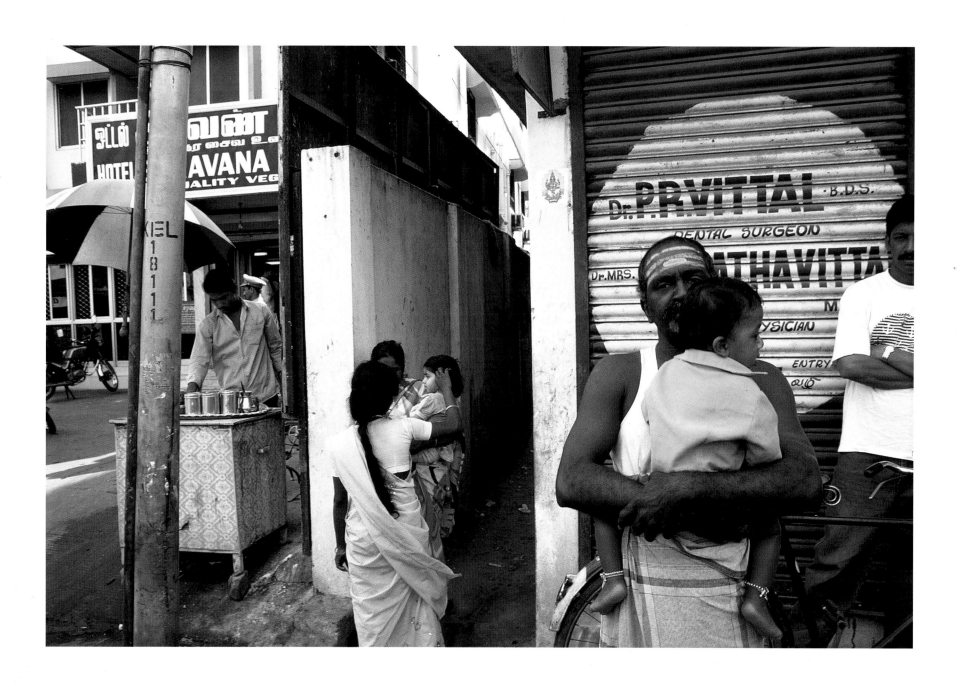

Outside a clothing shop, Dadar, Mumbai, Maharashtra, 1990

Purasawalkam neighbourhood people, Chennai, Tamil Nadu, 1993

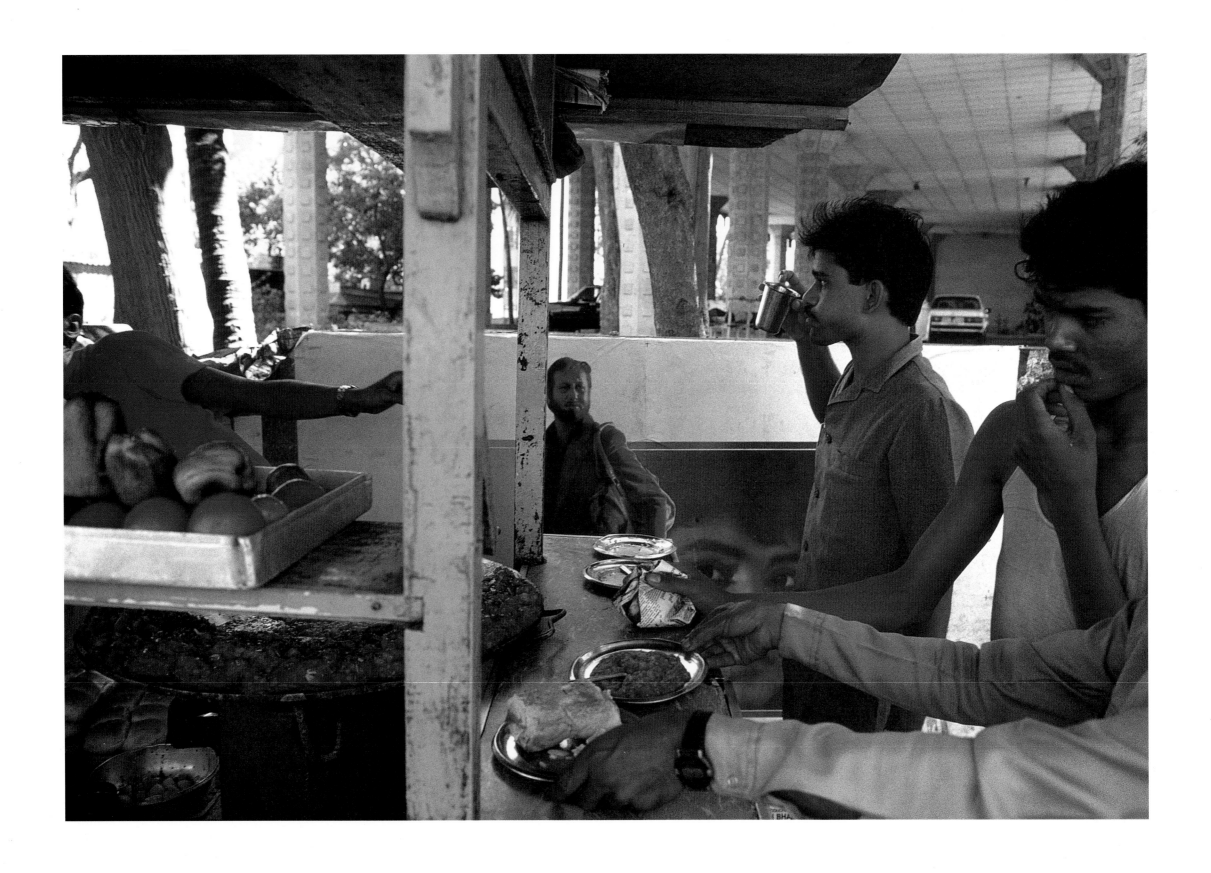

Workers at lunch, Mumbai, Maharashtra, 1991

Pedestrians, Firozabad, Uttar Pradesh, 1992

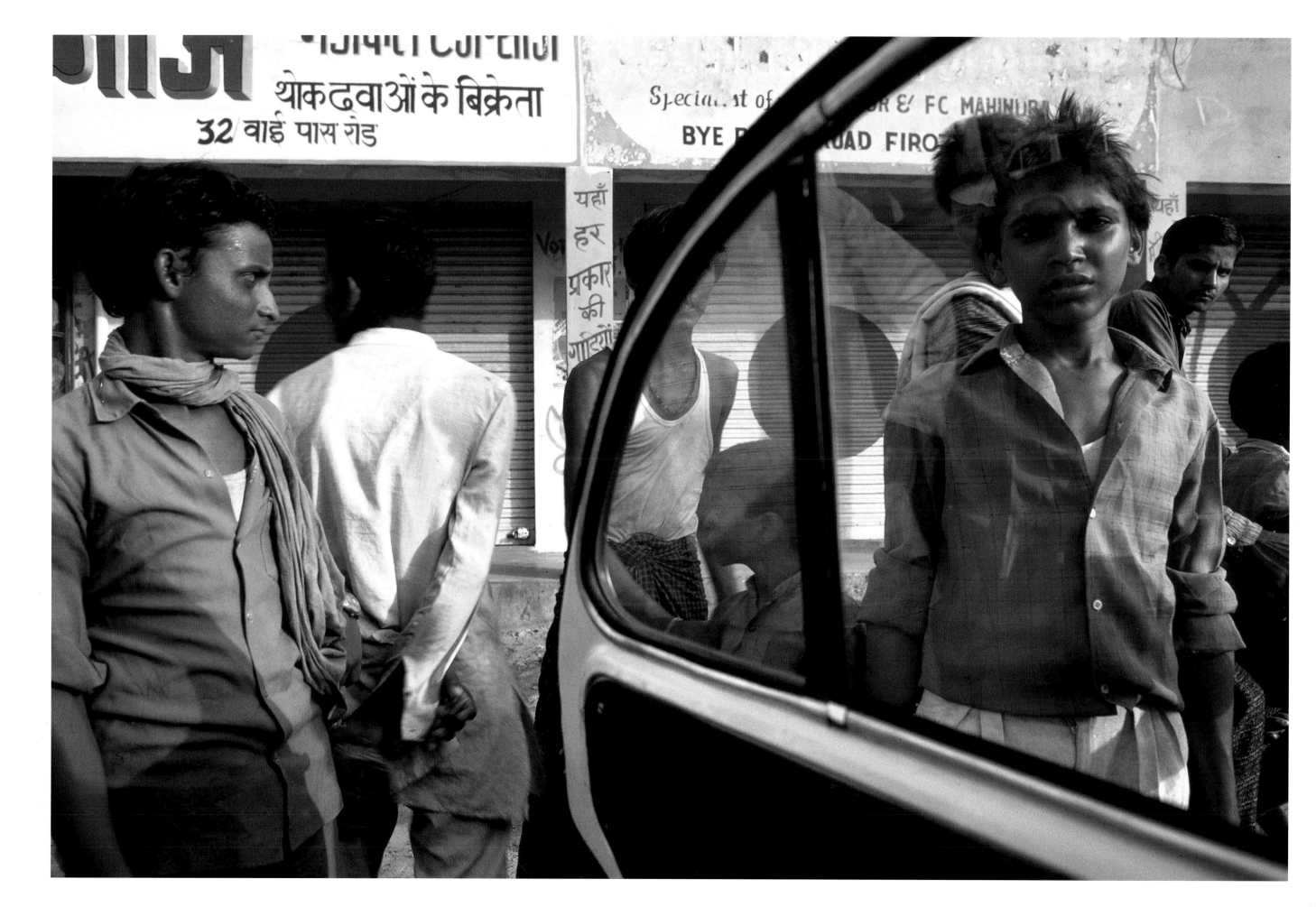

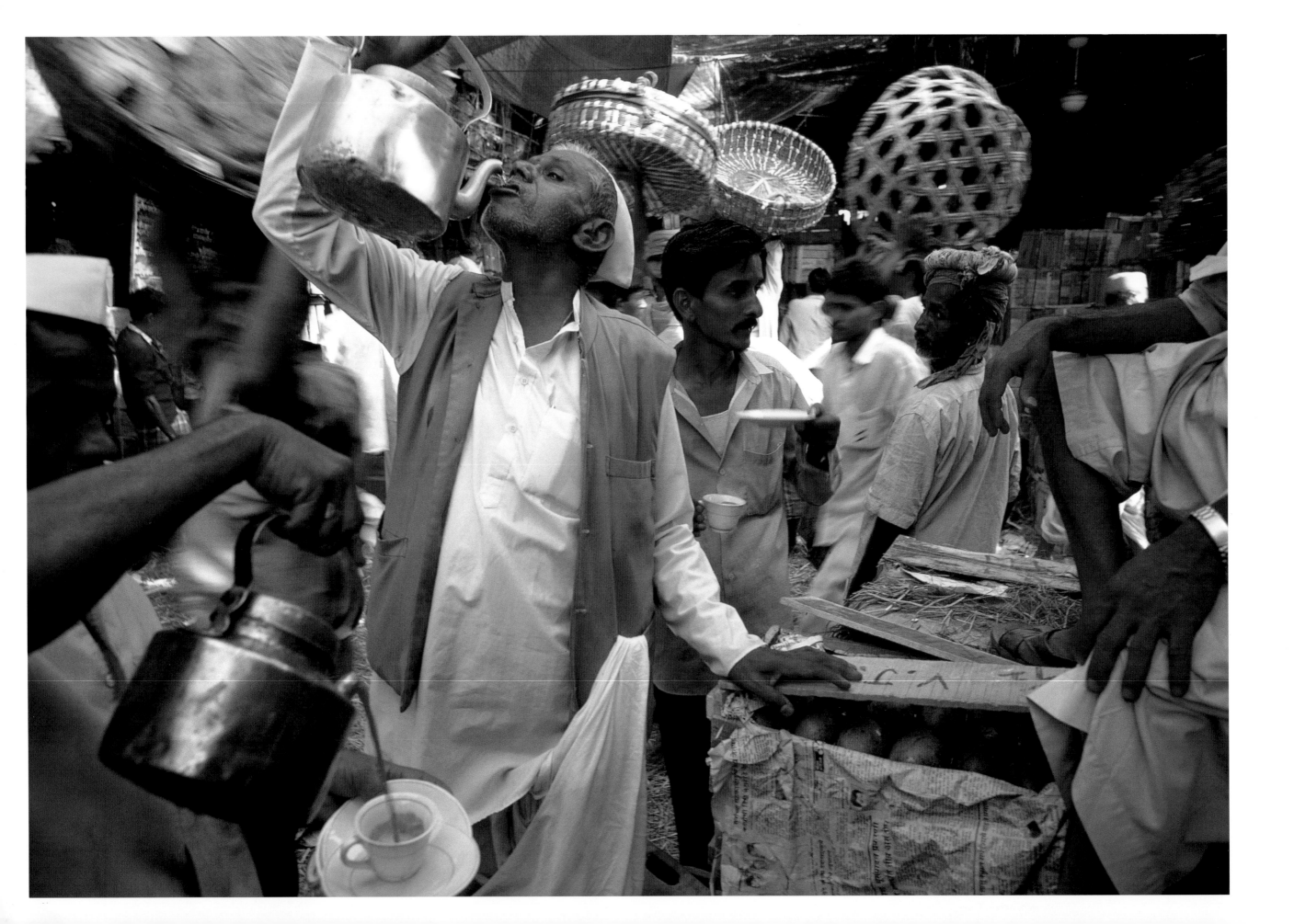

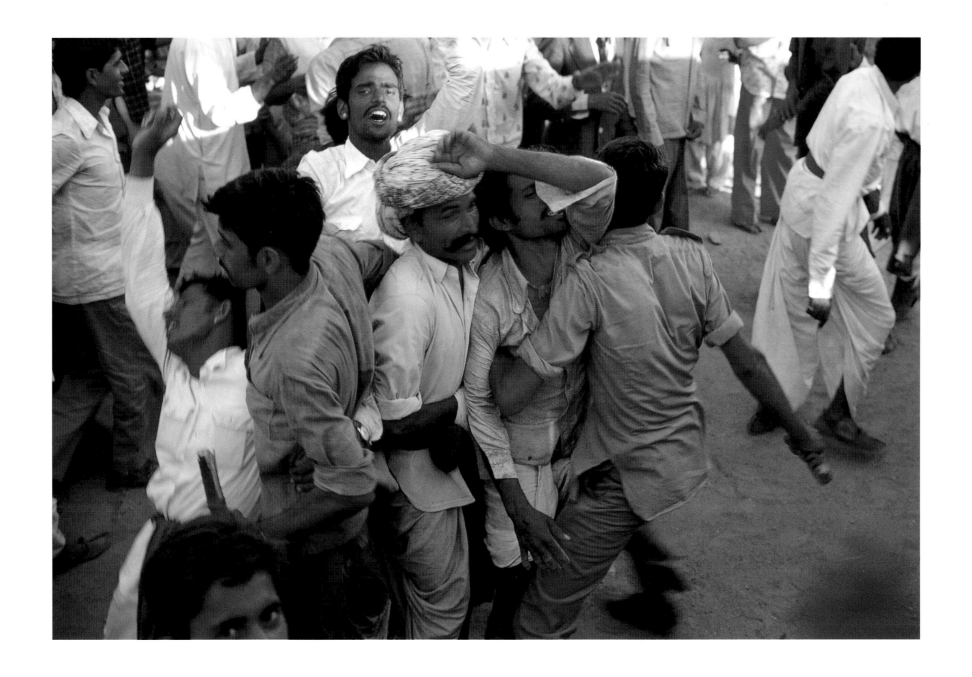

Crawford Market, Mumbai, Maharashtra, 1993
Holi revellers, Jodhpur, Rajasthan, 1975

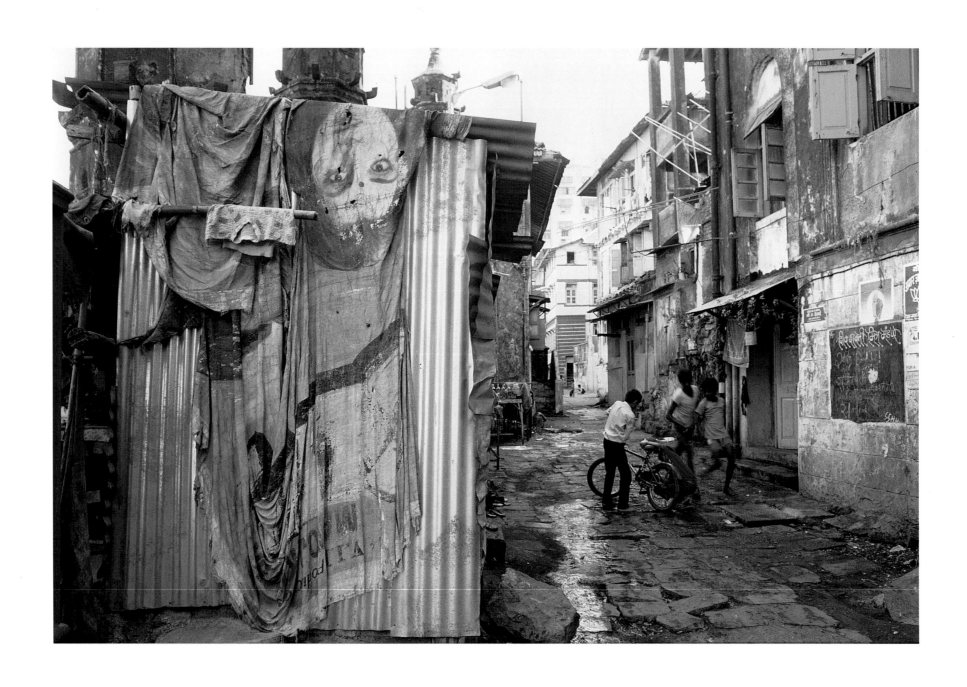

Cinema poster roofing, Mumbai, Maharashtra, 1989

A paint-seller, Hyderabad, Andhra Pradesh, 1996

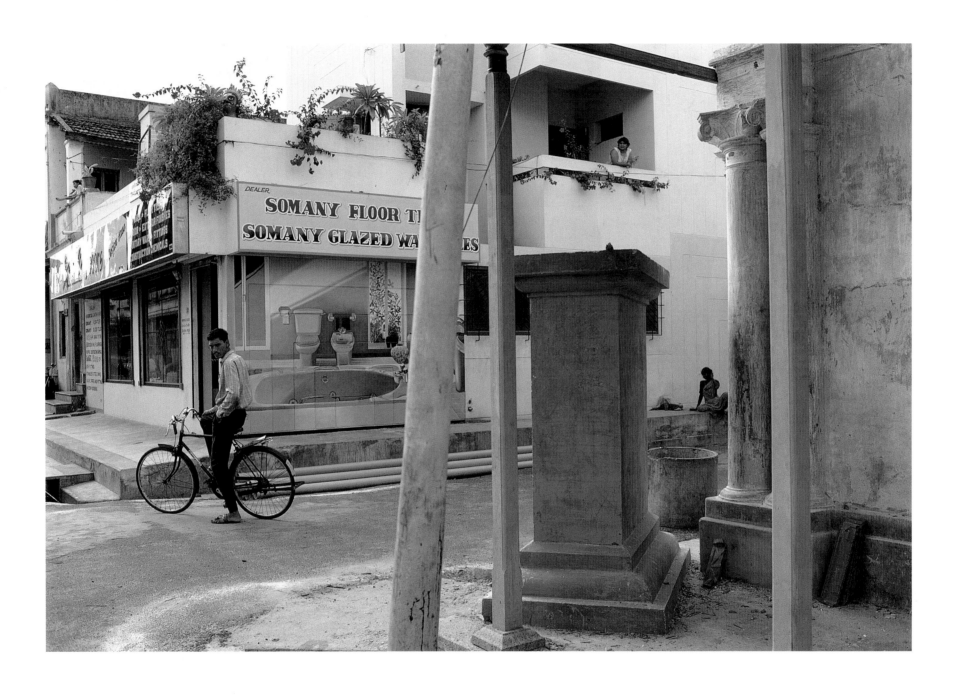

Pochampalli, Andhra Pradesh, 1996

Neighbourhood people, Pondicherry, Union Territory, 1993

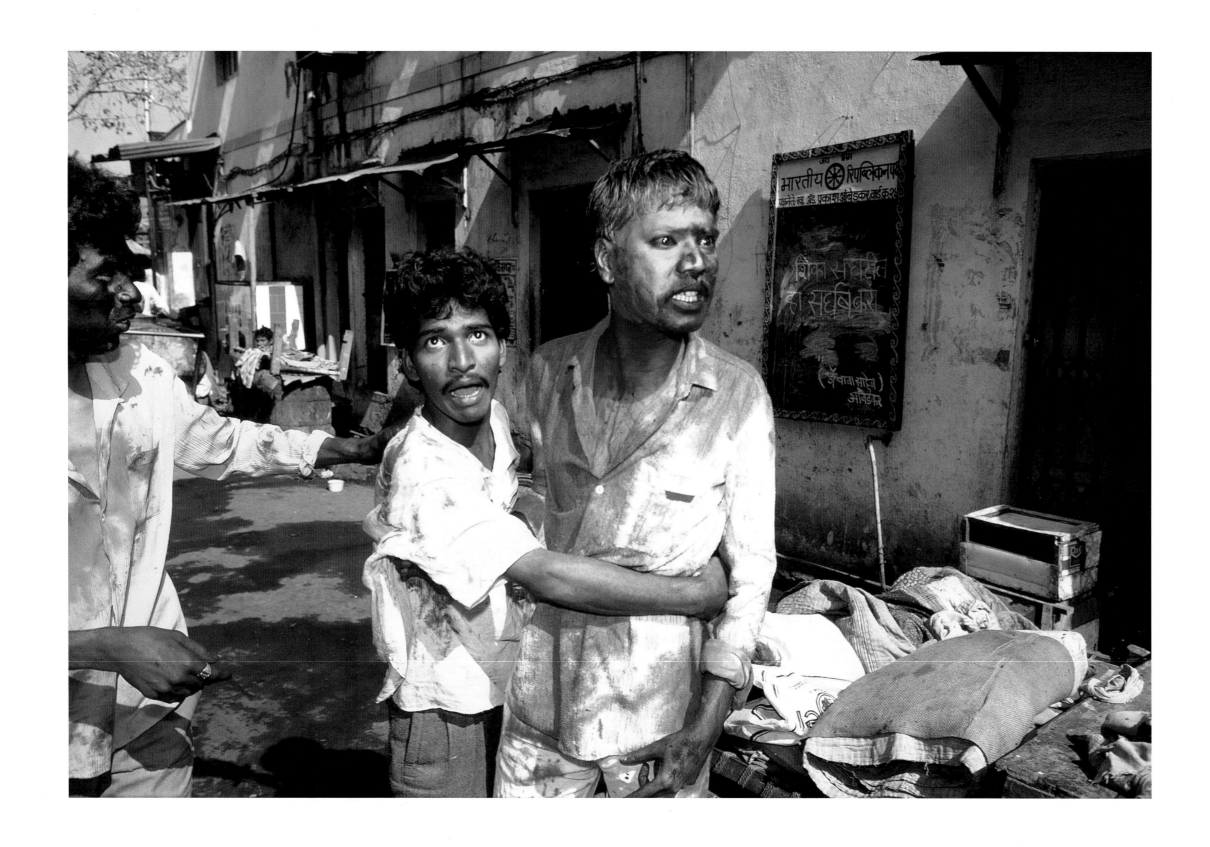

Holi revellers, Mumbai, Maharashtra, 1990

A prostitute, Falkland Road, Mumbai, Maharashtra, 1978

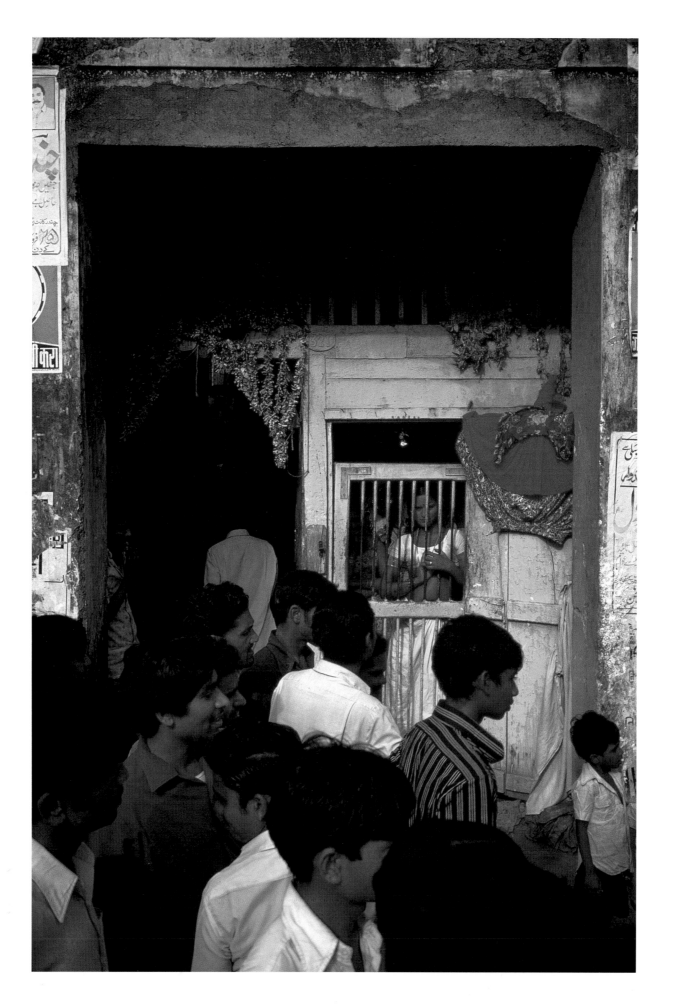

It was an emaciated channel where the water never was more than waist-deep and in most places only knee-deep. But we loved the stream. To compare small things with great, it was our Nile, our town was THE GIFT OF THE RIVER.

The Autobiography of an Unknown Indian by Nirad C. Chaudhuri

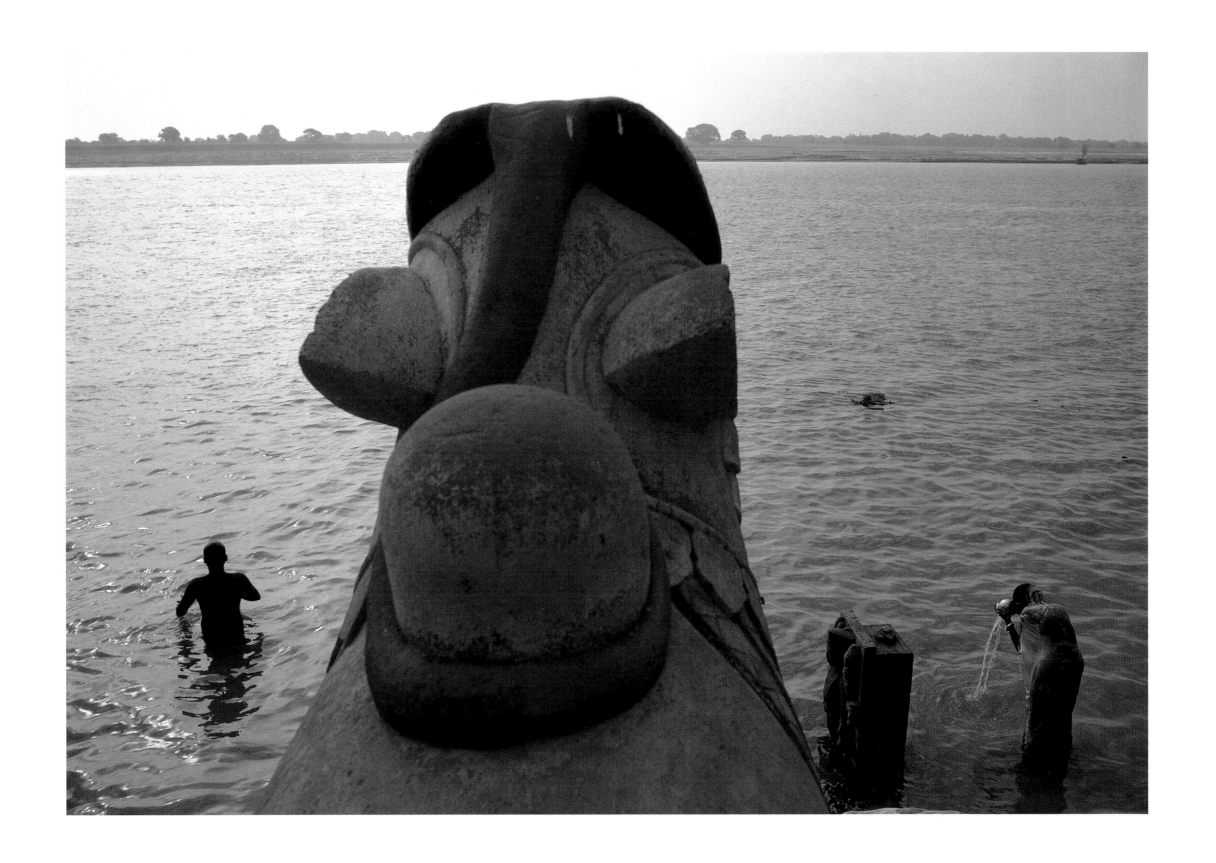

Bathers in prayer, Benares, Uttar Pradesh, 1985

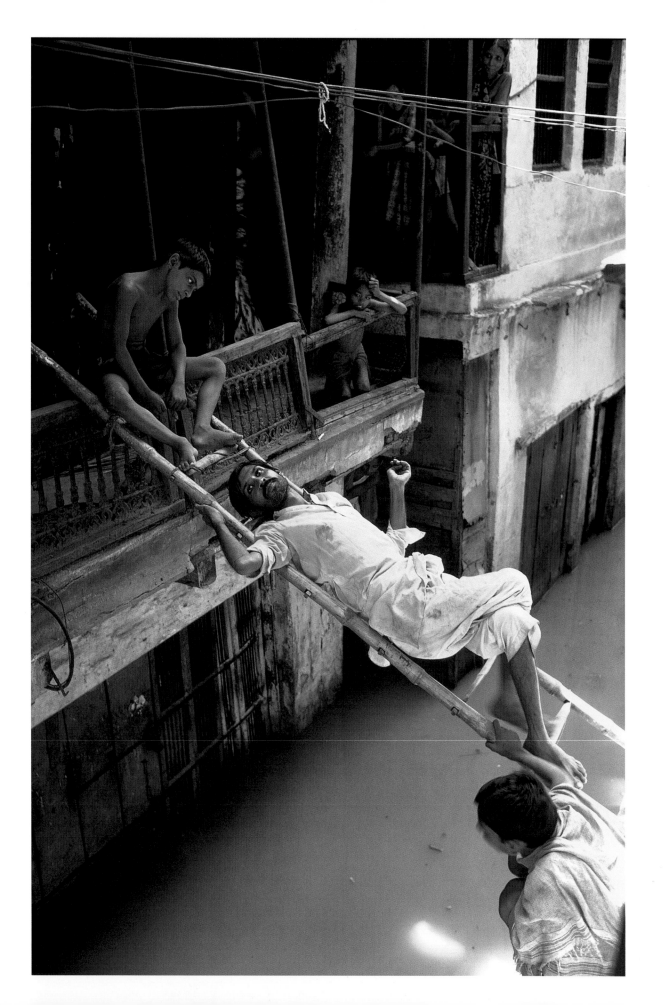

Waiting out the floods, Benares, Uttar Pradesh, 1983

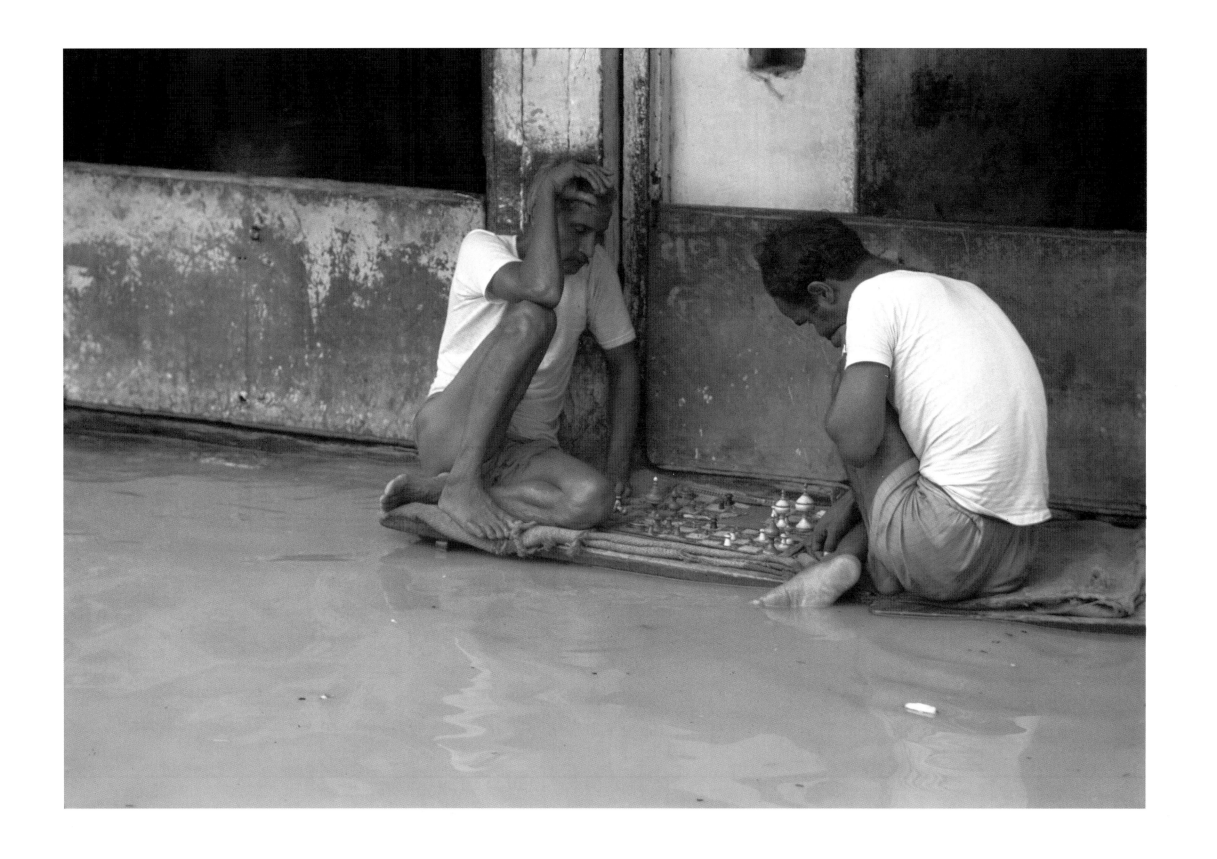

Chessplayers, monsoon floods, Benares, Uttar Pradesh, 1967

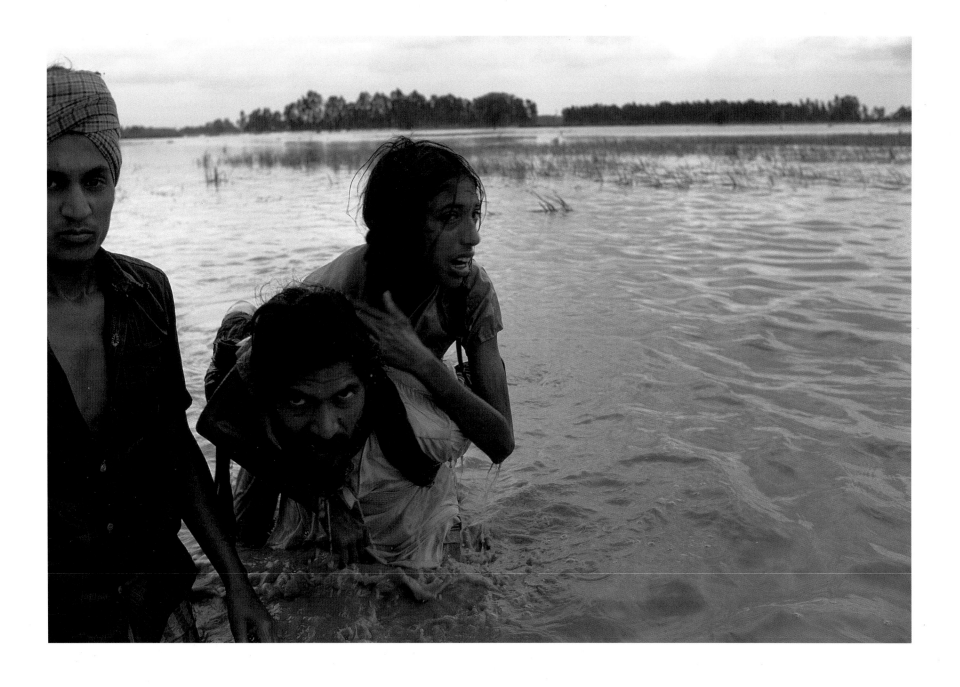

A rescue, Haryana floods, 1987

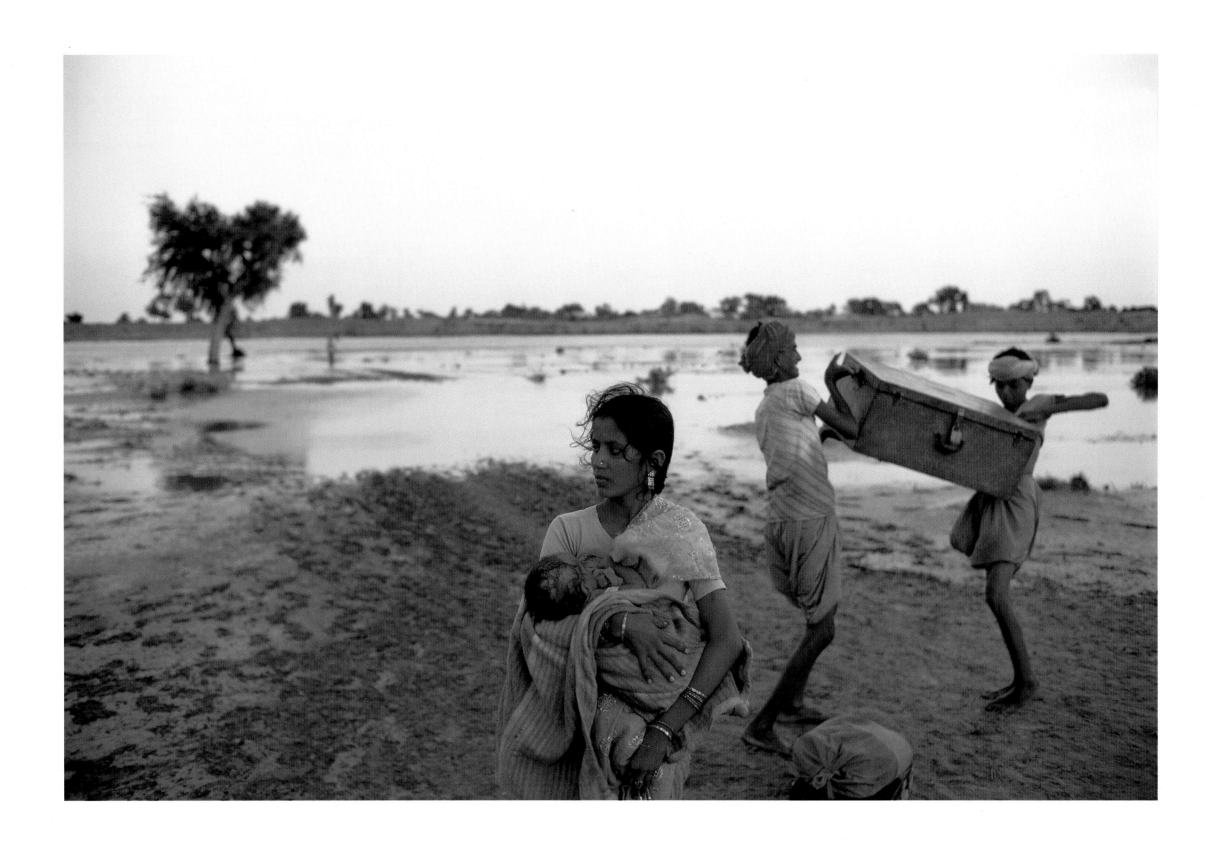

After crossing the flooded Luni River, Barmer, Rajasthan, 1975

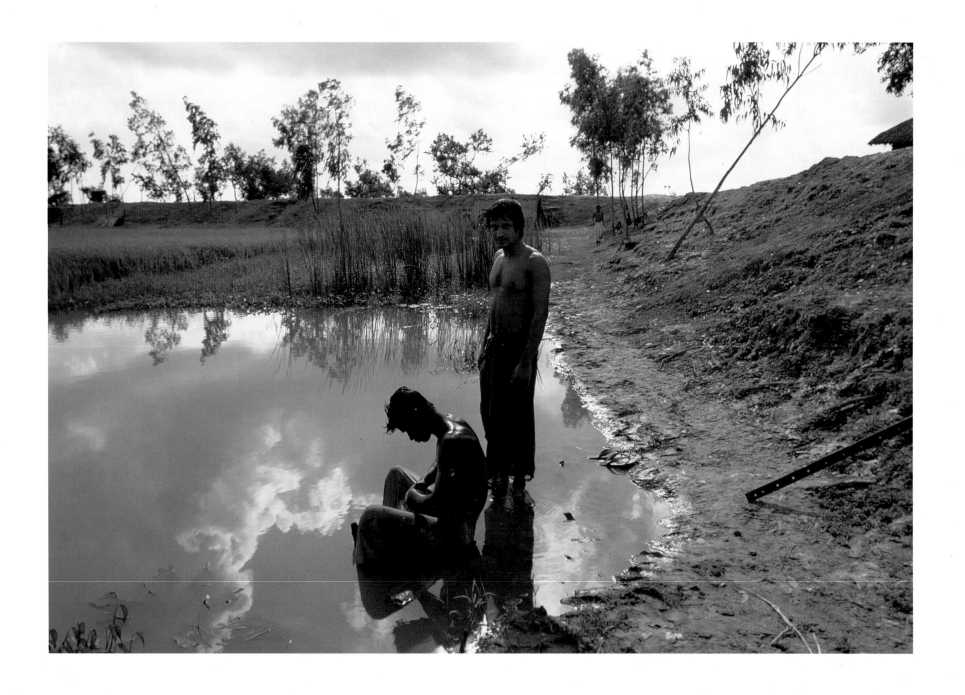

Bather in a reservoir, Sunderbans, West Bengal, 1988

Water tank, Modera, Gujarat, 1997

NOTES

FROM ONE WORLD TO ANOTHER

As Nirad C. Chaudhuri explains in his quotation that opens this section, when one passes from the North Indian plain to the Himalayas, there is an abrupt movement from one type of geography to another. Similarly, in other parts of India when one passes from the Deccan plateau to the Western Ghats, from Ladakh to Kashmir, Saurashtra to Kutch, or Kerala to Tamil Nadu, one enters unique regions each with their own distinct characteristics. Two powerful and interlinked forces that bind the social, geographic and climatic diversity of India are its rivers and the monsoon.

1 Morning on Panchganga Ghat, Benares, Uttar Pradesh, 1985
Bathers on the steps going down to the Ganges. Near them is one of the sacred city's innumerable shrines to Siva. Mark Twain, who visited Benares at the very end of the nineteenth century, humorously called the city Lingamsburg in his book *Following the Equator*.

15 Monsoon rains, Monghyr, Bihar, 1967 The photograph of the Ganges in Bihar is among my earliest works. When I went to take this picture, the women were working in the fields. They came up to the road and huddled together to break the force of the monsoon rain.

16 Porter, Bhagirathi peaks and Gaumukh – source of the Ganges, 1989; 17 Pilgrim at Gaumukh, 1967 Both photographs were taken at the Gangotri glacier in the Garhwal Himalayas. Known as Gaumukh or Cow's Mouth, this is where the Ganges emerges at 12,800 feet from the ice face of the glacier. Above the source, four mountains are visible: the Shiv Linga peak (over 21,000 feet) and the three Bhagirathi peaks (page 16) which rise to over 22,500 feet. Pilgrims, like the man on page 17, come from all parts of India.

18 Catching the breeze, Hathod village, Jaipur, Rajasthan, 1975; 19 Man diving, Ganges flood, Benares, Uttar Pradesh, 1985 The man who dives from a submerged temple in the flood-high Ganges and the young women on swings catching the monsoon breeze show divergent aspects of India's geography, bonded by the passage of the monsoon.

20-21 Morning on Dharbhanga Ghat, Benares, Uttar Pradesh, 1987
The city of Siva is built on a high bluff overlooking the Ganges and its low, flat plain. The ghats terrace down to the river.

22 Village well, Barnawa, Rajasthan, 1977 In Rajasthan the village well is a central element of life. Here at Barnawa, the village of folk musicians, a man in a red turban bends to pull a leather bucket.

25 Fishermen, Calicut, Kerala, 1996 The fishermen haul their nets at Kappad beach near Calicut where the Portuguese navigator Vasco da Gama landed, establishing the sea route to India in 1498.

26 Western Ghats, Tamil Nadu – Kerala state borders, 1995 Running along the west coast, the Western Ghats trap the south-west monsoon winds giving India some of its heaviest rains.

27 On Vivekananda rock, Kanya Kumari, Tamil Nadu, 1994 A female pilgrim is seen at Kanya Kumari, the Land's End of India. She stands on the Vivekananda Rock, named after Swami Vivekananda, the reformer, who meditated there and later propagated the philosophy of Vedanta. This pilgrim reminds me of my mother and her own pilgrimages. My mother's description of her journey to the Ganges in the Himalayas inspired me to trek there from the Indian plain. In doing so, I moved from one world to another.

HUNDREDS OF THOUSANDS OF PILGRIMS

Dilip Kumar Roy, a noted Bengali pilgrim and writer on India's holy sites, evokes the mood of the Kumbh Mela and other such pilgrimages in his words quoted here.

29 Himalayan pilgrimage, Amarnath, Kashmir, 1981 This section opens with a trek which takes place every August, at the time of the full moon, to the Amarnath cave at about 13,000 feet. The Shiv Linga, a stalagmite in the cave, is worshipped by the thousands of pilgrims from all over India who make the six-day trek. V.S. Naipaul, who describes the trek superbly in *An Area of Darkness*, made his journey 20 years before I did.

30 A holy man and devotees, Kumbh Mela, Prayag, Uttar Pradesh,
1977; 31 Sadhus, Kumbh Mela, Prayag, Uttar Pradesh, 1989;
36 Sadhus bathe at Sangam, Kumbh Mela, Prayag, 1989 The Amarnath cave is dramatically different from the Kumbh Mela, but both are astonishing pilgrimage destinations. The Kumbh Mela is held every twelve years and rotates between four different places: Prayag near Allahabad where the Jumna joins the Ganges, Hardwar on the Ganges, Nasik on the Godavari River and Ujjain on the Sipra River. These photographs from Prayag show one of the many processions of holy men and their entourages: going to the river to bathe at the confluence (page 30); a sect of Nagas (literally naked sadhus) returning from bathing in the cold and mist of a January dawn (page 31); and the sadhus rushing in and out at the confluence, the bitter cold dictating a quick dip (page 36).

32 Pilgrim camp, Lolarka Shashti Festival, Benares, Uttar Pradesh, 1985; 33 Bathing, Lolarka Shashti Festival, Benares, Uttar Pradesh, 1985 Honouring the Sun God, the Lolarka Shashti fertility festival draws families who camp by a water tank in which they bathe and discard old clothes.

34 Ganesh Puga, effigies for immersion, Mumbai, Maharashtra, 1991
Ganesh, the God of Bounty, became patron deity of Mumbai only early this century when the Ganapati festival was instituted. Effigies of Ganesh are carried in procession – small ones on foot, large ones in trucks – to the Arabian sea where they are thrown into the water.

35 Kite-flying festival, Ahmedabad, Gujarat, 1981 Kite-flying day falls yearly on the fourteenth day of January. Much of North India is on the rooftops from morning to sunset to watch the dazzling display of fighting kites . Cartier-Bresson photographed the same scene about fifteen years before I did.

37 Teyyam performer, Badagara area, Kerala, 1984 The Teyyam exorcism in north Kerala honours the Mother Goddess. The state is noted for its vibrant performing arts. Here, a performer is ready to dance. He will assume a godly role, whispering blessings to those who approach him and lead some into trances.

In the quotation that opens this section, V.S. Naipaul refers to centuries of migration from the villages and small towns of India to Mumbai – a condition that is also true for Calcutta, and other big cities. Each of Naipaul's three books on India begins with his arrival in Mumbai and proceeds into an analysis of the city and of India.

39 Pavement mirror shop, Howrah, West Bengal, 1991 Howrah, Calcutta's twin city, is crowded with small trades and a variety of workshops and foundries.

40 A porter in a *zamindar* mansion, Calcutta, West Bengal, 1971 A porter, who is a migrant from a village in Uttar Pradesh or Bihar, naps at the entrance to an old *zamindar* (landed family) house in north Calcutta. Once flourishing homes, such mansions are today in a state of neglect.

41 A family, Kamathipura, Mumbai, 1977; 42 Exhausted workmen, Mumbai, Maharashtra, 1977; 43 Slum dweller, Dharavi, Mumbai, Maharashtra, 1990 Much of Mumbai belongs to the migrant. In an overpopulated city the high cost of a closet-like single room makes the openness of the pavements and the streets far more appealing.

44 Windmill farm, Tirunelveli, Tamil Nadu, 1995 An extensive windmill farm outside the town of Tirunelveli, in Tamil Nadu, has been set up. The mountains on the right are the Western Ghats.

45 Worshipper, Kapalisvara Temple, Chennai, Tamil Nadu, 1994 Beside a massive satellite-dish antenna, a business man prostrates before the biggest temple for Siva, in Chennai.

46 From a high-rise, Sivaji Park, Mumbai, Maharashtra, 1991 A man looks out on the Arabian Sea from a high-rise facing Bandra. Such apartments of South Bombay are among the most expensive in the world.

51 A film studio, Mumbai, Maharashtra, 1989 On a science-fiction film-set, a grip waits for the director to start filming.

52 Prime Minister Indira Gandhi's funeral, New Delhi, 1984 I photographed the funeral of Indira Gandhi who was shot in cold blood by her own Sikh bodyguards following the Indian Army assault on the Golden Temple, the holiest Sikh shrine. Mahatma Gandhi, Jawaharlal Nehru (Indira's father and India's first Prime Minister) and Rajiv Gandhi (her son and also Prime Minister) were cremated on adjacent grounds, on New Delhi's Ring Road.

53 A body for burning, Holika burns, Rajiv Gandhi poster, Benares, Uttar Pradesh, 1985 Disparate elements of the city come together: an election poster for Rajiv Gandhi, a body being carried to the burning ghats for cremation, a tiny Nataraja (the Dance of Siva) and Holika, the witch, burning during the Holi festival.

RESERVOIR OF MYTHIC IMAGES

In India there is an ancient relationship between people and architecture, myth and the cosmos. Sculpture and architecture were very closely tied together during the Hindu period. However, when the Muslims were building in India, their architecture included no representation of the human or animal form, whereas the British considered their statues to be separate from their buildings even though they could be set inside or alongside them.

55 Victoria Terminus, Mumbai, Maharashtra, 1991 The Victoria Terminus was built in 1887 by F.W. Stevens, in time for Queen Victoria's Golden Jubilee. Its design, owing much to the aesthetic of William Morris and his Arts and Crafts Movement, was adapted to Indian architecture most successfully by John Lockwood Kipling.

56 Sher Shah's Tomb, Sasaram, Bihar, 1987 The fifteenth-century tomb of the Afghan ruler Sher Shah Suri set the foundation for an architectural style that led to Humayun's Tomb in New Delhi, the Taj Mahal in Agra and the Golden Temple in Amritsar. During his five-year rule Sher Shah rebuilt the Grand Trunk Road and established an exemplary form of government, emulated by the Moghuls.

57 Visitors and the Krishna and cow frieze, Mamallapuram, Tamil Nadu, 1987 Two visitors before the noted early seventh-century frieze of Krishna milking a cow nuzzled by her calf, in the Five Pandava Cave at Mamallapuram, near Chennai.

58 Visitors, Sun Temple, Konarak, Orissa, 1985 A stream of Bengalis visit the Sun Temple at Konarak, in Orissa state, built in the thirteenth century in the shape of the chariot of the Sun God. One of the chariot's wheels is seen here.

59 Babasaheb Bhimrao Ambedkar, Ferozabad outskirts, Uttar Pradesh, 1991 Dr. Ambedkar, the leader of the Dalits, wrote the Indian constitution. Both he and Mahatma Gandhi are the most popular subjects for statues all over India.

60 A guardian figure, Badami, Karnataka, 1995 The guardian figure at the mammoth sixth-century complex of caves sculpted with Jain and Hindu deities and set around a water tank at Badami, north of Chitradurga and Bangalore.

61 Brihadisvara Temple, Thanjavur, Tamil Nadu, 1995 A family camps temporarily at the great Brihadesvara Temple at Thanjavur. The temple was built in the eleventh century by Raja Raja, the greatest of the South-Indian monarchs, to honour Siva.

62 Barber and goddess Kali, Calcutta, West Bengal, 1987 A clay statue of Kali stands in Kumartuli, Calcutta. The statue will be coloured and decorated for the Kali Puja Festival and then offered ceremoniously to the Ganges. In this neighbourhood of potters and sculptors, a barber shaves a client.

63 Subhas Chandra Bose statue, Calcutta, West Bengal, 1986 A statue of Subhas Chandra Bose, the Bengali hero who sided with the Japanese and the Nazis in World War II. He died in an aeroplane crash in the Far East.

64 Wrestlers exercise, statue of Bhima, Rama Ghat, Benares, Uttar Pradesh, 1983; 65 Wrestlers exercise, Hanuman shrine, Benares, Uttar Pradesh, 1983 These photographs show people exercising around representations of legendary figures who symbolize strength: Bhima, the *Mahabharata* hero (page 64); and an abstraction of the god Hanuman, a major protagonist in the *Ramayana* (page 65).

66 Mahatma Gandhi, Rajahmundry, Andhra Pradesh, 1996 Old India

and new India meet through the sacred and the profane, in a statue of Mahatma Gandhi. He is deified in Rajahmundry, Andhra Pradesh, through the addition of the canopy of the hooded cobra, which is normally used in statues of Krishna, or Buddha or of the snake as the Serpent Mother.

67 Siva as the rider of the bull, Thanjavur, Tamil Nadu, 1993 The early eleventh-century statue of Siva (Vrishabhavana) at the Thanjavur Art Gallery. The bull against which Siva leaned has been lost. In the way of India, an electric fan gives a homely touch to one of India's finest but worst kept museum collections.

A RIVER OF LIFE

In his book *Kim*, Rudyard Kipling is evoking the magic of the Grand Trunk Road of old India. Even today, his words are relevant in expressing the mythic link between India's roads and the mountain, the river and the plain.

69 A taxi driver, Calcutta, West Bengal, 1987 An argument takes place on Calcutta's Chitpur Road between a taxi driver and a pedestrian whom he has touched with his car.

71 Traffic at a crossing, Benares, 1991 Traffic on Indian roads is an eclectic mix of over thirty items of traffic including animals, pedestrians and vehicles of all sorts, all travelling at different speeds.

73 A bhisti, or water-seller, Delhi, 1987 The *bhisti*, the water seller from medieval India, still lingers on in Old Delhi in the shadows of the great mosque that Shah Jehan built. In popular folklore, the Emperor Humayun is believed to have escaped from the army of Sher Shah Suri in the sixteenth century by crossing the Ganges, near Buxar, with such a bhisti and his inflated water skin.

74 After an accident, Grand Trunk Road, Bihar, 1991 An overturned truck lies on the Grand Trunk Road in Bihar. Such heavily laden trucks are commonly involved in accidents on India's big roads – a sight Kipling never saw.

76 The trucker's talisman, Bihar, 1987 A shoe hangs from a truck in North India to ward off the evil eye.

78 Cartpullers, Mumbai, Maharashtra, 1989 The most back-breaking work is done in Mumbai and the other big cities of India.

79 Bharatiya Janta Party procession, Haryana, 1991 On the Grand Trunk Road in Haryana state outside Delhi, a motorized procession of Bharatiya Janta Party workers – saffron party flags fluttering – conduct a rally protesting at the situation in Jammu and Kashmir.

80 Grand Trunk Road, Khanna, Punjab, 1989 The rival to the Ambassador is the low-slung Maruti, the Japanese Suzuki made under licence in India. With its fast acceleration, rapid turning and light, plasticized body, the Maruti has changed Indian driving habits.

81 Driver and Ambassador car, Jaipur, Rajasthan, 1997 The Ambassador, once known in Britain as the Morris Oxford, is now a wholly Indian-manufactured car. With its metal body and high chassis, it is a strong feature of Indian roads.

THE TWO WORLDS – HUMAN AND NON-HUMAN

The *Pancatantra* was written by Visnu Sharma to educate ancient India's princes, kings and statesmen through morality fables. It not only suggests the interaction between the human and non-human worlds but also the position that birds and animals occupy in the religions of India. Hinduism, Buddhism, and Jainism give the non-human world a soul, unlike Islam, Christianity and Judaism, which consider the human world to be supreme over the soulless, non-human world.

83 A village bus stop, Barmer, Rajasthan, 1974 The peacock is the sacred bird of Rajasthan. When the monsoon rains approach, the peacock's call is heard regularly.

84 Performing bear and owner, Burdwan outskirts, West Bengal, 1991 The bear is not given any position of sanctity in India's religions. Here, a dancing bear, accompanied by its owner, travels the Grand Trunk Road.

85 Worshippers and temple elephant, Srirangam, Tamil Nadu, 1994 The elephant is the vehicle of Indra, the god of rain, and is therefore a symbol of bounty. Not only in the temple (as shown here) but all over India, elephants offer blessings to devotees. With his trunk, the elephant collects coins and notes for his keeper.

87 Bullocks for sale, Pushkar Fair, Rajasthan, 1974 At Pushkar in Rajasthan, there is an ancient and sacred lake where, in the week of the October-November (Kartik) full moon, bullocks, horses, cattle and particularly camels are bought and sold.

88 Siva and bull effigy, Calcutta, West Bengal, 1998 This scene shows a cow tied to a pole, cowdung cakes drying and a statue of Siva by his bull. On the banks of the Hooghly, an arm of the Ganges, people bathe.

89 A devotee at a Siva shrine, Benares, Uttar Pradesh, 1984 Unlike the bull and the cow, the goat is not a sacred animal. In this photograph, a goat has wandered into a Siva shrine in Benares, where a woman is praying.

91 A bridegroom, Jaisalmer, Rajasthan, 1974 A princely bridegroom arrives with ceremony to marry the daughter of the Maharajah of Jaisalmer. In the background are the ramparts of Jaisalmer Fort.

AMONG THE WOMEN

Jawaharlal Nehru's words about Indian women are as true today as they were over fifty years ago when he wrote them in *The Discovery of India*. The women in this section largely relate to the world I saw around my orthodox mother in our Jaipur home. She ran our house and out-lived my father by over thirty years. She was the stronger character of my two parents, as so many women are in India.

93 Pilgrims, Sonepur Fair, Bihar, 1989 At full moon in the month of the Kartik, a young village woman attends the Sonepur fair's last day. She will take a bath at the sacred confluence of the Gandak River and the Ganges, near Patna, in Bihar state.

94 Devotee, Chennai, Tamil Nadu, 1994 The prayer room of the Guru

Krishnamachari, a legendary master of yoga, is used by a visitor.

95 Employees in a household, Calcutta, West Bengal, 1986 The household help of a large family (containing nearly 100 members) in north Calcutta discreetly watch a theatrical performance.

96 Housewife, Jaipur, Rajasthan, 1974; 97 Worker, textile factory, Kozhikode, Kerala, 1983 Two contrasting worlds: the old and orthodox woman in Jaipur is from a vanishing world, the young woman working in a textile factory in Kerala is educated and strives for a better quality of life. Her goal may be achievable in tiny but remarkable Kerala, where almost 100 per cent literacy has been reached among men and women.

98 Pilgrims, Kumbh Mela, Prayag, Uttar Pradesh, 1989; 99 Pilgrims distribute holy water, Kuttalam, Tamil Nadu, 1994 These photo-graphs show two kinds of pilgrimages: the mammoth Kumbh Mela at Prayag, Allahabad, and a small, regular affair at Kuttalam, Tamil Nadu, where a woman distributes holy water.

100-1 Housewife, Tambha Khata, Mumbai, Maharashtra 1992 A housewife doing an errand in the Tambha Katha area of old Bombay passes men pushing carts and labelling shipping crates.

104 Employee in a household, Mumbai, Maharashtra, 1992 The modern Indian woman from the big city is seen here. The elderly maid on the left, who has devoted her entire life to the care of one household, is a vanishing person in India. Today, domestic staff in the big cities demand a variety of comforts and rights, from their own television to at least one day a week off.

105 Employees, Morvi Palace, Gujarat, 1982 Women workers like those shown in this photograph are found in the old palaces of India. Employed by grand families for generations, they do all the household chores.

107 A wedding party, Jodhpur-Jaisalmer road, Rajasthan, 1988 A veiled bride tied to her bridegroom after finishing the traditional perambulation of the sacred khejra tree, near the Jodhpur-Jaisalmer road in Western Rajasthan.

LET DIFFERENCE REIGN

Salman Rushdie's words, written after Indira Gandhi was shot by her Sikh bodyguards, reflect the need for harmony among the many kinds of people who make up India. The photographs in this section are of Sikhs, Moslems, Christians, Hindus and a member of the Brahmo Samaj, a reformist offshoot of Hinduism which has affinities with Unitarianism. These people also reflect another kind of diversity found in India. They are Tamils, Malayalis, Bengalis, Maharashtrians, Kashmiris, Gujaratis, Rajputs, and Benarasis.

109 Visitors to the museum, Golden Temple, Amritsar, Punjab, 1987 Sikh visitors in a quiet room of the Golden Temple museum. The walls are lined with pictures of some of the religious heads of the community. The walls of the other rooms in the Golden Temple are lined with paintings that reveal the history of the Sikhs in gory detail.

110 A musician, Thyagaraj Festival, Thiruvaiyaru, Tamil Nadu, 1994 This young man is among the nearly 2,000 musicians who gather at Thiruvaiyaru, Tamil Nadu, each year in January to play or sing in honour of Thyagaraj, the greatest composer of Carnatic music (as South Indian music is known).

111 *Dhabawallah*, or professional lunch distributor, Mumbai, Maharashtra, 1992 A *dhabawallah* in Mumbai. The dhaba is a box, and Bombay has hundreds of people whose occupation is to carry boxes of hot lunch from housewives to their husbands. Here a *dhabawallah* crosses a street, while firemen fight a nearby blaze.

112 Visitor, Bombay Dyeing Office, Mumbai, Maharashtra, 1989 A visitor to the offices of Bombay Dyeing, one of the city's biggest textile mills.

113 Dr Mihir Mitra at home, Jhamapukur, Calcutta, West Bengal, 1986 The late Dr Mihir Mitra, a physician, is shown in his living room. Among Satyajit Ray's favourite houses in Calcutta were Dr. Mitra's and his cousin's homes, which he recreated in part in his masterly period film *Charulata*. The man at the door has simply

walked in from the street, without permission, to see the house, which some of his neighbours treated as a kind of walk-in museum.

114 Syrian Christian priests, Kottayam, Kerala, 1984 Syrian Christian priests eat lunch in a home near Kottayam, Kerala, after performing funeral services for a family. Christianity in Kerala is older than in Rome. The first conversions to have taken place in Kerala are attributed to St Thomas, one of the first apostles, who arrived here on a trading ship in 52 AD.

115 Brahmins at a yoga conference, Chennai, Tamil Nadu, 1993 Brahmin priests relax during a yoga conference in Mylapore, the old section of Chennai.

116 Craftsman Ghulam Hussain Mir and grandson, Srinagar, Kashmir, 1980 The late Ghulam Hussain Mir, a master papier-mâché craftsman from Srinagar, Kashmir, lies sick in bed; some of his work is propped against the wall.

117 Landowner, Barwara village, Sawai Madhopur, Rajasthan, 1976 A Rajput landowner talks to a man from his village.

118 R.K. Narayan, Chennai, Tamil Nadu, 1989; 119 Satyajit Ray, Calcutta, West Bengal, 1989; 120 V.S. Naipaul at home, England, 1991; 121 Shakti Chattopadya recites at a party, Calcutta, West Bengal, 1987 These photographs are portraits of famous men: R.K. Narayan (page 118), the novelist with a comic touch, whose original name Narayanswami was edited down by Graham Greene to make it 'readable by little old ladies in libraries'; the late Satyajit Ray (page 119), a member of the Brahmo Samaj sect, in the chair where he used to work all day, holding his katha, a type of notebook in which he wrote and sketched his film scenarios; novelist V.S. Naipaul (page 120) at home near Salisbury in the UK, is a collector of Kalighat prints from Bengal (an example is propped up on his bed), Japanese woodcuts and Moghul and Rajput miniatures; and the late Shakti Chattopadya (page 121), the Bengali poet, who is reciting one of his works at a small dinner party in Calcutta.

122 Bridegroom, Bikaner Fort, Rajasthan, 1974; 123 Dr Karni

Singh, Maharajah of Bikaner, Lalgarh Palace, Rajasthan 1974
The late Maharajah of Bikaner, a photography enthusiast, displays his equipment before his home, the sandstone Lalgarh Palace. His soon-to-be son-in-law (page 122) arrives at the sixteenth-century Bikaner Fort to marry the princess.

124 Employees, Vijainagram Palace, Benares, Uttar Pradesh, 1984
Like many maharajahs, the Maharajah of Vijainagram (a hunting and cricket enthusiast from Andhra Pradesh) maintained a palace in Benares. After his death, the palace went to seed and old retainers like these two men had to hang onto a dead and antiquated world.

125 Pranlal Bhogilal and daughter, Ahmedabad, Gujarat, 1986
Pranlal Bhogilal, a merchant-prince and a collector of old cars, lives mostly in Bombay, but is seen here with his daughter, his driver and a Rolls Royce, on a visit to his mansion in Ahmedabad.

WHEN WE WERE CHILDREN

Amitav Ghosh's words from his novel *The Shadow Lines* suggest innocence lost. In this cosmopolitan novel, Ghosh, the son of a diplomat, describes a new kind of Indian childhood.

127 Dikshitar Brahmin children, Chidambaram, Tamil Nadu, 1994
The Dikshitars are Brahmins who control some of the Tamil Nadu temples. They do not believe in educating their daughters. These girls were photographed near the Chidambaram Temple.

131 Playing 'Punishment' , a marble game, Mumbai, Maharashtra, 1991 Children playing 'Punishment', a game which calls for its loser to hit a marble with his elbow while holding his ear.

IN THE ACT OF LIVING

The style of the pictures in this volume echoes the philosophy expressed by Cartier-Bresson in his influential book, *The Decisive Moment*. Cartier-Bresson's approach to taking pictures influenced not only photographers, but also film-makers like Satyajit Ray, and the Italian neo-realist cinema. To Cartier-Bresson's words, I would add those

of Jean Renoir, one of his mentors. Renoir's statement, 'All great civilisations have been based on loitering,' could be used to describe the street photographer's art and convey a sense of the vision of the Parisian photographer Eugène Atget

135 Purasawalkam neighbourhood people, Chennai, Tamil Nadu, 1993 R.K. Narayan was born in a house, behind the vendor selling a pan and nut chew. It has since been replaced by a hotel.

138 Crawford Market, Mumbai, Maharashtra, 1993 A fruit seller drinks water from a kettle, as a chaiwallah serves tea during the mango season in Mumbai's big Crawford Market, noted for its fruit and vegetables.

139 Holi revellers, Jodhpur, Rajasthan, 1975 These men are tipsy from drinking bhang (marijuana) mixed with milk and condiments. They are celebrating the day of throwing colour and singing songs, which follows Holi.

140 Cinema poster roofing, Mumbai, Maharashtra, 1989 In Mumbai a discarded poster is used as a canvas rooftop.

142 Pochampalli, Andhra Pradesh, 1996 A street in a village noted for its production of handloom fabrics.

143 Neighbourhood people, Pondicherry, Union Territory, 1993 A housewife looks down on a cyclist in front of a shop selling bathroom ware.

144 Holi revellers, Mumbai, Maharashtra, 1990 In Mumbai, a man is angered when Holi-festival colour enters his eyes.

THE GIFT OF THE RIVER

Nirad C. Chaudhuri's words evoke the mood of much of India and its dependence on rivers, reservoirs, water tanks and the monsoon.

147 Bathers in prayer, Benares, Uttar Pradesh, 1985; 148 Waiting out the floods, Benares, Uttar Pradesh, 1983; 149 Chessplayers, monsoon floods, Benares, Uttar Pradesh, 1967 The photographs of Benares in these pages provide contrasting scenes: the seriousness of immemorial prayer (below a sculptured Siva's bull and cobra)

and the casualness with which periodic floods fit into the life of an ancient city built on a high bank of the Ganges. In the monsoon of 1967 the water reached a mile into the city.

150 A rescue, Haryana floods, 1987 A young woman is rescued from floods in the state of Haryana and Punjab. Heavy rains caused the floods which filled the Bhakra Nangal Dam brimful and forced the sluice gates to be opened to ease the pressure. Terrorists later shot the chief officer of the dam operations, a retired army general.

151 After crossing the flooded Luni River, Barmer, Rajasthan, 1975 While most rivers of Rajasthan are usually dry, they are prone to flash floods in the monsoon season. This woman, holding her child, has waded across minor flooding of the Luni River.

152 Bather in a reservoir, Sunderbans, West Bengal, 1988; 153 Water tank, Modera, Gujarat, 1997 These photographs depict contrasting scenes: two bathers at a water reservoir in the Sunderbans, a part of the Ganges delta; and a water tank at Modera, near the famous Sun Temple in Gujarat, a state in which water is scarce. This last photograph reminds me of Emperor Babur's words in the fifteenth-century *Baburnama*: 'I always thought one of the chief faults of Hindustan was that there was no running water.' But India is larger than Hindustan (North India). In the south and in the east there is an abundance of water, but often it is badly managed.

BIOGRAPHY

Born in Jaipur, Rajasthan, India, 1942

Began working as a photographer in 1965

SOLO EXHIBITIONS

Museum of Photographic Arts, San Diego, USA 1983

Williams College Museum of Art, Williamstown, USA 1983

Duke University, Durham, USA 1984

Fogg Art Museum, Harvard University, Cambridge, USA 1984

Museum of Art, Rhode Island School of Design, USA 1984

Pace MacGill Gallery, New York, USA 1985

University of California Museum, Berkeley, USA 1985

Arnolfini Gallery, Bristol, UK 1987

National Museum of Photography, Bradford, UK 1987

Arthur M Sackler Gallery (Smithsonian Institution),
 Washington DC, USA 1989

Center for Creative Photography, Tucson, USA 1991

Dallas Museum of Art, USA 1992

Sewall Art Gallery, Houston, USA 1992

Piramal Gallery, National Centre for Performing Arts,
 Bombay, India 1992 and 1994

Burden Gallery, Aperture Foundation, New York, USA 1994

Max Mueller Bhawan (Goethe Institute), New Delhi, India 1995

Feature Gallery, New York, USA 1998

Retrospective exhibition: Bon Marché, Paris, France 1998; Art
 Institute of Chicago, USA 1999; National Gallery of Modern Art,
 New Delhi and Mumbai, India 1999; CIMA, Calcutta, India 1999;
 Chitra Kala Parishad, Bangalore, India 1999; Jawahar Kala
 Kendra, Jaipur, India 1999

GROUP EXHIBITIONS

'The Art of Fixing the Shadow', Art Institute of Chicago and The
 National Gallery, Washington DC, USA 1989

Toppan Collection, Metropolitan Museum of Photography,
 Tokyo, Japan 1989

Participated in group shows in London, Paris, Bonn and Frankfurt

WORK IN PHOTOGRAPHY COLLECTIONS

Metropolitan Museum of Art, New York, USA

Museum of Modern Art, New York, USA

San Francisco Museum of Modern Art, USA

Art Institute of Chicago, USA

Williams College Museum of Art, Williamstown, USA

Arthur M Sackler Gallery (Smithsonian Institution),
 Washington DC, USA

National Museum of Photography, Bradford, UK

Metropolitan Museum of Photography, Tokyo, Japan

BOOKS

The Ganges: Sacred River of India, Perennial Press, Bombay 1974

Calcutta, Perennial Press, Bombay 1975

Rajasthan: India's Enchanted Land, foreword by Satyajit Ray,
 Thames & Hudson, London; Editions du Chêne, Paris; Perennial
 Press, Bombay 1981

Kumbh Mela, Arthaud, Paris; Perennial Press, Bombay 1981

Kashmir: Garden of the Himalayas, Thames & Hudson, New York and
 London; Editions du Chêne, Paris; Perennial Press, Bombay 1983

Banaras: The Sacred City of India, Editions du Chêne, Paris;
 Thames & Hudson, New York and London 1986

Kerala: The Spice Coast of India, Editions du Chêne, Paris;
 Thames & Hudson, New York and London 1987

Calcutta: The Home and the Street, Thames & Hudson, New York
 and London; Editions du Chêne, Paris 1988

The Ganges, Thames & Hudson, New York and London; Aperture,
 New York; also, editions in Japanese, German and Italian 1992

Bombay, conversation with V.S. Naipaul, Aperture, New York;
 Perennial Press, Bombay 1994

The Grand Trunk Road, Aperture, New York; Perennial Press,
 Bombay 1995

Tamil Nadu, foreword by R. K. Narayan, DAP, New York 1997

MAGAZINE PUBLICATIONS

Published in every major international photographic periodical

Monograph issue of *Asian Art* of Smithsonian Institution,
 Washington DC 1997

TEACHING

Lecturer at School of Visual Arts, New York since 1996

Guest lecturer at Columbia University, New York, and
 Asia Society, New York.

AWARDS

Padma Shri, Indian National Award 1983

First Fellowship in Photography instituted by the National
 Museum of Photography, Bradford, UK 1986-7

ACKNOWLEDGEMENTS

I have many people to thank, in several parts of the world, who have helped me in a variety of ways over the last thirty years.

For generously supporting several of my works, including a part of the retrospective exhibition: Cynthia Polsky .

For making the retrospective exhibition happen: Marukh Tarapor, Charles Correa, Manu Parekh, Mehli Gobhai, Bruce and Lucinda Palling, Paritosh Sen, Arthur Ollman, Anjali Sen, Sabrine Merle, Gabriel Bauret, Narender Kanwar, Dharmendra Kanwar, Abhisek Poddar, Jyotinder Jain, Michael Brandt, Anna Obolensky, Rakhee Sarkar, Regine Daric, Paolo V. Gomes, Susan Benn, Sherry Barbier, Sharada Prasad, Hudson, Paul Smith, Nicola Colby, Robert Skelton and David Mellor .

For giving a second home to a virtual nomad: Regine Daric, Francine Boura, Anne de Henning, Daphne Angles, Glenn and Susan Lowry, John and Sunaina Mandeen, Anna Friedlander, Hira Narayan, Zette Emmons, Gopal Menon, Belinda Wright, Joseph Lawton, Ilan and Alka Averbuch, Swasti Mitter, Anand and Neera Bordia, Ian Baruma, Ruchira Gupta, Asha Seth, Chandana Mathur, Dermot Dix, Soumitra Bannerjee, Sudheshna Roy, Nilima Singh, Menaka Singh, G. Venkatramani, Ram Rahman, Arif and Farida Khan, Mahindra Sinh, Jehroo Mulla, Hormadz and Naheed Sorabjee.

For valuable comments on the sequencing, as well as on my essay on colour: Thomas Roma, David Travis, Colin Westerbeck, Sylvia Wolf and Joseph Lawton .

For their deep insights into music, colour and modernism: Akeel Bilgrami and Partha Mitter.

For their enthusiasm about my essay: Amitav Ghosh, Ruth Keshisian, Michele Valadares, Ketaki Sheth and Aurobind Patel .

For their support: Maria and Lee Friedlander, Charles Traub, Milo Beach, Tom Lentz, Max Kozloff, Neale Albert, Geoff Winningham, Navina and Bernard Haykel, Soumi Roy, Mammen and Prema Mathew, Ashok Joshi, Brijesh Khindaria, Tsugao Tada, Jehangir Jehangir, Praful Patel, Michael Dalton, Shrabani Basu, Meera and Bhagwat Devidayal, Nikhil Laxman, David Gallant, Rashid Irani, John O'Neil, Sundaram Tagore, Richard Lanier, Willard and Gloria Huyck, Rahul Mehrotra, Bimal Maskara, N. Ram, R.V. Pandit, Meena Ahmed and Colin Ford.

I want to acknowledge my late brother Pratap Singh who started me on the photographer's journey when he brought me a camera from Hong Kong in my high school days; and my brother Bhopal Singh who then gave me the first instructions in what he called "the aesthetics of the candid style"; and R.P. Gupta who lectured me on the hunter's eye in crowded Calcutta.

Finally I would like to thank Phaidon Press: Richard Schlagman for the courage to do a very ambitious and radical book, Sara Borins, Amanda Renshaw, Elizabeth Rowe, Natasha Mitchell, Stuart Smith, Danielle Oum and Neil Palfreyman.